TIME FRAMES

By the same author

Wisconsin Death Trip
Real Life

TIME FRAMES

The Meaning of Family Pictures
by Michael Lesy

Pantheon Books New York

All rights reserved under International and Pan-American Copyright Conventions.
Published in the United States by Pantheon Books, a division of Random House, Inc.,
New York, and simultaneously in Canada by Random House of Canada Limited, Toronto

Grateful acknowledgment is made to Graphic Reproductions, Inc.,
for the pictures which appear on pages 263 to 264.

Photos by the author appear on pages 1, 21, 24, 29, 35, 49, 59, 69, 80,
89, 91, 101, 108, 109, 115, 123, 133, and the back jacket.

Library of Congress Cataloging in Publication Data

Lesy, Michael, 1945–
Time frames.

1. United States—Social life and customs—
20th century. 2. United States—Biography. I. Title.
E169.L6 973 80-7712
ISBN 0-394-42456-5

Manufactured in the United States of America

First Edition

Designed by Naomi Osnos and Robert Aulicino

Dedication

To Max and Alex

Table of Contents

Thanks to

Daniel Aaron
Martha Chahroudi
Color Craft Inc.
Roland Delattre
Alan Fern
David Hibbeln
Lee Kravitz
Pearl Cleage Lomax
Nancy Marshall
John McWilliams
Joel Newman
Mary Caroline Pindar
Mather Custom Prints
Michael and Judith Reagen
Sal and Hal Sebastian
Warren Susman
Alan Trachtenberg

This book was made possible in part by a grant from the
National Endowment for the Arts.

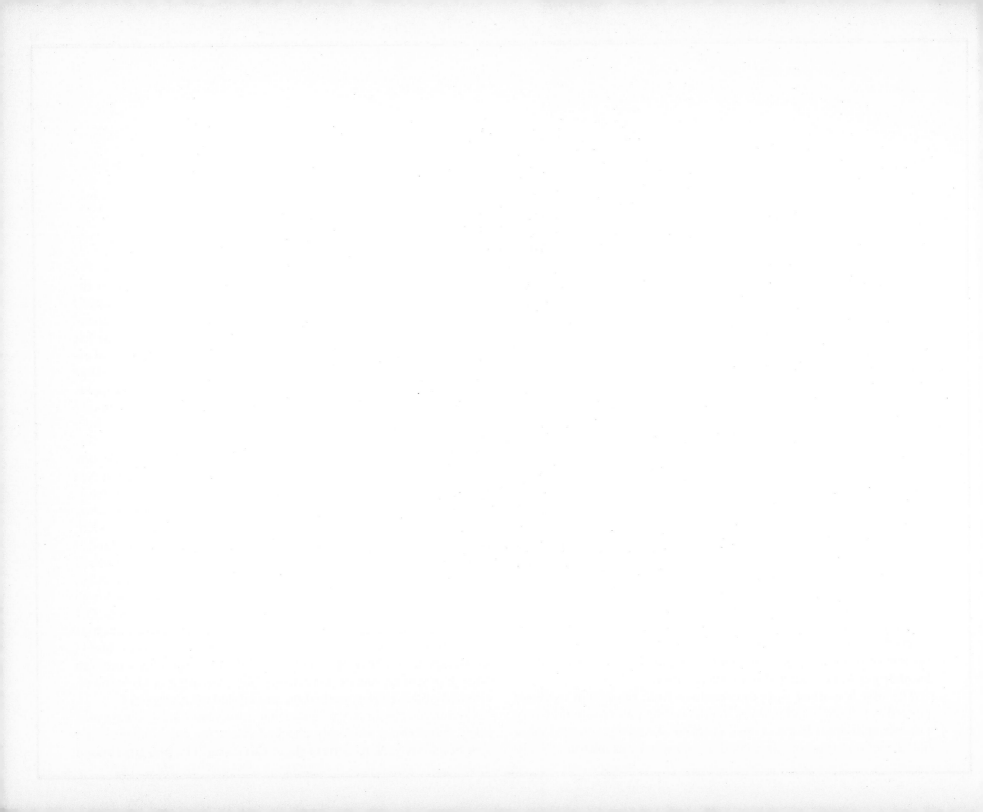

INTRODUCTION

I was standing there. In my backyard. I was looking at the garage. It was green, the color of an Easter egg, as green as candy, as deep green as the trees in *Snow White*, so green that if I ate it, I would live forever. When I saw it, I forgot my body; I breathed it into the middle of my skull; I sucked it deep behind my eyes, into a little room where I could keep it. It smelled like an apple orchard. I stood in the shade of my house. There was a hedge of thorns behind me; there were pink irises and red zinnias and string beans in the garden. My father was leaning down, and he looked into my eyes. He held me around the waist. I loved him. He said to me, "I just want you to do one thing. Just one thing. I always want you to tell me the truth." That's what he said.

When I was 21, I roomed with a guy who was a delivery boy for Technicolor Photo. He drove a Harley with a sidecar, back and forth between the plant and every drugstore in the city. On the way out, he delivered prints; on the way back, he carried film. All day, every day, day after day. He could have been a drone collecting pollen. The plant never closed. The bosses had their own offices, but everyone else sat in someone else's chair and stood in someone else's place. It was like a bus station with three shifts that beat like a heart. If you worked there and had any sense, you understood that you were just a version of someone you hadn't met. One guy said he was a replica; another guy kept talking about reincarnation.

The way it worked was: thousands of little black film cassettes poured out of red bags into bins. The bins rolled into the dark. Every cassette split apart like a crystal, cracked like an egg, popped open like a cocoon, unwound like a bud. Every spool was unstrung; every roll was pulled, stretched, and weighted so it hung down to the ground; hundreds of them hung in groves, jiggling like vines, clipped to overhead lattices that passed them through chemical developers.

At that moment, every dead interval was recalled and time past was renewed. Somewhere, in the center of the plant, every gesture of experience was recapitulated in outline, every object that had vanished was retraced. The films became negatives. Somewhere in the maze, smelling like fertilizer, they were taken down, fitted into clear plastic sleeves, and threaded into a color analyzer that sent a beam of light through each frame to discover its density. It was that beam of clear light that made the negatives bloom, one every twenty seconds, one after the other, the machine clicking like a metronome. Clouded eyes returned their glance; dark lips opened red; the hills in the background grew brown and then green; the water in the lake grew white and then blue; the chrome of car bumpers glinted, then sparkled; rooms filled with people; brides stood among gifts; daughters danced with their fathers; sons returned to their mothers; lovers embraced beneath trees; hunters held their weapons, as deer bled in the snow; cripples grinned, waved, and then walked; wise men sat alone in corners, while fools stood by the highway, pointing at signs. The whole goddamn human race shot out of the print slot, in a continuous line, flat-out to the cutting machines, where girls in white gloves shoved them into envelopes and stuffed the envelopes back into red bags. Every hour, one of the delivery boys, sweating in his leathers, climbed off his Harley, walked in, and hauled off a new load.

Commercial technology being what it was, there were always mistakes. Supervisors randomly checked prints for color balance and sent hundreds back to correct slight variations. The first-tries ended

up in the trash. At the end of the day, there were enough remakes to fill half a dumpster. That's when my buddy and I walked through the plant to be sure everyone was too exhausted to notice us; then we'd grab a few empty boxes and go over the side of the dumpster. We'd fill the boxes and go home. That went on, every day of the week, for two months. We looked at seven thousand a week.

My buddy got fed-up, left town, and became a fisherman. I kept looking at snapshots. For years and years and years. Pictures people showed me or pictures they left unclaimed at big photo finishers. Sometimes I think it changed my personality, and sometimes I wonder if it didn't damage my brain. What I mean is:

If you look at a couple hundred thousand snapshots, in various regions, under various circumstances, over a long enough period of time, you begin to lose track of the idea of people's individuality and freedom of choice as guaranteed by the U.S. Constitution and the Bill of Rights. You begin to lose track of specific faces and places, and you begin to think about genotypes. In between the howls and the whimpers and the cosmic laughter, you catch yourself short and start thinking about pictures as symbols; and once you start on symbols, you get into a lot of trouble with most civilians. Because it's not long before you start reading comparative mythology. Which does you about as much good as the study of chivalry did Don Quixote. The trouble comes because scholars of comparative mythology claim that the actual details of even the most significant events last only as long as three hundred years in collective human memory. After that, they say, whether it's the life of a saint, a savior, a hero, or a fiend, it's assimilated as part of an already existing, already ancient set of stories. That sort of consciousness was very useful in detecting consistent, long-term patterns, but it created a bit of distance between me and the flash and rustle of daily life.

That distance grew so great by the time I was 35 that I thought it was going to kill me. For years I gave lectures in various parts of the country to anyone who would listen. I'd set up my slide projectors, turn off the lights, and start talking. I'd explain that a photograph was a cultural artifact; that it was a thing made to achieve an end like a letter, or to be an end in itself like a poem; that, in either case, it was tangled within a whole culture that was itself pinned within a social structure, both of which enclosed and were enclosed by the projections and perceptions of the mind. I'd admit that to comprehend a photograph was like opening a set of Chinese boxes, only to discover a message that had to be translated from one language to another. I'd concede that it was frustrating, but then I'd recount how, in the Middle Ages, Jewish scholars had translated Aristotle from Arabic into Latin, first for the benefit of the metaphysicians of Paris, and then to the great good fortune of European civilization. I'd claim that the use of photographs as data was of the most remarkable importance for the humanities and social sciences; that such uses were revolutionary and redemptive; that their discovery was equal to the discovery of a new land mass and a new sea! My listeners smiled at my charming enthusiasms, as if I were an ingenious macaw that had taught itself a new way to crack a walnut.

I grew more and more worried. Nobody believed me. My colleagues in the profession of history couldn't decide if photography was merely a pleasant hobby like painting with watercolors on weekends, or a shallow and degenerate invention which encouraged habits of thought equivalent to those of a 13-year-old whore who couldn't take her eyes off herself in the mirror. My friends who were photographers either found such arguments boring and irrelevant or so full of words as to be disgusting. I began to imagine that all my intellectual colleagues were Calvinists, and all my photographer friends were deaf mutes.

The more I talked, the poorer I became. There were no university jobs except as temporary help to fill in while some regular faculty member went abroad for a year because teaching was driving him crazy. The departments that employed me used me to give their students the impression that something new was happening. Students came to listen because they were bored or angry, or because they thought I was some sort of celebrity who would punch their ticket on the way to a good job. Tenured faculty would no more speak with me than they would converse with a part-time secretary. All I did was travel from one region of the country to the other, year after year, like an intellectual migrant worker. I finally ended up with a two-year contract at an art school that was run like the Volunteers of America. Six months after I was hired, the place ran out of money. I didn't know what to do. I had a family to feed, but I didn't have a dime. I'd spent years constructing a device of inquiry that everyone but advertising and intelligence agencies found interesting but useless. Nothing made sense any more. So I got ahold of a tape recorder and a camera, filled up the car, and went west. I decided I'd go home and find out where I went wrong.

I started talking to people I'd known or known of for thirty years.

People who were about 60 years old, who'd grown up during the Depression and lived through the Second World War. Some of them were friends; some of them were relatives; a couple of them I'd never met but heard about. There were a few I'd encountered when I was so young and they were so alive, that the sight and sound of them shorted every switch and blew every fuse in my body.

There was one guy who used to show up every couple of months, smelling like a bedpan, carrying a dozen eggs, a jar of marmalade, a pint of strawberries, a bag of tomatoes, and a dozen cloves of garlic. There was another one who came for dinner with his kids one night when his wife was away. He had two whiskies, a piece of rye bread, a pickle, and a few bites of roast beef and then he fell over into a bowl of mashed potatoes. We hauled him away and stretched him out, and I opened his mouth and kissed him, sucking air and blowing it into him, tasting the whisky fumes and the garlic, fanning his heart till the ambulance came.

There was one woman whose daughter I loved for ten years, but she preferred figure skaters; there was another one whose daughter loved me for just as long, but I never even noticed. And there was one whose daughter slept with me, then brought me home like a cat with a sparrow, only I didn't know and I fell in love with her mother.

There were three guys who taught me how to ride and throw and drive. There was one kid who showed me how to piss into a bottle, and another one who kept pictures of women under his bed. There was one man who knew everything except how to give advice, and another one who would have been a saint except he thought everyone was just like him. They all knew as soon as I started talking that I was desperate. That everything I'd learned was squandered. That everything I'd hoped for hadn't even begun. That I was as confused as they were. So when I asked them if they would tell me their stories and show me their pictures, they knew my life depended on it. They were kind to me.

I'll tell you exactly what I said. I said, "I've looked at hundreds of thousands of snapshots and listened to a lot of stories over the past ten years. I can read a picture the way some people can read the palm of a hand. I'm not working for the Gallup Poll. If you tell me something or show me something, I'm not going to say thanks and walk away. I'm going to stay right here and I'm going to tell you what I know."

I told them I was going to write a book about them. That they were going to be in it because it didn't make any sense when someone like Winston Churchill died and all the obituaries said he was a great and complex human being—it didn't make any sense because *everyone* was just as complex as he was, and *everyone* had lived a life and had a story to tell. Everyone. And I was going to do my best to transmit it. That's all I wanted: to transmit it. I told them I'd be their ghost writer. *Their* words and *their* pictures, on their own terms. So it wouldn't get lost when they died.

I promised them that I wouldn't use their real names or the place they lived so they could stay anonymous. That's when they said, "How can we stay anonymous if you're going to use our pictures?" I said, "There are maybe twelve people in the whole world who know you by your face. And of those twelve, there are only a couple who know what you looked like when you were 6 or even when you were 20. And those people, who can recognize you by your face alone, are so close to you that they probably know all about you already. People's faces are hard to identify. That's why everyone has a Social Security number or a driver's license."

Some of them wouldn't talk to me because they were modest, and some because they weren't reconciled to themselves. But the ones who knew who they were and were proud of it trusted me. I told them, "It's not going to be easy going all the way back. It's like swimming all the way down and touching the bottom of the river and coming all the way back up for air, into the light. It's hard touching the bottom and coming up. It'll tire you out, but it'll make you feel good when it's over. I promise. And I'm not going to go away. And I'm going to make sure it doesn't disappear. I'm going to pass it on."

Most of the time, we'd sit in the kitchen and start looking at the pictures. They'd go through them, quickly at first, one after the other or one page after the other. But then it always happened: we'd get to one picture or one page and they'd stop, and it was almost as if a little bone, a tiny little bone, somewhere inside, as thin as a wishbone, just *cracked*, and they'd sit up and rise back and start talking, looking right through me, and then they'd be *gone*. Back there. Gone. And then they'd come up again and say something, and then go back and start talking again; and I never said a goddamn word except "yes" because I was back there with them, riding the wave, holding the table, my eyes on theirs, my eyes *in* theirs, breathing till it passed and the next one came. Wave after wave: recapitulation, conjunction, revelation. Again and again. Sometimes it would last for three hours. Sometimes for five. Sometimes once and not again. Sometimes twice

or three times over as many days or weeks. Often alone. But just as often with their spouse.

When it was over, I'd gather up the snapshots to take them home to make copies, and we'd set a date when I'd be back to return the pictures and talk. Then they'd walk me out the door. Thinking, for the moment, that I was their son, or their nephew, or their brother, or the husband they should have had. They'd stand on the front steps and I'd walk to the car and they'd wave good-bye. It would be 3 o'clock in the morning or 4 o'clock in the afternoon, and I couldn't find the keys; and then, when I did, I couldn't find the ignition. I'd wave good-bye, then I'd crawl up the expressway ramp, thinking it was all over, until I'd wake up and notice I was tailgating someone at 75 mph and heading in the wrong direction.

Sometimes I'd hear stories and see pictures that didn't hit me for two days; but once they did, I'd have a hard time answering the phone or walking into a drugstore. There were some stories that were so misshapen and horrendous that I destroyed the tapes and never even borrowed the pictures. And there were some things said about other people that were so gratuitously cruel that I knew their publication would get everyone into a lot of trouble.

But in every case, the people told me stories; they spoke parables; they made confessions. They told me tales; they recounted epics; they recited myths. They told me the way things *really* are. They sat, all of them, at the very center of the universe, looking out at the worlds of the lives of the people they had known, spinning around them. They sat alone at the center, heroes and heroines to whom it all flowed, from which it all came. They passed judgment. They held the scales. They told me the Truth.

What the Truth is has nothing to do with the checker games that sociologists think are the equivalent of life. The Truth is three-dimensional chess. It has nothing to do with the quantitatively verifiable data that professional social scientists hope and imagine are the only things of which the social world is composed. The people who were telling me and showing me the True Facts were speaking in metaphors and allusions. Metaphorical Fact and Poetic Truth as opposed to Quantified, Cross-Tabulated Data. There are no etiological case histories or random cluster samples to be found here. Such models and methods are adequate if the living world is considered to be either a hospital ward, a marketplace, or a voting block. Sociological truth is merely the current version of an explanation that is

so simplified that everyone is willing, for the moment, to agree, abide, and bet on it. It is the current bare minimum. It asks only the questions it can spell.

Most of the time, I didn't ask too many questions. I just listened. It wasn't that I *wanted* to ask the questions I did: I *needed* to; I *had* to. I was more than merely interested. Professionals would not consider that either appropriate or genteel. What is genteel is to ask careful questions of perfect strangers; what is appropriate is to verify a hypothesis; what is best is to satisfy a client in a disinterested fashion for a fee. That is what is known as doing the right thing for the right reason. According to those conventions, I did the right thing for the wrong reason. I asked people questions because if I didn't, I thought I'd go crazy. I never said it out loud. But they knew. I wanted to know *what it all means*.

The Truth conveyed by the stories and the pictures in this book is sometimes contradictory and always multivariate. It is the Truth of Paradox. It is the stuff that kept Heraclitus and Swedenborg warm in the winter and cool in the summer. The images and stories in this book are, within themselves, sometimes conjunctions of opposites; but more often, they are simultaneous, disparate versions of reality. Tweedledum and Tweedledee with their eyes crossed.

This is very much the nature of the pictures. Pictures made as lessons of the heart to deny a fear *and* indulge a hope, counterfeit a fact *and* reveal a truth. Pictures whose messages are contained in a tacit code of gesture, juxtaposition, exposure, and scale. Pictures that are psychic tableaux, in which the flow of profane time has been stopped and in which a sacred interval of self-conscious revelation has been imposed by the cutting edge of the frame, the glare of the sun, or the flash of a strobe. Pictures like frozen dreams whose manifest content may be understood at a glance but whose latent content is enmeshed in unconscious associations, cultural norms, art historical clichés, and transcendental motifs. Pictures that are both clichés *and* archetypes, vulgar *and* miraculous, fact *and* fiction.

Taken together, the words and images in this book may describe dramas of love and money whose principal actors were first- and second-generation immigrants, living in the midwestern United States just before, during, and after the Second World War. All of the episodes that follow may even be described as variations of the story of Pandora, in which the war is the box, and the principal actors take

turns being either Epimetheus or the girl herself. This entire book may be nothing more than an illustrated adult fairy tale, complete with morals drawn and lessons learned. However, the lessons occasionally become as serious as those described by St. Augustine in the *City of God*, and the fairy tales are sometimes interspersed with pictures from the Garden of Eden.

The nature of this book is somewhat similar to that of Tiresias who, the story goes, was the only human who ever had it both ways: a man who was turned into a woman and then turned back again; a man who therefore knew more than the Gods, who then made him blind but gave him the gift of prophecy; a creature who could tell the *whole* truth. When Oedipus called Tiresias to him, he could have asked him to predict the weather or to entertain him with stories before bed. Instead, he asked him to tell him the truth. Which was what Tiresias could do best, and what he unfortunately did. By analogy, this book uses both words and pictures in an attempt to convey some natural truths by engaging the verbal and visual imaginations of its readers. It is a work of history that relies on the conventions of art, literature, and drama to describe the coincidences, disharmonies, multiplicities, and paradoxes of ordinary life that cannot be adequately reproduced using conventional historical methods. The book's obvious need to rely upon such aesthetic, literary, and dramatic conventions to convey the complex patterns of ordinary life may indicate the need of the historical profession to begin to trust its senses in order to reevaluate its definitions of evidence, investigation and discourse.

There are a number of visual artists and art historians who believe that snapshots have the charming grace of nineteenth-century genre paintings; there are also those who claim to have seen snapshots that possess the same miraculous beauty as a unicorn prancing through a suburban garden. Unfortunately, other people believe that whatever beauty such snapshots may possess is less miraculous than absurd, similar to that of a sonnet inadvertently produced by a million monkeys, pounding away at their typewriters.

By itself, an ordinary snapshot is no less banal than the *petite madeleine* described in Proust's *Remembrance of Things Past*. By itself, it is as bland and common as a tea biscuit; but as a goad to memory, it is often the first integer in a sequence of recollections that has the power to deny time for the sake of love. In Proust's novel, the discovery of the magical properties of the *madeleine* was fortuitous, but such denials and affirmations through the use of things seen or eaten, built or burnt, buried or unearthed, also characterize religious rituals of renewal and recapitulation. Snapshots may not have the numinous power of Communion wafers, Sabbath candles, nor Eleusinian sheaves—but they are often used as relics in private ceremonies to reveal to children the mysteries of the incomprehensible world that existed before love and fate conjoined to breathe them into life.

If a snapshot is broken from its context of life and love and, like some anonymous curiosity, is stuck to the wall of a studio or pinned to the bulletin board of a study, it may appear to strangers to be as enigmatic as a piece of quarried stone in the middle of the desert. However, once it has been restored to its narrative and iconographic context, the ordinary snapshot becomes the capstone of a pyramid whose base rises from the human heart.

The people who appear in the photographs in this book often strike (or have been directed to strike) theatrical poses, and make (or have been directed to make) symbolic gestures whose meanings are to be deciphered by their intimates and descendents. At times, they make gestures of their own free will; at other times, their actions are directed by photographers whose decisions about distance and point of view slice the world apart, as if they were gods separating the water from the dry land. When a camera is raised to the eye of a friend, a lover, or a parent, it becomes the symbol of a judgment, attention, and insight even more intense and scrutinizing than that which ordinarily characterizes such intimate relationships. Its presence transforms the people it beholds into actors, standing in sets, posing with symbolic props, the whole scene a private allegory of love, defined by the edge of an imaginary proscenium stage [Cf. Ronald Paulson, *Emblem and Expression* (Cambridge, Mass.: Harvard University Press, 1975); and Mario Praz, *Studies in 17th Century Imagery* 2d ed. (Rome: Edizioni Di Storia E Letteratura, 1975)]. Sometimes the people pictured have been well rehearsed, know their parts, and enjoy them. Other times they "forget" or improvise them, or even evade them. Often the snapshot is a picture puzzle in which everything manifest is only a fraction of what is revealed.

Years after such puzzles have been made, they inevitably fall into the hands of children, whose pasts are made accessible to them by images, which provoke questions never before asked or never before

answered. Once the puzzles have been worked, they reveal to children that they have been standing in a place—until now invisible—where four rivers of time converge: their own, private, secret time ("Who is that baby? Is that me?"); their family's time ("Is that when we lived in St. Louis?"); their country's time ("Is that when Daddy was in the army?"); and mythic time, the common poetry of the human family ("Is that when you and Daddy were in love? I mean, before you got married and had babies?").

Three types of photographs appear again and again in this book: photographs of love, intimacy, and family life; photographs of war; and photographs of work. There are a number of objects and situations that occur so often in these images that they could be said to constitute motifs.

Men often pose (or are posed) against telephone poles or electrical poles, or are photographed in such a way that these poles, and even distant towers, seem to sprout from their heads. Men are also photographed, more often than women, near machines (particularly vertically upright machines), as well as near aircraft, light and heavy weapons, and heavy vehicles.

Women, more often than men, pose (or are posed) leaning against or standing near trees. Occasionally, they, like the men, are photographed near poles. But more often than men, they are photographed while standing beside fountains and swimming pools, or while standing by the shores of lakes, rivers, and oceans.

Husbands and wives very often chose to be photographed while standing together or embracing in gardens, parks, or swimming pools. They also took turns posing with statuary or monuments, but the nature of the statuary, and the way a person may be juxtaposed to a monument, often depended on the person's sex.

Some of the differences between photographs of men and those of women may be the result of social norms and values, characteristic of the historical period in which the photographs were made. Thus, if the subjects of the photographs had lived and worked principally during the decades of the 1960s and 1970s rather than during the 1940s and 1950s, there may very well have been more photographs of women with weapons and heavy vehicles, and even more photographs of husbands and wives enjoying vacations in distant places. The visual record of such places and objects would depend on such variables as changes in the composition of the work force, fluctuations in the economy, and the conduct of American foreign policy. However, there are some objects—such as poles, trees, and fountains—and some places—such as oceans, parks, and gardens—that exist in photographs not so much because of economic activity or social conventions but because of the emotional necessities of loving and being loved. As such, they exist neither as objects of material culture nor as social artifacts, but as symbols that express states of mind, engendered by love. Freud stumbled upon such images in the dreams of hysterics, as did Jung in the pronouncements of schizophrenics. Both men discovered that hope combined with unrequited love produced the most remarkable visions. Freud came to believe that such images were the sexually charged expressions of the libido, the basic energy of life. Jung called them archetypes and claimed them to be manifestations of the "contents of the [collective] unconscious, the archaic heritage of humanity, the legacy left behind by all differentiation and development and bestowed on all men like sunlight and air" [Carl Jung, *Symbols of Transformation*, trans. by R. F. C. Hull, Bollingen Series, 2d ed. (Princeton: Princeton University Press, 1976), p. 178]. Both Freud and Jung collected thousands of examples of such symbolic representations, as they appeared in dreams, stories, conversations, folktales, mythology, art, and literature.

Even if it is difficult to acknowledge that what may appear to be visual clichés are actually "primordial images" (Ibid., p. 293), it should be obvious that the technical errors (two double exposures and a light flare) that occur in three photographs in this book (pp. 7, 43, 25) are acts of omission *and* commission, as amenable to psychoanalytic interpretation as any of the unintentionally meaningful gestures of lovers, imaginary intimates, patients, and passing strangers chronicled by Freud in *The Psychopathology of Everyday Life* (New York: W. W. Norton, 1971). The superimposed juxtapositions of such inadvertant double exposures are so visually redundant that they reveal, even more clearly than "intentional" single exposures, the unconscious projections and associations activated in photographers' minds by the appearance of the people they love. It may be that the only difference between making such photographs and dreaming is that the photographers have kept their eyes open, while using a device that preserves the creations of their unconscious visual imagination.

What follows is an analysis of five sets of snapshots, enmeshed in their narrative and iconographic contexts. This analysis will rely on

the interpretative strategies and theoretical constructs of both Freud and Jung, whose combined efforts constitute a physics, and a metaphysics, of love.

Frank and Cathy and I ate dinner in their kitchen. After coffee, they showed me their pictures and told me their stories of fertility and desire, intimacy, separation, and renewal.

There was a story about Cathy's mother, who had been so beautiful a girl that she had been mistaken for a queen, and so young a bride that she had played with dolls; there was a story about Frank's grandfather, who had played guitar for the Devil, wrapped snakes around his body, and died arguing over a young woman; and there was one about Cathy's father, who had chased her with a shotgun while she ran down the street, carrying a large box of sanitary napkins.

As they talked, they showed me their pictures. There was one (p. 53) of Cathy before she was married, her head thrown back, laughing, dancing the tango with a girl friend, their thighs rubbing against each other; there was another (p. 52) of her delicately lifting her skirt above her knee, posing like a pin-up girl, teasing Frank, who was far away in the navy. There was even a picture (p. 54) of Frank as a young man

who had never before been away from home, standing straight against a telephone pole, proudly dressed in his sailor uniform.

Once Cathy and Frank were married, they lived together by the sea and played out their happiness in pictures made by obliging friends. There was one photograph of Frank, kneeling in the sand by the sea,

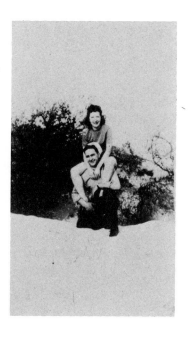 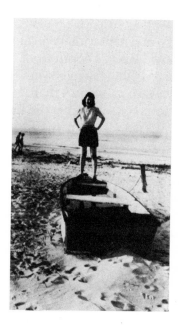

with Cathy's arms and legs circled round his neck (p. 54); and there was one (p. 55) of them holding each other in so deep and complete an embrace that they seemed to share the same head and the same body.

Frank photographed Cathy standing by the sea, her hands on her hips. He made another (p. 55) from close behind her, as she smiled and looked away, like a bathing beauty on a postcard. He made another photograph (p. 55) from farther away, while she stood in the prow of a beached rowboat, her back to the sea, facing him. Frank composed the photograph in such a way that the sides of the rowboat form a receding isosceles triangle whose apex is at the deep center of the image. The waves of the sea break between Cathy's legs, while the ocean's horizon line is at the same level as her waist. The ocean, which appears in this formal tableau as a band of water that begins at a woman's thighs and ends at her hips, has a symbolic significance:

"The maternal significance of water is one of the clearest interpretations of symbols in the whole field of mythology, so that even the ancient Greeks could say that 'the sea is the symbol of generation.' From water comes life. . . ." (Jung, *Symbols of Transformation*, p. 218; Freud, *The Psychopathology of Everyday Life*, pp. 388, 435–39). The very boat on which Cathy stands, its prow pointing between her legs toward the sea, is itself a symbol of the uterus (Freud, Ibid.).

A woman who had been unable to conceive for eleven years became pregnant within one month while she and her husband shared Cathy and Frank's beach-front cottage. Cathy attributed the woman's fertility to "the change of air." Whether it was the ocean air or the obvious sexual rapport that Frank and Cathy shared, Cathy herself became pregnant during the first six months of her marriage, when she and Frank lived by the water.

In the photographs that their friends made of Cathy and Frank during her pregnancy, the swelling size of Cathy's belly gradually appears to separate her from her husband. Even though they returned to the exact spot where they had first embraced so completely that they appeared to share the same body, and even though the camera records (p. 55) a kiss as deep as the one that first joined them, it is Cathy's pregnant belly (as well as the long light coat she wears) that keeps her body from appearing to fuse with Frank's. By Cathy's eighth month, the camera records neither a kiss nor an embrace, but a hug in which Cathy leans on Frank for support (p. 55). Very soon, the image of the hug is itself replaced by a picture (p. 55) of Frank taking a picture of Cathy.

By the time Frank junior was 2 years old, Cathy and Frank had been separated and reunited by him. The three images that Frank made (p. 56) of himself, his wife, and his son form a triptych, at whose center is the child, and at whose sides are the parents, separated but joined by the composition's formal structure, which is itself a replica *and* a metaphor of their family. In the triptych's left panel, Cathy reclines on the couch, exhausted by her struggle to raise her child and hold a job. She has twisted her left hip toward the camera to reveal her leg and thigh. The gesture is a form of erotic display, similar to the pin-up and bathing beauty poses she struck during her courtship and early marriage, but it is a gesture dulled by a fatigue so constant that at work, she would stretch out and sleep on the hard bench of a lavatory, and at home, she would send her son to look for snow in July just to get a moment's rest. Because Cathy worked a night shift in order to be at home during the day to care for her son, the time she spent with him was often robbed of its pleasure. It may be for this reason that in the left panel of the triptych—a photograph made during the day—she lies alone on the couch, while in the triptych's right panel, Frank sits happily with the child.

As Frank junior grew older, Cathy and Frank took turns photo-

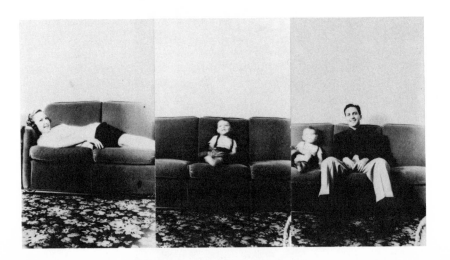

graphing each other playing with him (p. 57). During the first ten years of their son's life, they made at least half a dozen such pairs of photographs. The images became testimonials of a physical rapport they continued to share through the child, who became an object of delight, affection, and entertainment for them (p. 57). Because Frank junior was one of the few reminders of their early happiness, and because he provided them with an opportunity to express and share spontaneous affection, Cathy and Frank decided not to get divorced seven years after they were married, even though they worked different shifts during the week and argued over money and housekeeping during the weekends. "We said, 'Well, let's break it up.' I said, 'I'll take Frank.' She said, 'No. I'll take Frank.' I said, 'No way.' So we says, 'Let's sit down'; and we talked it over and we said, 'Well, let's try it over again.'"

As Cathy and Frank and I sat and talked in the kitchen, I noticed a reproduction of a painting on the wall. It was a picture of some pomegranates. The image was stark, simple, brilliant, and somber: a seventeenth-century still life painted in the manner of Zubarán. Twenty years ago, a lithograph had been made of the original; it had been printed in the thousands, glued to cardboard, and sold in bins in Woolworths. As Cathy and Frank told me more and more stories and showed me more and more pictures of love, loss, and desire, I kept looking at the pomegranates and thinking how meaty and blood-red they were.

Near midnight, Cathy and Frank showed me some photographs of the place where they'd lived before they'd moved into their new home. On the wall of their old kitchen was the picture of the pomegranates. That's when I remembered the mythological origin of the fruit. Zeus had changed himself into a snake, and had intercourse with Persephone. In time, Persephone bore Dionysus, whom Zeus set on the throne to rule. But the Titans came with knives and hacked Dionysus to pieces, and from his blood grew the pomegranate tree. But that wasn't all. Another myth tells that Zeus and Demeter had intercourse, from which act Persephone was born. When Persephone was still a maiden, Hades, the Lord of the Dead, carried her off to his kingdom below the ground. As soon as Demeter discovered where her daughter was, she came to rescue her. But Hades had tricked Persephone into eating seven seeds of a pomegranate tree that grew in his orchard. Once she had eaten the food of the dead, she was obliged to live with Hades as his queen for four months of every year.

Because the pomegranate was associated with the fecundity and regeneration of both Persephone and Dionysus, the fruit became a symbol in the Eleusinian mysteries of fertility, death, and resurrection, and in Christian iconography, of hope. It was this fertile image that Cathy had carried with her from house to house. When I saw Frank and Cathy again a few weeks later, I told what little I knew, but they didn't believe me.

When Jerry and Faye talked to me, they had been married and in love for thirty-six years. "Thirty-six years! Would you believe it?" When they'd met, Jerry was the "campus wolf," a "football jock," waiting tables in a women's dormitory, "cater[ing] to all these young girls." When Jerry told me about it, he smiled and said, "It was disgusting. It was horrible. I was a straight-laced individual. I was prepared." He said that while Faye sat beside him; he tried not to laugh from the pleasure of the memory.

Faye said she'd gone out with Jerry on a blind date to make her old boyfriend jealous. Jerry hadn't known that at the time. He probably thought he was doing her a favor. When he saw her, all he said was, "Hmmm. Sweet." But what he felt was a little different. It came close to being love at first sight. "We just both felt this *something* the first time we met. And it has not changed."

That "something that has not changed" was an erotic rapport which, in their early marriage, they acted out before the camera and to which, in their later marriage, they alluded with such conventional

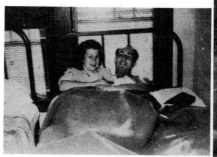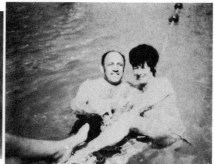

gestures as hands clasped in the center of the picture frame and embraces in a sunlit garden (p. 95). This erotic rapport was also in the pictures they kept from their vacations. In Miami, they embraced beside the ocean and held close to one another, floating in a pool (p. 95). In New Orleans, they visited a park and took pictures of each other. Jerry photographed Faye in the very center of his vision, with a water-filled fountain beside her on the left and an equestrian statue of

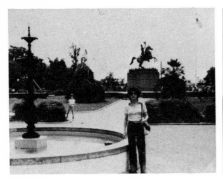 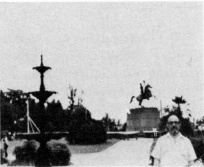

General Jackson rising behind her in the background (p. 95). Faye photographed Jerry very differently. Her vision arranged objects in the space before her in the shape of a receding triangle. At its apex in the background was the hero on his horse; to the left in the foreground was the central shaft of the fountain, cut off from its watery base; and to the right was Jerry, himself cut off at the waist, with a tree growing behind his head. Faye's "cut-offs" are graphic equivalents to the Freudian dream work of displacement [Cf. Sigmund Freud, *The Interpretation of Dreams*, trans. and ed. by James Strachey (New York: Avon Books, 1969), pp. 340–44].

The sea beside which Jerry and Faye embraced, the pool in which they floated, and the fountain beside which Faye was pictured—all these water images share the same symbolic meaning as the ocean that appeared in the photographs which Frank made of Cathy when *they* were first married. Just as the sea that rose from Cathy's thighs to her hips was "the water of life" (Jung, *Symbols of Transformation*, p. 218) and the boat on which she stood was itself a symbol of the uterus (Freud, *Interpretation of Dreams*, pp. 435–39), so the fountain beside which Jerry photographed Faye was a uterine symbol. And just as Jerry placed Faye next to a symbol of the uterus, so Faye responded by photographing Jerry beside the symbolic equivalent of a phallus

(Freud, pp. 389–400). Behind them both rode the hero on his horse—an image that, since the time Mithras mounted a bull and Christ rode an ass, has symbolized the subordination of animal instincts (Jung, *Symbols of Transformation*, pp. 275–76).

Many of the episodes in Manny's life story, as well as many of the gestures he made in the pictures his wife, Marilyn, took of him, are examples of "acting out," a common variety of "immature" defense mechanism characterized by a "direct expression of an unconscious wish or impulse in order to avoid being conscious of the affect that accompanies it. It includes the use of motor behavior, delinquent or impulsive acts, and 'tempers' to avoid being aware of one's feelings. . . . Acting out involves chronically giving in to impulses in order to avoid the tension that would result were there any postponement of instinctual expression" [George Vaillant, *Adaptation to Life* (Boston: Little, Brown and Co., 1977), p. 384].

Manny described his boyhood and adolescence as times of loneliness, confusion, rage, and despair, created by a mother who gave custody of her children to a father who periodically beat and deserted them. Manny's need for fatherly affection led him into one homosexual and one homoerotic encounter before puberty; his need for revenge manifested itself in a series of fistfights with bigger boys and older men during adolescence; his need for fatherly guidance took him on a lifelong search for somebody to "*lead*" him. Manny's need for a mother who would never desert him resulted in his marriage to Marilyn.

Manny first saw Marilyn behind a counter, making ice cream cones. At the time, he was living alone in a basement infested with rats. He was very hungry for food as well as love. Her effect on him was as startling as a flash of lightning. He was so unnerved that, poor as he was, he dropped the ice cream he had bought. "*Heaven opened up!!* . . . I saw in her the kind of girl that I thought would make the best wife—the best mother—the best housekeeper! . . . These things just flashed in my—just flashed in my whole mind." He had experienced an illumination.

His belief that his meeting with Marilyn partook of the miraculous was confirmed when he was invited to share in the sacrament of a Sabbath dinner with her and her family. One of the ceremonies performed before such a meal is begun is the lighting of the Sabbath candles by the wife and mother of the house. These candles are lit to

honor the Shekhina, the Queen of the Sabbath, the radiant, female, physical manifestation of God, Who Jewish mystics believed had expelled Adam and Eve from the Garden, brought the Great Flood, parted the Red Sea, shone as a cloud by day and a fire by night in the desert, and finally dwelt in the tabernacle of the Great Temple in Jerusalem [Raphael Patai, *The Hebrew Goddess* (New York: Avon Books, 1978), p. 117]. By the seventeenth century, common Jews had come to believe that at the moment a Jewish woman lit the Sabbath candles, she became invested with the Queen Herself. Manny witnessed this ceremony in which Marilyn, her mother, and her sisters participated. "I walked into this *home*. Her father—this was a *real Orthodox* Jewish man. A real Orthodox woman—that was his wife. They had all these children around. . . . I thought *only God* could do *this*."

Four years after they were married, when Marilyn was in the seventh month of her first pregnancy, Manny took a picture of her (p. 25) but "forgot" that if Marilyn did not turn towards the sun, her face would be in shadow. He "forgot" because all he could think about was that he "wanted something that *belongs to me! My* house. *My* wife. *My* kid." The result was a lens flare, which in the print became a half ball of light hovering over Marilyn's belly.

Manny preserved this "mistake" even though, without its caption, it revealed nothing of Marilyn's pregnancy. He preserved the image because it confirmed what he implicitly believed: the luminous ball that hovered over Marilyn's belly was a sign that she was invested with the radiant life force of the Shekhina, that she was an agent of illumination who had intervened to rescue him from the depths [Raphael Patai, *The Hebrew Goddess*, p. 117; and Mircea Eliade, *Myths, Rites, and Symbols*, ed. by W. C. Beane and W. G. Doty (New York: Harper and Row, 1976), pp. 337–38].

Marilyn may have been a bit reluctant to assume such a superhuman role. When Manny spoke with me, he complained that "she isn't the demonstrative type. She doesn't show it as much as I would. . . . She's just . . . more reserved." Yet during their early courtship, they publicly enacted their passion and affection (p. 27); and during their middle

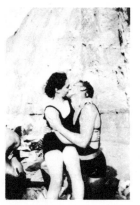

age, in the privacy of vacation hotel rooms, they still alluded to these feelings by photographing each other in bed (p. 31).

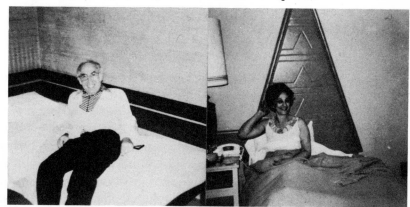

Their vacations provided many opportunities for picture taking, and many of the photographs allude to the hopes and needs that had originally drawn Manny and Marilyn together. During early middle age, Manny paid homage to Marilyn's energy and sexuality by photographing her beside an active fountain (p. 26); and in later middle age, when she was in ill health (a fact communicated outside of the interview context), he photographed her standing between and touching two statues of a little boy and a little girl who bore baskets of fruit (p. 25). Marilyn touched these statues of childish health, happiness, and plenty as if they were her own children or grandchildren. It was a sympathetic touch, as if to transfer some of their "childlike creative powers" to herself [Carl Jung, *Psychology and Alchemy*, trans. by R. F. C. Hull, Bollingen Series 2d. rev. ed. (Princeton: Princeton University Press, 1968), p. 199].

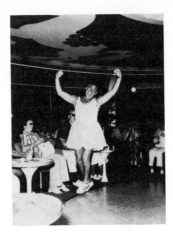 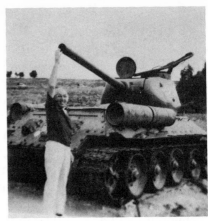

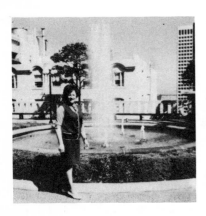 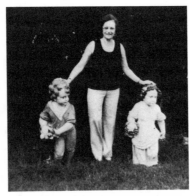

Manny's gestures before the camera were somewhat more complex. On board a cruise ship to Israel, during a "beauty contest," he dressed as a ballerina in track shoes (p. 23). The shoes alluded to the sports that, in his adolescence, had given him a sense of his own worth; the tutu was a burlesque identification with the sex whose representatives had first broken his heart and then healed it. Once in Israel, he reached up and stuck his fingers in front of the cannon mouth of a disabled enemy tank—the mock heroic gesture of a precocious little boy showing off to his mother (p. 28). Later, he alluded to the power of women, more solemnly than he had done on board ship, by standing, with an uncharacteristic stillness, in front of a dome that curved behind him like a great breast (p. 22). Back in the United States, while on another vacation, he playfully pulled the beak of an eagle totem (p. 28) and nonchalantly rested his arm beneath the jaws of a Big Bad Wolf (p. 27). In dreams, such animals are "employed . . . to represent passionate impulses of which the dreamer is afraid, whether they are his own or those of other people. . . . We have not far to go from here to cases in which a dreaded father is represented by a beast of prey or a dog or a wild horse. . . . It might be said that the wild beasts are used to represent the libido. . . ." (Freud, *Interpretation of Dreams*, p. 445). In this way, Manny played among the beasts of his past, safe from them while under the watchful eye of the woman who had rescued him from them.

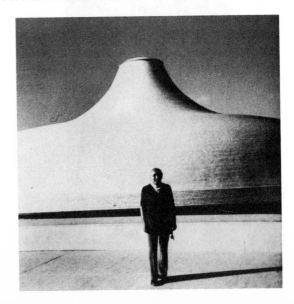

Herb and Lin were both raised in the ruins of first-generation immigrant families from which their alcoholic fathers had withdrawn after losing the loyalty and affection of their wives, and the control of their households to their mothers-in-law. Lin said, "It's funny how our stories are a lot alike"; and Herb added, "We're both introverts. We both had a hard, sheltered life."

There is one photograph from their early courtship, and several from their honeymoon, that suggest the intimacies of their relationship. One afternoon during their courtship, Lin stretched out on her back while Herb lay on his belly, his head at her feet. Lin kept her legs together as Herb took a photograph (p. 39) that at first appears to be

Packard (p. 37). Automobiles, like other major possessions, are synecdoches of their owners. Whether or not there is any sexual significance to either of Lin's gestures, their resemblance to each other implies that she felt somewhat the same way about Herb ("He was my first and only love") as she did about her father. (In later years, Lin may have tolerated Herb's rare but regular presence at home because she had already learned to accept her father's intermittent presence during her childhood.) In the next picture of the honeymoon sequence (p. 40). Lin stood next to a sign that bore the name not only of a town but of Herb's mother. Although, at the time, both understood the picture to be an allusion to Herb's mother (Lin explained this outside of the interview context), the fact that *Lin* stood next to the sign and *Herb* made the picture implies that Herb projected his mother's identity onto Lin, and that Lin was willing to accept such an identity. In the final picture in the album Lin posed on the lawn of Mount Vernon. The optics of the camera, combined with Herb's proximity to Lin and Lin's distance from the house, produced a *trompe l'oeil* in which Lin appeared to be the same size as the mansion behind her. Such a distortion of scale, resulting in an equation between two figures of unequal size, is the visual equivalent of a pun which, in Freudian dream work, is a form of condensation. Such a juxtaposition between two subjects as disparate as a historical landmark and a newly wedded wife "guarantees that there is some specially intimate connection between what corresponds to them among the dream thoughts" (Freud, *Interpretation of Dreams*, p. 349). Since, within the same honeymoon sequence, Herb had already associated Lin with a town that bore his mother's name, it may be that by visually equating

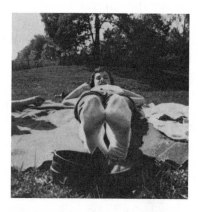

nothing more than a humorous picture of her feet. Because of a combination of camera optics and Herb's proximity and point of view, Lin's loafer and feet fill the center of the image. Receding from them into the background is Lin's foreshortened body, on which sits her small smiling face without a neck. A tree grows from behind her head. Had Lin's legs been apart, Herb's photograph would have revealed her groin. Yet in spite of her modesty, the space between her feet resembles the shape of the labia majora.

During their honeymoon, Herb photographed Lin standing by the shore of an unidentified body of water and soon after, he photographed her standing in front of his car (p. 40). (The photographs reproduced on p. 40 are arranged in the order they appeared in Herb and Lin's original honeymoon album.) Lin held the hood ornament of Herb's Chevy in much the same way that, before she was married, she rested her hand on the headlight of her father's

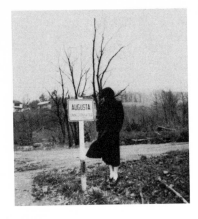 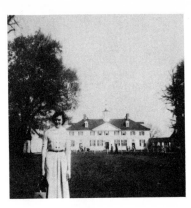

her with the house in which the "father of our country" raised his family, Herb was projecting onto Lin an even more grandiose maternal role.

This projection was further elaborated after Lin bore her first child, which was a boy. On the day of the child's baptism, Herb photographed Lin holding the infant both inside the Catholic church where the ceremony was performed and, afterwards, outdoors while standing beside a tree (p. 43). In the interim, he "forgot" to advance the film. The result was an optical and psychological projection of great emotional and religious intensity, which Herb tacitly acknowledged by preserving it after the film was processed and printed.

The separate components of the image combined to produce a symmetrical, oval figure, composed of four elements at the center of the picture frame. The composition and outline of this figure very much resembles that of a *mandala*, the Sanskrit word for "circle:"

> In the sphere of religious practices and in psychology, it denotes circular images which are drawn, painted, modeled, or danced. Plastic structures of this kind are to be found, for instance, in Tibetan Buddhism and as dance figures whose circular patterns occur also in Dervish monasteries. As psychological phenomena, they appear spontaneously in dreams, in certain states of conflict, and in cases of schizophrenia. Very frequently they contain . . . a multiple of four. . . . In Tibetan Buddhism, the figure has the significance of a ritual instrument . . . whose purpose is to assist meditation and concentration. . . . In modern individuals . . . a mandala occurs in conditions of psychic dissociation or disorientation, for instance . . . in adults who, as the result of a neurosis and its treatment, are confronted with the problem of

opposites in human nature and are consequently disoriented. . . . Images of this kind have, under certain circumstances, a . . . therapeutic effect on their authors in that they often represent very bold attempts to see and put together apparently irreconcilable opposites and bridge over apparently hopeless splits" [Carl Jung, *Mandala Symbolism*, trans. by R. F. C. Hull, Bollingen Series (Princeton: Princeton University Press, 1973), pp. 3–5].

The mandala that Herb produced was in the shape of an egg, an image that in the Hindu Vedas (Cf. Jung, *Symbols of Transformation*, p. 381) was a cosmogonic symbol, an image of the origin of the universe. At its very center, Lin stands inside the church, looking not at Herb, but at her child; she is turned to the right, in the direction of two religious statues. At the circumference of the mandala, Lin stands outdoors, once again looking only at her child, but this time, she is turned to the left, toward a tree whose limbs arch over her head. The figure of Lin facing right is fused at its elbow to the wrist of the figure of Lin facing left. Each of these directions has a symbolic significance: " . . . It is probable that, in general, a leftward movement indicates a movement towards the unconscious, while a rightward . . . movement goes toward consciousness. The one is 'sinister,' the other 'right,' 'rightful,' 'correct' " (Jung, *Mandala Symbolism*, p. 36).

Thus, at the center of Herb's mandala, Lin, the Mother, turns toward the Church, holding a child that has been sanctified. At its

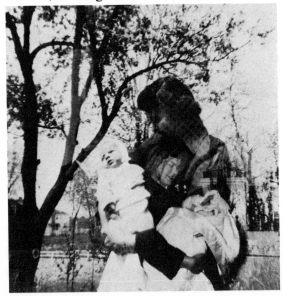

periphery, Lin, the Mother, turns toward Nature, holding the same child beneath a tree, which since the Fall has symbolized temptation and carnal knowledge. Yet the Mother at the center is joined to the Mother at the circumference, just as the interior of the church is visually encompassed by the limbs of the tree. The tree itself is a symbol of great complexity and ubiquity. As a cosmic tree, it appears in mythologies as disparate as those of Mesopotamia, India, and Siberia. "There are examples where the Cosmic Tree reveals itself as [the image of the world] and, in other examples, it presents itself as the [axis of the earth] as a pole that supports the sky, binds together . . . Heaven, Earth, and Hell, and at the same time makes communication possible between Earth and Heaven. . . . Other variants emphasize . . . the Cosmic Tree as the Center of the World and the cradle of the human race" (Mircea Eliade, *Myths, Rites, and Symbols*, pp. 381–82). Long before Mother Church, the tree as a Tree of Life symbolized the Mother in the myths of Osiris, Attis, and Adonis, and in the worship of such female deities as Juno (Jung, *Symbols of Transformation*, p. 219). Yet, just as the Tree in the Garden was associated with the phallic snake, so the very tree that symbolized the Mother in the Egyptian, Greek, and Roman myths was also worshiped as a phallus (Ibid.). These "various meanings of the tree . . . the tree of Paradise, mother, phallus . . . are explained by the fact that it is a libido symbol . . ." (Ibid., p. 222), a symbol of creative energy that is neither male nor female but common to both.

Thus, the apparent conflict at the center of Herb's mandala was actually a conjunction of opposites which he produced at a time of stress and transition when the woman on whom he projected the identity of his mother turned away from him to become the mother of her own son.

Herb's life before and after marriage was characterized by a series of willful acts whose purpose was to master the form and content of American life. His efforts began with baseball: in junior high, Herb wanted to play shortstop but didn't know how, and he made a fool of himself trying. The coach told him to forget it, but Herb wouldn't. He soon not only made the team but played infield for the next forty-five years of his life. "It shows you the power of the mind. If you make up your mind you're going to do something, no matter how badly you start, if you work at it, you can do it." About the time he gave up baseball, he moved his family from a small, nondescript house in a lower-middle-class city suburb to a large American colonial house in a corporate bedroom community. He made the move even though he couldn't afford it and even though his job had given him enough ulcers to cost him two-thirds of his stomach. "I decided, 'Man, I want that house; I'm going to build it, and by God, I'm going to get the money to pay for it!' It was an incentive."

The game of baseball, which Herb mastered during the Depression, was *the* American sport. And the house that he wanted in 1967 was as good "a copy of a 200-year-old house in Rhode Island" as any being built at the time. Herb knew what he wanted not only because of what he had seen on his honeymoon, but because of what he had learned during family vacations spent at Colonial Williamsburg. "I don't like contemporary-looking things. I like solidity and longevity. I think [Lin and I are] more proud of our American heritage than anything else. Should we have Polish or Italian furniture? I think we're Americans. I *know* we are."

Herb used his camera for two purposes: first, to document for future reference the early-American architecture and interior design that he admired (p. 47) and was determined to imitate (p. 42, which is a picture of Lin taken in the family living room by their daughter Kay); second, to create a visual document of his children so that he could console himself with appearances. By the time Herb and Lin talked with me, this visual document amounted to perhaps as many as fifteen hundred color slides. Because of their quantity as well as their quality (well-exposed portraits of his son and daughter that seemed to have been made at the right time and the right place), I imagined Herb to be an ever-present, attentive father. Lin's recollections were somewhat different: "Herb always traveled a great deal. He'd leave on Sunday night and return home on Friday evening. . . . So, basically . . . I was mother *and* father for at least fifteen years. All the while we lived in our first house. It was difficult . . . Herb was never around. But we had a good marriage. . . . The kids helped each other a lot. . . . Since I didn't see Herb very much, when I did see him, I appreciated him more. . . . He'd come home on Friday . . . and then on Saturday, we always did something with the children. We always gave them their choice of what we should do. . . . And it worked out well."

Herb was attentive because he was rarely present. He photographed his children on weekends and holidays—certainly with great love—but in somewhat the same spirit as he photographed Williamsburg on

vacation: he was a tourist, appropriating appearances. If he could not remain at home, he could at least register his presence as an observer by telling his children to stand still and look at Daddy. He tried to be fair: when his children were very young, for every picture he made of his son with a six-gun, he made one of his daughter with a pussy cat. He was more careful about ceremonies than his father may have been ("I once met my father on Christmas Eve. . . . There was a bar there. And I saw two guys fighting. I couldn't believe it! On Christmas Eve! . . . I said, 'Boy! I will never get like that.'") As his children grew older, he photographed each of them on Easter, on their birthday, on their first day of school, on their communion (some of these pictures are reprinted on pages 44–45). He even recognized and recorded their love for one another that grew in his absence. He didn't look away.

Peggy said that she'd dreamed the same dream for forty years: every night she floated "deeper and deeper into a . . . deep galaxy" where "the stars would be spinning. . . ." She floated until "I'd get to a certain part where . . . I'd know if I got past that place it would be dangerous, so I would—stop myself, and that's when I'd jerk clear up, off the bed, and come crashing down." The dream lasted from the time she was a girl until she had a hysterectomy, when ". . . the dream disappeared. I feel like something's missing. Like my soul's been taken."

Freud claimed that "sleep is a reactivation of the intrauterine situation. We have rest, warmth, an absence of stimuli . . ." [Sigmund Freud, "Metapsychologische Ergänzung zur Traumlehre" in *Gesammelte Schriften*, vol. 5, pp. 520–21, quoted by Geza Roheim, *The Gates of the Dream* (New York: International Universities Press, 1970), p. 1]. Geza Roheim has elaborated: "Falling or sinking are typical hypnagogic sensations. . . . The sleeper turns into himself and falls back into the womb, his own body being the material substratum of the dream womb. . . . In the case of the woman, the womb into which the sleeper withdraws is also her own erotically cathected vagina" (Roheim, Ibid, pp. 7, 62). Roheim claimed that the dream of intrauterine regression was one of the basic dreams of mankind, whether the dreamers were ancient or modern, Western or non-Western, urban or rural, industrial or tribal, well-adjusted, neurotic, or psychotic.

In psychoanalytic terms, the recurrent dream that Peggy experienced translates this way: the galaxy into which she floated and sank

every night was both her own uterus and her mother's; her nightly fear of sinking too far was the fear of never being reborn from a fetal sleep; her nightly jerk was both a willful act of rebirth and a discharge of erotic energy; the soul that had been taken from her was her own womb.

Just as every night Peggy sank into and sprang out of a depth that was filled with the water of life, a space that was her own as well as her mother's, so, in waking life, she and her mother shared "this passion to be by water. I'm afraid to get into it, . . . but I have a passion to live by it." Not just water, but trees: "See, I always feel happy when I'm by water or trees." She posed for pictures with trees from the time she was 15. She stood beside them in parks in the North, by highways in

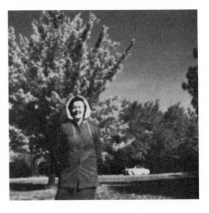 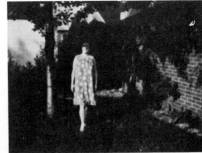
 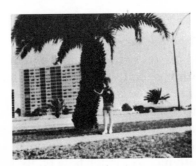

the South, by rivers in the Midwest. She even associated with them after they'd been cut down and turned into poles without roots (pictures on p. 3). Four months after her only child was born, she sat with him outside on a blanket while her unmarried sister-in-law (Peggy explained this outside of the interview context) took a picture. When the film was processed and printed, an "inadvertently" double-exposed tree ran straight through her and the child (p. 7). The trunk of the tree was as thick and branched as a spinal column, as dark and veined as a *vena cava*, as filigreed as the wings of a butterfly. At its very center, Peggy sat with her son. She was sick; her child would grow ill; her husband was disabled and unemployed. But a dark tree of life shone through her.

It was a tree that grew in hardship and outlived death. It was a sign of hope. After Jack's father died, it appeared again. Jack's father had been a hero. He crossed the ocean nine times, memorized *The Thousand and One Nights*, and spoke four languages. When he was 50, he could jump a fence like a hurdler; and when he was 65 "he could take twenty acres of ground like nothing with a spade and shovel." He taught his children not to steal; he never drank water when there was wine; and he kept his promises. When he died, "this great big, gorgeous apple tree" that grew behind his house "dropped dead" overnight. Two months later, an old stunted pine that hadn't grown in fifty years changed from a dwarf into a giant: "It got gigantic. It's bigger now than the house."

There is a legend about such trees that is carved in stone above the west portal of the Strasbourg Cathedral (Jung, *Symbols of Transformation*, plate 37): "The legend says that Adam was buried on Golgotha, and that Seth [the son Eve bore after Abel's death] planted on his grave a twig from the tree of Paradise, which grew into Christ's Cross, the Tree of Death" (Ibid., p. 247).

The Tree of Knowledge grew into the Tree of Death, which became the Tree of Life. These trees lovers see behind the heads of the ones they love. They are the trees that Faye saw behind Jerry (p. 95), and that Herb saw behind Lin (p. 43). They are the ones that Peggy saw growing beside and behind Jack (pp. 16, 19), and that Marilyn saw growing beside Manny (p. 28). Stripped of their bark and turned into poles strung with wires, filled with energy and voices, they rose behind Bernie (pp. 72, 75, 84), Bernie's mother and sister (p. 82), and Jimmy's grandmother (p. 118). Their roots in the ground and their limbs in the air, they appear behind nearly every husband and wife, mother and father, son and daughter, grandmother and grandfather, in this book. At the end of it all, such trees grew behind Jacob's daughter and encompassed his wife, Ruth.

They are trees of an earthly paradise, growing in a garden from which no one has yet been expelled. They are images that belong to the "stock of inherited *possibilities of representation* that are born anew in every individual" (Jung, *Symbols of Transformation*, p. 181), and that "the unconscious coins today in much the same way as it did in the remote past" (Ibid., p. 179). They are transcendental visions of hope and love. They are tangible evidence that this sweet and ordinary life is filled with gestures of immortality.

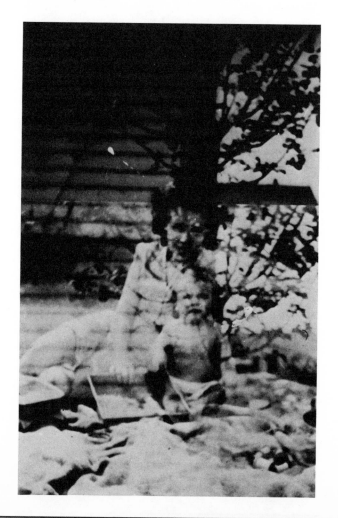

Peggy and Jack

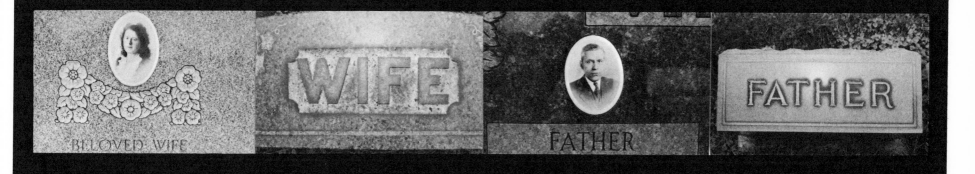

PEGGY: Growing up, I just think of as torturous. Some people grow up easily. I didn't. I don't know. I had a happy life. It just seems that every time I thought something was going to be *nice*, it went horrible.

I tell you—it was funny. I got *bored* with the town. I always felt like I didn't belong there. I said, from when I was young, I always felt like I'd gone on the wrong planet. Everybody *thought* different. The people were different there. I just didn't feel right. First, I thought it was bananas. But after a while, it was *boring!* The things they liked, I didn't like. The men: first comes the guns. Then comes the dog. Then comes going out and drinking. And then, down at the bottom, was the woman.

I just got tired of it. I'd read out the library and done everything else. [Laughs] I got a job. I had four or five jobs. And then I decided—one night, when I come home on a Saturday night— I packed two bags and said I would leave—for *Seattle*. So they said, "Why don't you stop in Buffalo?" 'Cause I had an uncle up here. So I stopped. And I stayed. Because of the water. Because it was on the lake.

See, I always feel happy when I'm by water or trees. Especially water. I *love* water. My mother had it. My sister had it. We have this *passion* to be by water. I'm *afraid* of water, to get in it, but I have a passion to live by it.

I was born in 1925. At ten minutes to three. A Virgo. And my son's a Virgo. I got born in Brownsville, Pennsylvania. It was one of those places that died. Many years before. And I always thought it should have been wiped out. They had a lot of industries there. Chemical industries, mines. And then the mines became unprofitable. Coal mines. Everything died around there. The chemicals killed off everything. I don't know, it had something to do with the

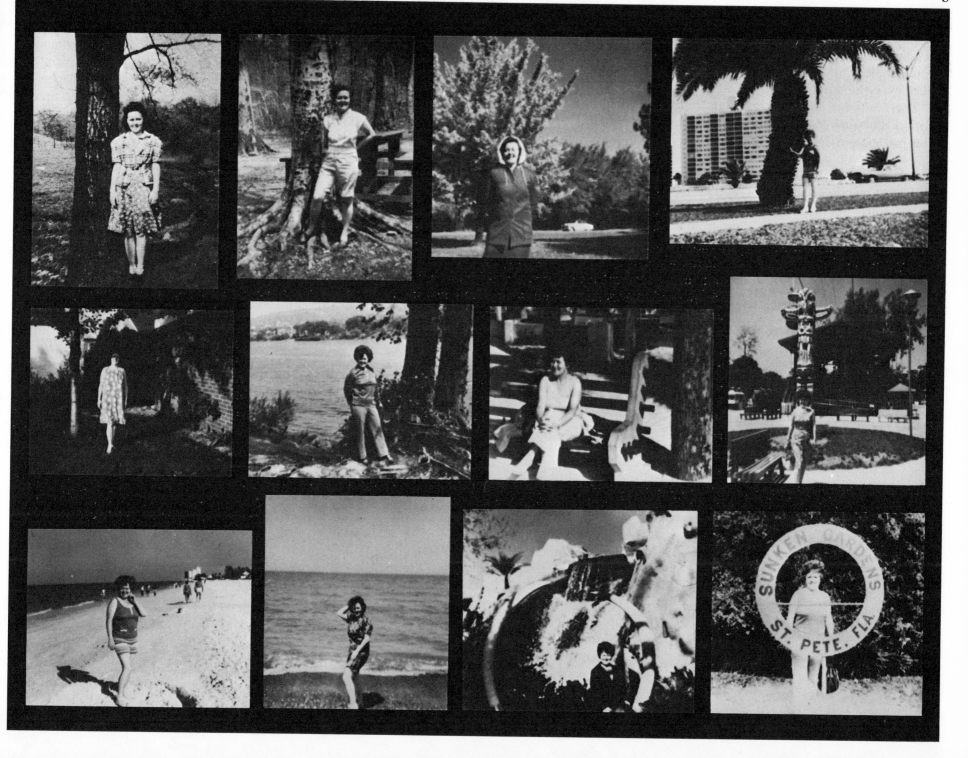

wars. They put some kind of chemical gases . . . It killed the grass and everything. Nothing grew. The people were all sick and poor. Everybody eked everything out.

There was this big chemical plant in town, with this *gigantic*, big smokestack. The chemicals just spewed out and killed everybody. Fifty miles away you could see that smoke. It just killed everything. Used to be a big railroad center. Everyone who lived there worked in the plant or the mines. But the smell was just horrendous. Nothing grew around there. The ground was dead. And they had what they called the tailings from the mines—that were gigantic piles that caught fire from spontaneous combustion. Sulphur dioxide was always in the air. You could taste it. You could eat it.

I have no idea how my family ended up there. My mother's mother was a Biddle. A mainline Biddle. Her brothers and sisters were very, very wealthy. Very nice, but *very* stingy.

My grandmother was a big woman. With brilliant red hair. She got married to a man who was quite a bit older. He wanted to have a lot of children. So she had two boys, then my mother, then another boy. Then they said if she had any more children, it would kill her. My grandfather couldn't understand that. So he went back to where he came from and opened a barbershop. And we stayed in Brownsville.

My grandmother must have been *very naïve* —about things. Sex was a dirty word. Up until the day my mother died, when she was ill, it was a crime to even have your blouse open too much. They were Presbyterians. And Masons. On Sunday, you didn't do anything except go to church and then *sit!*

When my mother was 17, my father came to town. On a job or something. He must have been some WILD, BIG BLADE. They fell in

love. And they were going to elope, but my grandmother went with them and they got married. And then they went west. In an automobile. In 1921 or '22. There was no work. So they headed out, up in the mountains. Out west. It didn't last too long. She got pregnant. He didn't want any kids. So, he sent her home. I was born, and when I was a year and a half old, they got divorced.

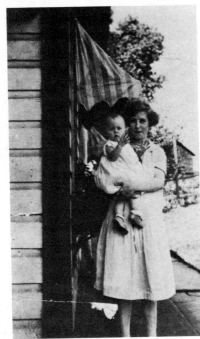

All I knew was his name. I never saw a picture of him. She never talked about him. I used to think I was illegitimate or dropped from another planet. See, the closest thing I remember is, when I was 6, somebody said my father is coming and I ran away and hid. And I never saw him again until Billy was born. That was the one and only time.

I was very ill, in the hospital, with Billy, after he was born. The middle of the night, the doctors come in, they say, "How are you *feeling?*"

and I said, "Lousy." I was feeling terrible. And I said, "Why?" And they said, "Your father's coming to see you." And I thought, "Well! It's a fine time of night!" And they said: "He flew in from Japan." And I said, "Oh, you mean my *father*." And they said, "Yes." And he walked in and stayed the whole night. He'd heard from my mother that I was ill and having a baby. So, he sat down. And the woman in the next bed got *so excited!* She said, "Oh! This is just like *True Confessions!*" And she had a miniature heart attack! [Laughs] He stayed the whole night. Then he left. And I never heard from him again.

When I was 3, my mother remarried. To my stepfather. Who she used to go with in high

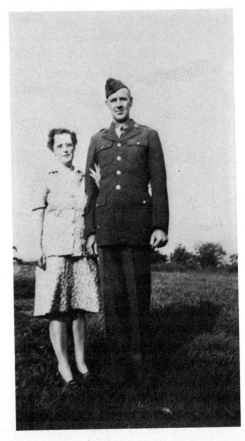

school. Before my father showed up. She got married again and we moved to Midway. It had no stores. One school. No business at all. My stepfather had relatives there.

He was Pennsylvania Dutch. He was the oldest brother. He was a great big guy. His father decided, when he was 35, that he wasn't going to live long and his sons should support him. And they did till the day he died at 98. [Laughs]

My stepfather worked in the mines till they ran into rock and sealed them. And then he went to the steel mills.

We lived in an apartment. It was just in the Depression. I must have been 4. And I remember my uncle, he was an artist, and he was painting a mural on the top of a college, and he fell down and died. His best friend never got over the fact that he was down below and saw it and he couldn't catch him. Everybody said, "If you would have caught him, you would have both died." And I remember sitting up all night by the casket.

Then, that next week, my grandfather came home. And my grandmother and grandfather had been separated for, like ten years. And—he come home, and he motioned to me and he couldn't talk. He must have hurt his throat. So the next thing I know, they tell me *he* died.

The funeral directors came for him and put him in a casket. And we lived upstairs. And they tripped and fell and he fell out and they had to go down and put him back in.

I remember, when I was 4—I remember that there was a kitchen. A living room. And up in the front was the bedroom. And there was a lot of people. And they were boiling stuff and they were going to can. But my mother was over there. And I thought it was strange: my mother was over there. And I didn't get to see her. And my sister was being born, only I didn't know it.

I remember—this is very strange—I remember there were these two old ladies. They must have been very old. Sisters. Who had once been schoolteachers. And they used to entertain me *by drawing pictures*. Well, one of them—she used to throw potatoes down and we'd watch them drop on people's heads. [Laughs] That lady—as my sister was being born—she went stark, staring, raving mad. And so her sister called my stepfather—he was a big man. It took *four* men—and they wrapped her in a sheet to hold her down—till they got her in a car to take her to an institution. And I can remember saying, "Can I look at her?" I wanted to see how someone looked when they were mad. And I thought her eyes were very brilliant red.

And then everybody was running around; they took her out, down in the car. All these men carrying her. She's screaming. And I heard this other noise. And I said, "Something's going wrong." And they said, "Oh, no." And my sister was born.

So. My uncle died. And my grandfather died. And my sister was born. And the woman went crazy. All in a two-week period. When I was 4 years old. In Midway. In the middle of the Depression. In 1930.

I used to play with a boy. We were real good friends. His parents had the only store in town. His mother always gave me root beer, frozen with little pieces of ice.

One time we were out playing in the hot, in the summer, out on the street, in front of his house. And we see a whole bunch of people running down the street. We can't figure out why. And we hear a man screaming, and we see this dog coming, and the dog is coming, the dog is coming, and here it is, mad, and the policeman shot it just before it came at us. [Laughs]

We moved to another town when I was 9. We used to move almost every year. Every year I was in a different school. We moved for the work or to get into a better house. We were always moving. My mother never said anything. She was a quiet, a very quiet person. I never remember her being well. She was always tired, always tired. I always thought of her as a very old person. But she was very young. She was real quiet and everybody took advantage of it. People always would get her to do stuff beyond what she should have been doing. She'd *never* refuse anybody a thing. She didn't want to hurt their feelings. So that's when I decided; I used to tell everybody, there's the stompers and the stompee. I'm a stomper.

When I was 13, we moved to a house on a bad street. It was the only place we could get. In a bad section of town. Next door was a *house of ill repute*. And across the street was a joint. They called it The Bucket of Blood, because somebody got murdered every night. I remember the house next door because we'd have to make sure all our doors and windows were locked because they'd mistake—it was a hotel like—they'd mistake our house for that and they tried to get in and they'd think we weren't going to let them in because they didn't offer enough money or something. And I remember one other time. There were two of them: one was a colored woman who had real pale skin, green eyes, and

brilliant red hair. And the other woman: she was tired of her stealing the man. And there was a fire escape. And they fought the whole way down. Almost tore one another to pieces.

We had a room with a turret on it, and I used to sit there, and right next to the bedroom was a railroad. And I used to watch the train practically come through the house. But that's where I had this boy—well, he wasn't a boy; he must have been in his twenties. He took a liking to me. He was going to *protect* the family. Anytime anyone would come around, he would threaten them with a gun. Then they left us alone. [Laughs] My mother said, "Go to a dance with him." I was so ashamed 'cause he wore blue jeans and a shiny red satin shirt. Everybody had a suit. I never got over that in my whole life. [Laughs]

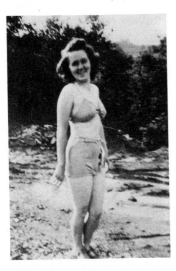

When I got out of high school, I left for good.

Jack and I met at a club. He had gotten out of the army. We went on a date. We went on a couple of other dates. Then he disappeared. We had gone with this other guy and I thought, "W-e-l-l!" This other guy kept trying to date me. And then he finally says, "Oh!" And I says,

"No." He says, "Jack's back in the marine hospital." I went over to see him. And we went on two more dates, and he says, "We're going to get married." And we got married. A month later. I was just 18. Jack was 25. His family was real Catholic. And mine were Masons. So we got married by a justice of the peace.

We both got sick on our honeymoon. He went back to the marine hospital. He had bad malaria. He got so cold, he started shaking the bed. And I got sick. Some honeymoon! [Laughs]

Then I went back to work, and I got pregnant two months later. I had morning sickness, morning, noon, night, and evening. I couldn't quit throwing up.

Then Billy was born. I was sick a lot, and Jack was out of work. I was in and out of the hospital a lot. So Jack took care of Billy. It was a year or two before I really felt good. And then Billy was sick a lot. Pneumonia. Allergies. He was allergic to everything. You could stand there and watch the bumps pop up on him.

We had it rough for five years after Billy. It seemed like everything went wrong. Just everything. He'd be out of work and then Billy'd get sick, and then I was. And then my mother died. She was just 39. She had a heart condition, and it . . . eventually killed her.

The worst part of her funeral was the funeral director. He'd been a real close friend of hers. When my stepfather called him, he didn't tell him it was my mother. So, he thought it was my grandmother, 'cause she'd been sick for years. So, when he took her back to the funeral home and opened the lid, he almost had a nervous breakdown. [Laughs]

And then my grandmother died.

And then my uncle died.

In two months, all my relatives, all my grandmother's brothers and sisters, they all died. I

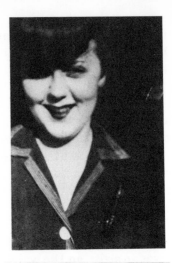

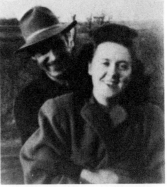

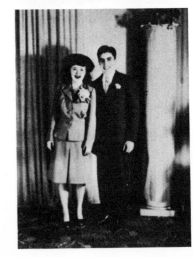

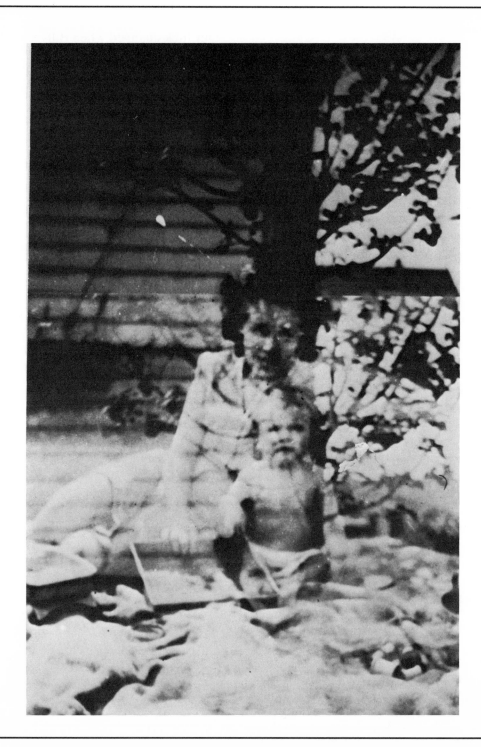

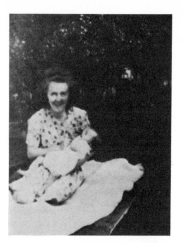

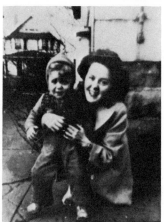

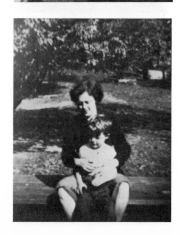

8

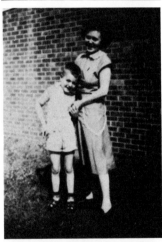

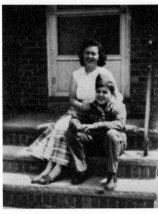

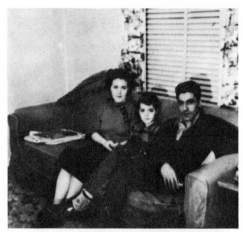

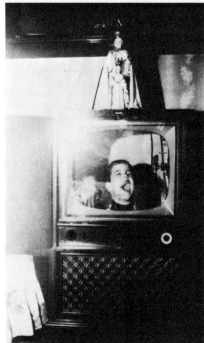

Our luck changed when Billy was about 9. It got better. And then it hit again: Jack's father, his grandmother [laughs], everybody died again. But it was better: she was old; she was 94; it was good. She said, "I don't feel good. I'm hot. I'm going to go take a little nap." And she was dead. We went in with a glass of water and she was dead. That was a nice way to go.

Then this really weird thing happened. In Jack's backyard, in his family's house, they had these two trees. One was this old pine tree. It must have been fifty years old. And it never grew! Stunted. A dwarf or something. And they had this great big gorgeous apple tree. The day after Jack's father died, that apple tree dropped dead. Overnight! And two months after that, that pine tree started *growing*. It got gigantic. It's bigger now than the house. I got a picture somewhere of my mother standing next to it when it was still a dwarf. And then it just shot up!

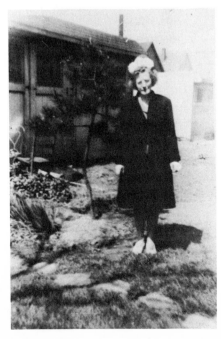

must have gone to fifteen funerals in two months.

The only good thing was Billy. He was so happy. So happy! Never a sad day. You'd go to a theater with him. And everybody'd be quiet. And he'd be laughing! Everybody would turn and look at him, and then they'd start laughing . . .

But I'll tell you what's *really* weird. Every night of my life, for as long as I can remember, I had the same dream. I remember it from when I was a little girl. Every night. Nobody could sleep with me because, at the end of it, I'd jerk clear up off the bed. It was, you know, when you look into a galaxy and you're floating? Only I would go *further* and I would be floating and floating. Then, as I got further out, the stars would be spinning, and I'd think—I'd get to a certain part where I'd be getting *deeper* and *deeper* into it, into a deep galaxy with the stars. And I'd know that if I got past that place it was dangerous, so I would—*stop* myself, and that's when I'd jerk clear up, off the bed, and come crashing down. Jack put up with it for years and years. I'd jerk and wake up, and then I'd sleep fine after that. It went on for years. And then, ten years ago, I had an operation, a hysterectomy, and the dream disappeared. I feel like something's missing. Like my soul's been taken.

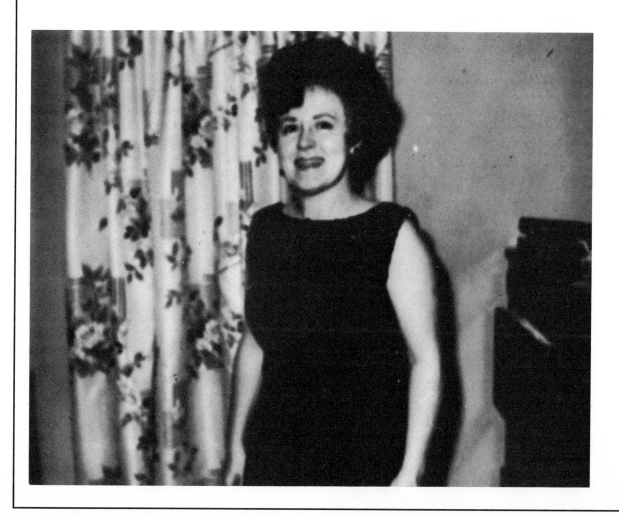

10

JACK: I had four brothers. There was eight kids. And I think—two died. One had T.B. of the bone. He suffered a long time. He died at 21. And another sister—she died real young. I don't remember her. I was the third youngest.

My oldest brother and sister were born in the old country. In Italy. In Calabria. Right down—in the bottom—in the boot. It's very, very rugged and mountainous terrain. My father used to get around there—with a donkey. Course, his father brought him over to this country when he was 8 years old.

My grandfather was the first one over. His name was the same as mine—I think. He brought *just* his son with him. Just him and the boy come over. Working on the railroads in Pennsylvania. My father was, maybe, 8. They gave him a job the *same as a man!* Fifty cents a day. Waterboy. When he was 12, he went back. And says he just suffered the *agonies of the damned* till he could get back to the States.

So, he come here when he was 17 and he got his citizenship, and then he went back when he was 24, and got married there. To my mother.

Her name was Maria—I think. I don't know, really. There's nothing much to say about her family. They had—in the old country, I guess quite a bit of property. They had a lot of *money*. Then one of their . . . you know, in the old country, they have a lot of these *bandits*. They *stole* one of the kids, one of the family, and they had to *pay*—a huge ransom; then they never did get him back. All their money. They lost everything.

They got married. But he didn't bring her back. She stayed there. And then they had a child, and he went back to America. He stayed here awhile, and then he returned, and they had another child [laughs], and then he went back to the States.

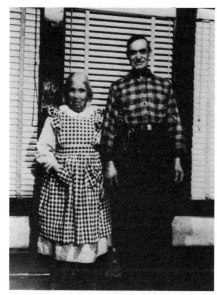

My father crossed that ocean nine times! And—you know—he didn't pay for his passage one time! He says, "You need a cook. Look! I'm a cook!" [Laughs] He says, "They had big caldrons of oil, *boiling*. You want to cook a chicken? You cut off his head, peel him, *dip* him in there!" [Laughs]

He got to be foreman on the railroad. He built this famous horseshoe curve someplace in Pennsylvania. Then he built the railroad that runs along the Ohio River. He was the foreman there. Then he moved up here and worked for the New York Central. He was foreman for the New York Central until they built the Fisher body plant here. He put *twenty-one switches* in for them. But they had to have somebody to maintain them. So, they told him that they'd *double* his salary if he'd come keep track of things. He worked thirty years there! Foreman at Fisher body.

I couldn't get a job when I was out of high school. Not at all. In 1936, I guess I was 16. I decided I was sick and tired of this business, so I hopped on a freight train [laughs], in the middle of the school term, and *took off!* [Laughs] I got down as far as Missouri. And I decided, "Hell! This isn't for me." I ran out of money. And you

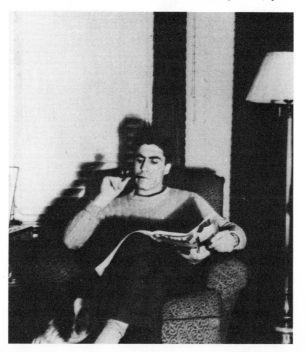

couldn't bum nothing. So, I rode the rails back up to Kankakee. South of Chicago. And I damn near fell asleep on the thing—hanging on to the side of a tank car—some colored guy held me on there—I remember he *grabbed* me! And *then* I was wide awake. When I got to Kankakee, I thumbed a ride with a truck driver and got back to Buffalo.

We lived outside the limits. It was a wilderness! Nothing paved. The streetcar used to turn there. The end of the line. We had the house built in 1916. The only thing my father worked on was under the porch. He dug it out and put a wine cellar in! [Laughs] What else?! And—he made his eleven barrels a year. Neighbors would come and have some. Oh, man, he made good wine! It didn't bother you. Of course, you could get loaded on it. He used to drink it all the time. He wouldn't drink water. He said it rusted your pipes! Only time he drank water was at work. He always went to work *dead sober*. Didn't even drink nothing in the morning. On the weekends! Wheeew! That's another story.

But at work he had to be sober. Especially in the wintertime! They'd call him up in the middle of the night. Sometime—no way to get down there! He'd walk! Walk! Dead of winter.

He was a rough one! I mean, when I got older, he was my height, but he was strong. When he was 65, he could take two acres of ground like nothing with a spade and shovel. Working on the railroad all day long.

I'll tell you how he was: when I was about 14, I done something and he *didn't like it*. He said, "Come here!" I says, "No!" I put my hand on the fence and jumped over. He went over that like a hurdler! [Laughs and laughs] He had to be in his forties or fifties! He just flew! And I got a good paddle! But, otherwise, he never did hit any of the kids. He said, "Now, look, I'm

going to tell you kids right now, if you ever get in any fights or anything like that—Hell!—I'll be the *first one* to get you out of jail! But you *rob* something—don't look for *me*. 'Cause I won't come!" And you know, I had a few brothers who got into fights at the park—they threw somebody over the railing of the dance floor—and my father went down there, put up $500, and bailed them out right there. Never said another word. Five hundred dollars was a lot of money in those days.

Even when I was 16 and went away from home, he never said a word to me. All he said was, "Come on down. Let's have a glass of wine." Went down to the basement. Sat down, had a glass of wine. Says, "What you think of the wine this year?" That's the way he talked! Never said, "How'd you like it out there?" He says, "I know what it's like. I felt the same way. I took off the same time."

He used to tell stories. A *storyteller!* Remember *The Thousand and One Nights?* He knew that thing by heart. He'd tell you every word for word. *Smart*. He was smart. He could speak very good English, Hungarian, and Italian. And Polish. 'Cause he worked with them. Nobody could speak English back then.

He did very good. He paid for the house, raised all the kids, never was out of work . . . And my mother, she worked! OOOO-EEEEE! Taking care of those kids. All she did was cook and wash.

Anyway, I got out of school and I couldn't get a job. So I joined the Civilian Conservation Corps. They'd pay you $31 a month, but you only kept $8 and the rest went back to your family. And it was just like a camp. All the way out in Bridger, Montana. Along the Cook River . . .

That's where I got built up, man. I really

worked *hard*. I really got built up. It was like boot camp or something. It was 1938, 1939. All

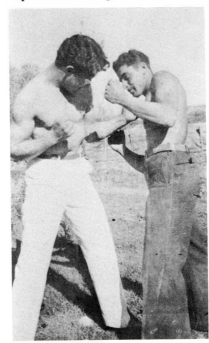

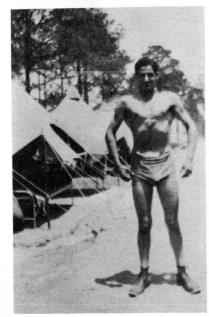

that fighting going on in Europe already. They were getting us set. We got everything but the gun, that's all!

I ended up in the army in 1940. A year before the war. Grew myself a mustache. I was 22. I couldn't get a job, so I volunteered for that. Really, I was happy to go in! I was looking forward to it. I thought it was going to be *nice!* [Laughs]

I was a private, then I got to be a sergeant. And that's as high as I wanted to go because—what the heck—you didn't make any money either way. I ended up with a bunch of bronze stars. For three campaigns. For the Guadalcanal Campaign. A bronze star means "major action." It means I damn near got blown away. And everyone did around me. They buried *a lot of guys there*. The whole outfit got medals. 'Cause it was bad. Oh man, it was bad. We didn't even have no food.

You know, I didn't want those darn medals, but Peggy sent away. I didn't care for the *damn*

stuff, I don't know why they give it to me, I get so goddarn mad, I don't want to be reminded of it!

I was trained for an 81-millimeter mortar. Mostly from a book. 'Cause we didn't get any guns until we were in combat. It's a high-angle weapon. It goes up and comes almost straight down. There's nowhere you can hide. It broke down into three pieces. And each one weighed at least thirty-five pounds. The breastplate, the barrel, and the stands. It took eight men to do it. Three guys to carry the weapon and five to carry the ammunition . . .

We went on maneuvers. The air force and everybody was in on it. If they'd drop one of them damn flour sacks, and it exploded within a hundred yards of you, then the umpire would say [his voice descends the scale], "You're dead; you're dead; you're dead; you're dead; you just died." And you'd say, "O.K."

They didn't ship us out until '42 or something. They put us on boats in the Brooklyn Navy Yard. They gave us all winter clothes. And on the boats—they took all them winter clothes away from us and gave us all this tropical stuff . . .

It took us thirty-one days from when we left the damn Brooklyn Navy Yard to get to some place called Tonga Tabu. It's in the Friendly Island Group. Then we landed at Guadalcanal.

They'd tell us to get up on such and such a hill and set up a field of fire. So, at one of these damn points, they had to send the infantry down into this big, steep ravine. And the lieutenant says, "Look it, fellas! These goddamn shells cost $7.50 apiece! Don't throw too many in there. [Laughs] The people back home are hollering because of the cost of the war."

So, Christ! We sent these guys *down*, and half of them *don't come back!* Two guys would be carrying two other guys with them. And I says, "Hell! That thing's full of Japs down there. Where's the other guys?" "I don't know. They got hit."

So, some colonel came back up there. "What's the problem?" "Well . . . They told us not to throw too many shells in there." "Throw them *all* in there!"

So, we started throwing shells in there. Every gun covered one hundred yards. Four guns: four hundred yards. Boom, boom, boom, boom, boom, boom, boom, boom. Just as fast as you could throw 'em in the damn gun. We covered that *whole* valley. And on the end of the shell is a delayed action fuse. So it could go through the trees and explode near the ground. BEW-BEW-BEW-BEW! Worse than the Fourth of July!

We went down in that valley—and, if you know what jungles are—there was *no underbrush*, just *twigs!* I mean that whole damn thing was just *cleared out*. Dead Japs—all over the place. Them Japs! They must have been swimming. Dead in the water. Half with clothes on, half not. Hanging over banyon trees. We slaughtered them. God Almighty! They finally got one prisoner; he says, "Before you shoot me, I want to see your automatic mortars!" [Laughs]

You'd see jeeps turned over guys covered with blankets. Or you'd see dead Japs. I saw the biggest Jap of my life there. At least seven foot. Big. Chest as big as a trunk. Dead on the side of the road. Maggots crawling all over him. One arm straight up in the air and his mouth wide open. And you walk by.

I mean: if somebody tells you, it's nothing. If you hear about it, it's nothing. If you see it in the movie, it's nothing. But if you go by it, and you *smell* it, it's something. You sit down and you're eating your lunch and [sniffs], "What the hell is that?" And you move the goddamn branch and—Jesus Christ!—there're three dead Japs under the damn thing! That's something you know. [Laughs] And you go down these roads, and you don't know what's in those goddamn trees and branches.

I was in this foxhole. We were all spread out. Waiting. Listening. A human being, you can tell right away. He'll crawl, stop; he'll crawl, stop.

Everyone was getting skinnier. Skinnier and skinnier. We didn't have anything fresh! Like bread. Or eggs. The only thing you could get was C rations. Corned beef hash. Give you little packets: This is coffee, this is soup. Jesus Christ! It tasted terrible! Everyone had diarrhea. And they ran out of paragoric or some darn thing and they had to go without it half the time.

A lot of guys started acting funny. I mean, how much can your mind take? But—we had a real tight-knit outfit. Wasn't nothing one guy wouldn't do for another. We stayed and we fought. We didn't *move back*. They come at us, we *stayed right there*, man. Stayed right there. We didn't give an inch. We never moved back at all. We moved forward *all the time* . . .

I was on one of these damn hills, and this Padre comes up to me, and he's drunk, and he says I'd got a message. And, the only time you got a message was when somebody died back home. He says, "I've got something to tell you." And I says, "Before you start, I know what it is." He says, "You do?" I says, "Yeah." Because it just [snaps his fingers twice] hit me for about a week. I just—*knew* it. Something you *know*, I guess. I knew my mother had died. That's it.

Then guys started getting malaria. And Jesus! It just wrecked the whole thing. No quinine. They give us Adabrine tablets. And aspirin. For headaches. And temperatures were *way up!* The first time I was in a marine hospital, the nurse took my temperature and started running! She'd never seen a temperature that high. Way up! You're supposed to be dead, but you still live with it.

I kept taking aspirins. I had touches of it in combat. I didn't get it bad until they took us off the island.

That's a human being. But—this night, this thing kept crawling along. I knew it wasn't human. I didn't want to shoot. Not at night. You carry this big machete, and you use that. 'Cause it's too easy to hit somebody else. And you *don't leave your hole.* You leave your hole, you're dead. You got to go to the toilet? You better do it right there, buddy. 'Cause anything moves, gets *hit.*

Anyway, this damn thing—I was so goddamn scared! I was just ticking. I thought my throat was going to bounce out—and this damn thing went to my hole and went *right over me.* And it kept going. Then I heard the awfulest scream. I stayed in my hole! I didn't get out! *You're trained.* That's it. You don't move. You *stay there.* If it's somebody else, let *him* take care of *his own* problem. You take care of your problem. You don't move. You don't run. No time! You stay there and fight. Morning come, the guy about ten foot from me, that [laughing] lizard, he thought it was a Jap. He [laughing] slashed that thing into ten thousand pieces! [Laughs]

It all really hit you when you were out of it. That was the worst there was. Then you start—thinking. What happened. [Laughs] You know, after combat, a lot of guys went out of their gourd. [Laughs] We got out of there on an LST, and one guy starts screaming, "My mother's my father. My mother's my father." Went off his rocker. [Laughs] A few of them did. You couldn't talk to them. It was going on inside their head and that was it. The same goddamn thing was going on inside mine! [Laughs]

They sent the whole outfit to rest on British Samoa. That's where I came down with the malaria. They sent me to a field hospital on American Samoa. But the goddamn place is full of elephantiasis. That's got to be the *dumbest* place *in the world* to put a field hospital. The natives had legs and arms that looked like Popeye! Organs all swole up!

I was sick with this malaria and *nervous.* They said, "Boy, you look awful nervous!" Yeah, Christ, sitting around after all this stuff. They gave me some phenobarbital—would you believe it?! You'd take them damn pills and—honest-to-God—you'd go down the damn road and

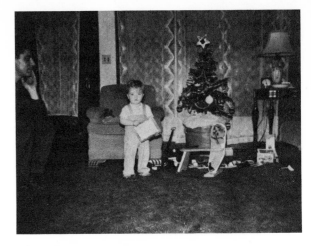

you're floating! Hey! Nothing bothers you! [Laughs] I mean, ain't nothing bothers you. A month later they put me on a boat, home.

On the boat, I got *so sick*. I don't know if it was seasick or nervous or what. I told this guy, "Gee, I'm sick and nervous and everything. What you going to do for me?" "Here, take these!" He gave me a whole goddarn bottle of these phenobarbital pills! *Whole bottle!* He said, "When you get bad, just take one of these." Well, I took them and I felt a lot better with them. Got back to San Francisco, and I didn't touch them after that.

I was down to ninety-eight pounds. My ribs were sticking out. And I was all yellow. I don't know if it was jaundice or the goddamn Adabrine they gave us. They discharged me from the army "unfit for further military service" with the damn

malaria. Sh-i-t! I wound up in the marine hospital, back in Buffalo. Ch-r-i-st! It took me five years before I could quit going back there.

Believe me—you're coming back, you're ready to settle down. You ain't looking for nothing! Before that, you're looking for fun, you're looking for treasure. When you get out, boy, you ain't looking for *a thing*. Just want peace and quiet and solitude and nobody to bug you! [Laughs] Then I met Peggy! Just the opposite! [Laughs]

When I got out of the hospital, I heard they were looking for someone down at Fisher body. In the powerhouse . . . I got the job down in the powerhouse. I got that malaria, even there. But it didn't knock me out. Even in the army! So what! You got malaria? Shoot your gun! What the hell!

The day Billy was born, *the day he was born*,

I got laid off. Guys with seniority were coming back from the war. I got bumped out. I didn't ask any questions. What the hell. I figured, Peggy was *so darn* sick, if I had a nurse to take care of her, she would have cost me more money than I was making. I figured if I stayed home—hell!—I'm making money! [Laughs]

Then I got called back. I worked in the stamping room. The *noise* is deafening. They stamp out floor pans and quarter-panels for automobiles. Well—I worked there three days and that's it! I couldn't hear nothing. They wouldn't give ear protection! I couldn't stand that. 'Cause the ground would shake underneath you all the time. And you couldn't keep up with them guys. All foreigners: "Hurry up! Hurry up!" And that's all—they wanted to make this damn piecework. Jesus! I think I had the easiest job there and I couldn't keep up with them.

So I told the boss, "That's it." He said go down to the office and see the doctor. I went down there. And this guy was in there. Looked like a Gestapo. Really a German. I told him, "Listen.

I was in the war, and I put up with all this other crap!" I said, "I don't want any more noise. I'd like to get someplace where it's quiet." So, he takes me to the personnel manager, and he says, "This guy here says he can't do the work! He says it's too much noise. Listen, we don't want him around here. Let's get rid of him!" Meanwhile, the personnel manager, he was talking to somebody else and he only got half of this. And the doctor walked away. So, the employment manager says to me, "Well. The doctor says that the noise was too much for you? That you're looking for a place that's a little more quiet? Well—if *he* says it's all right, then it's all right with me." See! He didn't hear what the doctor said about getting rid of me! So he gave me a job up on the fourth floor, where they shipped out nuts and bolts, and rubber fasteners. Nine months later, I was a foreman. I was a foreman ever since.

If you're a worker, and you belong to a union, the thing there is: the foreman—that's the enemy. You don't do nothing. You don't say nothing. You don't have nothing to do with him. 'Cause the foreman's working for the company. That's the way it is in a factory. So—what happened: I had a buddy. My best friend. And when I made foreman, he wouldn't talk to me any more. He says, "Well, it don't look good. If I go to the union hall, if somebody finds out I'm playing golf with you, they say, 'What the hell?! You giving away union secrets?! You working for management?!' It don't look good. I can't do it." Somebody must have said to him, "What are you doing out with that guy?" It was crazy. We had real good times, too. *You sacrifice a lot.* Everybody stopped coming around. Every last one of them walked out! The only friends I had were a few of the foremen with me at the plant. I didn't have a friend in the world! It's like the caste system in India. In all these plants it's like that. And it's not like I was making all kinds of money. They'd say, "Oh, you got so much money." And I'd say, "Hell! I ain't got half a million, yet!" They think we got millions of dollars.

If you worked for me, I'd put myself in *your spot.* I'd know enough about *my men,* I could tell you their family history. I had as many colored guys as I had white. And I *always* put one with the other. We got along fine. I'd say, "Now, look, if there's something you don't like, don't go blabbing it out to the union, come and see me. We'll straighten it out. If I can't do it, we'll think of something between us! Look! We got to work here for thirty years. What the hell is the use of you being mad at me, and me being mad at you! It's a helluva thing to come in a place and everybody hates each other! We'll make the most of this goddamn thing."

This place is *very well organized. Everybody knows his job. Perfect.* And everybody knows his immediate superior's job. *Perfect.* Everybody moves up, through the ranks. You come from the *ranks.*

It's *intense!* They always say, "If you can't do the job, *get out!*" I always felt insecure. You have a couple foul-ups and *that's it!* I was taken in the office one time: I ordered boxcars. And I had to schedule them in, no more than a day ahead. I ordered these rocker panels, the heavy underparts of the car. This boxcar was supposed to have 375 right sides and left sides. There's *a difference,* you know. The boxcar come in. By 1 o'clock they'd run out, on the line, and I had to get this boxcar emptied, an eighty-foot boxcar.

Well, you open the car, there's a sheet that tells you what's in there; I knew the damn thing had to be in the back. So, I dug to the back of the car. 'Cause one set of rocker panels was on one side and one set on the other. I cleared one side out and got them out. And I was clearing the other. I get to the back, and it was all right sides, and I get to the other and it was all the same. All "*rights*." No "*lefts*."

And! My superintendent says, "By God! You should have known that!" He took me to the office in front of the "Old Man." And he says, "I want this guy written up! He didn't do this, and this, and this, and this!" So, the personnel manager wrote it all out, and he says, "You sign this." I said, "You mean I'm going to sign this to tell you I'm *guilty?* I'm not *guilty!* If the car comes in and the invoice is in order, and the records in the office show it's in order, then I ordered the right boxcar!" I wouldn't sign it. I says, "Go to hell." I says, "I'm not signing it. You can fire me, but—by God!—I'll go *right to the top* with this thing. I'm not getting fired for nothing! It's not my fault." So, I never heard nothing ever said about it. But—meantime!—I had to send four thousand people home! I had to send them home at 2:30. About a half an hour before quitting time.

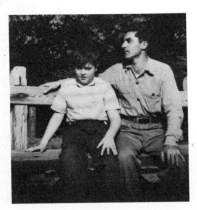

I wasn't leading a normal life. Peggy never saw me except on Sundays. Billy never saw me until he was in the eleventh grade. Because, for the first eleven years, I worked the afternoons into the night, from 2:00 P.M. to 12:00 midnight. Billy would get up to go to school, and when he came back, I'd be gone. And then on Sunday, I'd be so tired I couldn't talk to him. Billy got so used to talking to Peggy, when I got out, he'd go *around* me to her for something.

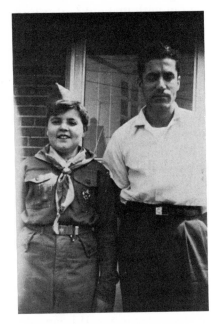

A lot of foremen got disabilities because of nervousness. Ulcers. Asked to be transferred back to an hourly wage. This one guy, this foreman, I seen him on the loading dock, talking, and—Christ—there wasn't anyone within a hundred miles of him! Back in the corner, someplace, talking! "I can't take any more. I can't take another day of this." He just couldn't stand it. 'Cause if you're a foreman, you get it from the union, and the management, and the men.

My kid got out of high school; he was a pretty smart kid. He got straight A's. He was an honor student all the way through. So, this guy says, "You're sending your boy to General Motors Institute, aren't you?" So *he* could be a manager. That's what all the foremen did with their kids. So they could get a shot at the top. Well, he never forgave me for what I said to him. I says, "Look! DO YOU THINK I WANT MY KID to get into Fisher body and go through the GODDAMN STUFF that I been going through all those years?! Do you really think that I'd send him *there!?*" I said, "HELL, NO! He's going on to some other college. I don't care what it'll cost me. I DON'T WANT HIM WORKING IN THIS GALLDARNED PLACE!" And, do you know, that man never talked to me again?

I had an opportunity, many times for advancement. And here's what I'd tell them. "I don't want the damn job that I've got! [Laughs] I'm not looking for trouble. All I want to do is get through this thing. And get a halfway decent pension." This went on until I retired in '73. I was on vacation and I come back, and they were having a lot of trouble with OPEC, and they were laying a lot of guys off because the auto-

mobiles weren't selling, and they says, "Would you like to take an early retirement?" And I say, "What the hell you going to give me?" "We'll lay you off for a year, because you're only 55, that'll make you 56, and you got twenty-nine years with the Company, and we'll *give* you another year after you're laid off, and that'll give you thirty years and you'll get your full pension from the company." So, I told Peggy. I says, "What do you think?" And she says, "Get out of there!" I went back and he says, "Have you made up your mind?" I says, "Where the hell is my coat? I'm leaving!"

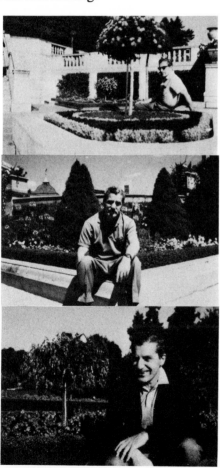

Manny and Marilyn

MANNY: When was I born? I was born on a Saturday night, June 22, 1912. It was a Sabbath.

My grandparents came over here from Russia and they started a business. They sold chickens. The women would come in and feel them and pluck them. Then they started a grocery store. They *bought* the building they were in. They were always successful.

My father was an expert tailor—in ladies' garments. And he was good. He was the type of man, when other people couldn't get work, he was in demand. He and my mother met in Europe. *That* came from my mother. Because my dad . . .

Let me tell you what happened:

[His voice rises.] I come from a broken home. My dad and mother—when I was small—after he came here, he considered himself a lady's man. He was *a nice-looking man*. And he was the kind of a *man* that was very—egotistical. He felt, "*I am the boss!*" The man is *The Man*. And the lady is just there to have children and take care of the home. "Don't-ask-me-where-I-go-and-where-I-don't-go!" My dad was very much that way.

First place. I was born. Right here in the city. Where the Central Market, the food market, is today. I was *born* on Fulton. Set way back in there. I was *raised* there. Well—we *lived* there.

But my dad—because my dad was a chaser—they were always arguing. And we saw this—me and my brothers—saw this in the home. The biggest thing was that he'd never leave any money. And he *always made money*. But that was strictly for himself. The *family* meant very little to him. It was something that was *there*. He felt that he had to take care of it, but take care of it in the *least* possible way.

The first thing I remember was when I was taken to kindergarten. I didn't want to go. I was very *shy*. I was *afraid*. I felt that they were going to *leave* me. I remember—they had a picket fence—an iron picket fence—around this... I was hanging onto this fence. Outside of the schoolyard. I didn't want to go.

When we lived in the area I was born—they had what they called Canterberry Run. There used to be a lot of killings. There was railroad tracks run down through there. They used to find heads and bodies in this ravine, this gully. And we used to play down in there.

It was a place where, in the wintertime, you'd come with sleds. And there was all sorts of things going on there. Because there was *nobody watching*...

The trains used to run through there. And they used to dump the water. They used to clean their boilers. And the water used to run down. And we used to use that as a swimming pool. It was nothing but polluted water. But we weren't the only ones. Skinny-dipping. Absolutely in the nude.

For years, they used to find heads and bodies in this gully. Somebody was doing it. This man. But they never solved it. They never solved this mystery. They would find a head, an arm, a leg.

It was a big place for homosexuals. Kids used to come down to play ball. Or go hiking. That kind of a place.

See—my dad was never there. He was the kind of guy who would work, come home, read the paper, get dressed, and leave. My mother was stuck with the boys.

Something happened that stuck in my mind. For a long time. It seemed to me that there was one, two—there was three men. I think they were guys in their early twenties. I was a kid.

To me they were men. They started to touch me and play with me. And they started to *undress* me. And. It scared me. And I ran off. I ran like hell...

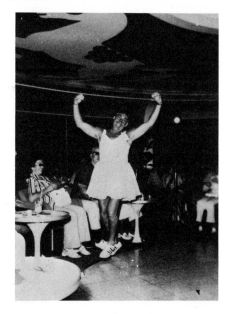

Later on, we moved from there. And my dad —left. Just up and left. He didn't disappear. We knew where he was at. The court said he was supposed to support us. But *just go and get it out of him!*

When he would come around—we were very much afraid of my father. He was a very, very, *strict, strict* man. We would see him once a week. My mother was always threatening, "If you can't listen, your father's going to whip you." And, when he'd come around—and you never knew when he'd come around—instead of talking to me, he used to *whip me*. Unmercifully. Honest to God. I used to beg. Get over his knee. I had to take my pants down. *On my bare can.* He used to whip me with a strap thicker than a belt. *I mean whip me!* And then, get up and *leave!* Just like that!

I must have been 10 years old at that time. I realized help was needed. We never had any money. I remember I used to walk up and down the street, selling papers. I used to walk into stores. And one day, I walked into this jewelry store and the man asked me if I'd like a job after school. I jumped at it!

I worked there about four days. And one time he says to me, "Come on down in the basement." And he *locks the front door.* And I couldn't figure out what in the world he was going to do! I go down to the basement. And they didn't have a toilet in the place. And this man had to go! And he made me—he put me in the other corner to clean up some stuff. In the meanwhile—he did whatever he had to do in the corner. But. You see. *I saw this.* And it *bothered* me. And I went upstairs and I quit. I just couldn't take this thing. That the man wouldn't trust me to stay up there and watch the store. *Made me go down there.* There was *no reason* for me to go down there. And I was *just a kid* at that time. I just felt—it wasn't right. And I just turned around and quit.

I haven't thought about that in forty years. It just *came*. It just stuck.

You see—my father. I never really had a father.

We had *absolutely nothing*. Everything we had was what welfare helped us and the little bit my father threw at us.

My mother wouldn't divorce him. She didn't want to give him his freedom. This way, she had a little something.

One day, my father's two sisters came and they talked to my mother. They says, "Look. These kids are growing up. You can't control them. As they get older. They're not *bad* boys. But they're not *good* boys. And the place they

live—anything can happen. Dave is going with this woman. He wants to set up a home. This woman has a son. He wants to make a home for the boys. If you give him *the freedom*, we'll give you some money. The kids and everybody'll be happier. You won't have this headache of taking care of them. You can go out and get yourself a job. Make a little money." They convinced her.

And so.

I left my mother.

The three of us felt that the world had come to an end.

We went with my father. He married this—woman. Her name was Ruthy. She had a son. His name was Dick. We moved. He set up a nice apartment. We had two bedrooms. They had one. And the four boys had the other. There were two beds. I slept with Dick. And the two younger boys slept together. I was just going into junior high school.

He *did* set a home up.

And Ruthy as a stepmother was as good to us as to her own boy. Made a *marvelous* home for us. She was a good cook. She cleaned. She used to take care of us. Bathe us. But, my father—never changed much. He still would go to work, make good money, come home, and when he came home, we had to be clean; we had to be sitting there doing our homework. We knew his routine. He'd come home, read the paper for about an hour, get dressed, and *go*. Where he went to, I don't know!

I would be out playing ball. It was evening. And all the kids. Their fathers standing along the fence! Watching the kids play ball! My dad *never*. And I was a *real athlete* when I was young. He would *never*. And I would say to myself, "My God! I wish *my father* would come and watch me." But *my father would never*.

My father was a stranger to me. Except he was a very *mean* man.

That's when I learned I was an athlete. I came to junior high school, and I was *very shy*. I couldn't talk to people. I would blush. I would hang my head.

I don't know what happened, but after school one day, I walked into the gym. Into the stands, and I see these guys practicing softball. They were all dressed in uniforms. I don't know how I got down on the floor. I says, "Let me try pitching!" I got on the floor. And the varsity was practicing. And [in a louder and louder, higher and higher voice] I *was getting the biggest kick out of it!* I didn't realize that the coach was watching. When they got through, he walked up, and says, "Come over here. What's your name?" I tell him. And he says, "I would like to have you come out for the team." I didn't even know there was a team! And sure enough, I became the pitcher. When I didn't pitch, I was playing left field. As it turned out,

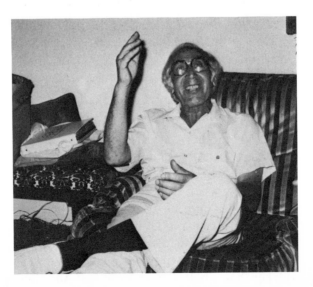

we won the city championship for junior high schools. I had *my name* and *my picture* taken into the newspaper. If you go down to the library and look at the newspaper—June 1927—you'll see a picture on the sports page of this young fellow here! So help me! To me—this was *the biggest thing*! . . .

Then Ruthy got fed up. My dad never took her anyplace. And the money problems came up again! Never enough. They started to argue. And, eventually, he threw her out. Of course, she took her son with her. I was 15. She'd raised us. She was marvelous.

She went to a friend's house. I followed her. I came to this lady's house, and I walked in, and I said, "I want to talk to Ruthy." And I said, "Ruthy. *What are you going to do?*" And she was crying. It was a *big* thing. She didn't know. I think I had $2. I said, "Ruthy, you got any money?" She says, "I haven't got a *dime*." I says [in a tender voice], "Well. I have—this is all I have." I felt like she was my mother. And I gave her this money. And—*she was all over me*, kissing and hugging. And I left.

He broke up the apartment. And we moved. To furnished rooms. We were strictly on our own. He used to leave us lunch money. We'd get up, go to school, eat supper in a restaurant.

I got to a point . . . *I couldn't take it any more*. I wasn't a *person*. My dad wouldn't let us do absolutely *anything*—when he was *around*. But he wasn't *there* most of the time. It got to the point that—I was 15, 16 years old already!—I was starting to think for myself. I *couldn't*, I *couldn't* take it any more. We had a big fight. I picked myself up and left. I left home.

I went to one of my aunts. I said, "Look! I got no place to go. I got no money! Can I stay?" I said, "I'll get a job. And whatever you want, I'll pay." She said, "O.K."

It happened to be wintertime, and she was the type of person who wouldn't let go of two cents. *That* house was *cold!* And I'd come down in the morning to look for some breakfast —and there was nothing there.

I went out and got a job. At Woolworth's. I was in the kitchen, in the basement. It was great. Because I was able to eat! But—I couldn't stay with my aunt. I was *too cold!* She was just like a stranger. And she wanted [in a very high voice] *to get paid!* At least your aunt! I was *just a kid*, see?!

Well—I left there. And I don't know what in the hell I did. I had one uncle. A dentist. I came to him and I said, "Earl, I need a job. And I need a place to stay." He says [in a soft voice], "Well, I'll tell you what we can do. Let's put a bed into this basement." It was nothing more than a store with a basement. We put a bed down there. And this is where I lived for five years. Almost till I got married. Till I met Marilyn.

He said to me, "I'll teach you how to make false teeth." I learned how to do that. Some of my other uncles were dentists. I would make $2 on each set of teeth. I used to make $12 to $15 a week.

I was doing all right. I was doing *fine*. And Earl was *so good to me*. [His voice grows soft.] We were the same size. He used to wear good clothes. He wouldn't give me rags. Once in a while, if I needed a car, he would give me his. He was that kind of a guy. *Always*.

So. I lived in this store. And, at night—*the rats!* Living in this *basement. All alone. Nobody* had any interest in me. *Nobody in the family paid any attention to me! I was strictly on my own. Absolutely, strictly on my own.* Nobody knew what time I came or what time I went. Nobody would tell me what to eat, when to

eat. Anything. I was just strictly—*an alone person!* Let me tell you—it was *really bad*. To be alone is the worst thing in the world. You can have people around you all day—but when you're alone, and you know that you have nobody, it's a *terrible thing*. And it can depress you to the point where, really and truly, you don't know what you're doing. You lose confidence in yourself. In *everything*.

I met Marilyn by accident. I was on this double date. We stopped to get some ice cream. They had "rainbow" cones. Ice cream with different colors. They used to slap them on, build them up with these long flat spoons. So, I walk in, and [his voice grows soft] I see this little fat girl behind the counter. About as tall as she was wide. And [breathlessly], I said, "God! This is . . ." *Heaven opened up!* Honestly! I didn't know her! She was busy. I ordered four cones. I got so excited that as I was carrying these things out to the car [he giggles, shrilly], I *dropped the whole thing!* I said to my boyfriend, I says [breathlessly], "I just saw the girl in there. I don't know who she is, but I'm going to marry that girl!" This is the *honest-to-God truth!* I didn't know her from Adam.

The next day, I went back. And I started talking. I thought [tenderly], she was—the greatest thing in the world. I saw in her the kind of girl that I thought would make the best wife! —the best mother!—the best housekeeper! I just—*I never thought of it until I saw this girl!* These things just flashed in my—just flashed in my whole mind. And why all this happened I don't know. I guess because I was lonesome— looking for *somebody*, so that I could have *something*.

I started coming around in the evenings. And she was dating *this one* and she was dating

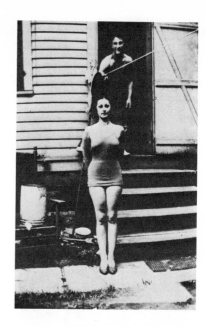

7th month

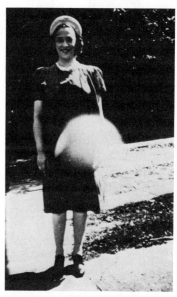

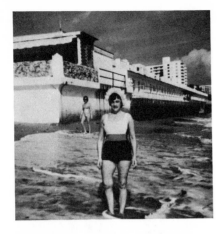

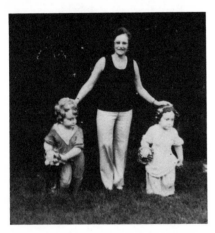

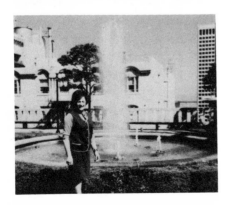

that one. I just used to eat my heart out. I was *so jealous*. I would never [choked cough] tell her this. I was so jealous.

MARILYN: He fell in love with me before I fell in love with him. I was going with these two fantastic guys. Who had money. And my father couldn't see me falling in love with Manny, and not liking the two guys who had money. They had stores. One was a salesman. And the other had a fruit store. They had these steady jobs. Manny didn't have a job. My father was the type of father who thought I was so beautiful that I *deserved* the *best*. And since Manny had no family and he wasn't working, he didn't feel that Manny was suitable for me. It was a father's *ambition* for a daughter.

He fought it. He refused to let me see Manny. So, I had to meet him up at the corner. Then finally I told my father that I just couldn't work it that way, any more. Manny just had to come to the house. I was going with him and he just had to let me be with him. I was just that crazy about him. And finally he said, "O.K."

MANNY: I think [wistfully] the first time I

came into her *home* was [wondrously] on a *Friday night*, on *Sabbath*. They welcomed in the Sabbath. I was invited to come to Friday night supper. Well—I walked into this *home*. Her father—this was a *real Orthodox* Jewish man. A real Orthodox woman—that was his wife. They had all these children around. And here [in a tender voice] I have this girl. I walk into this home—*I never had a home*—I had *never seen*—to actually come into a home where there are sisters and brothers and a mother and father and everybody's sitting around—and to have a Friday night supper! Like that! And to hear him make the prayers. Boy!—I tell you —I thought *only God* could do *this*. It was the greatest thing in the world.

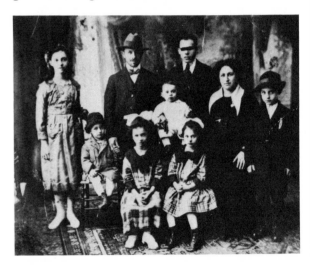

From then on—we started to date.

We went to speakeasies. Where the black and white used to come. Used to call it "the black and tan." A lot of these places doubled as whorehouses. What some of these women would do! People used to take a silver dollar, put it on the edge of the table, and a woman would walk up to it and pick it up—but not

with her fingers!—you know what I mean? I seen it done over and over again. And! Everything she'd pick up, she'd keep!

One time, we went to a house party. In a home. Upstairs. We were playing "spin the bottle." So, someone spun the bottle and took Marilyn into the bedroom. She was my date. All of a sudden *I hear her scream.* I don't know what she's screaming about, but she's screaming. And I dashed in there! I almost killed the man. I took him, and I pulled him out of the room—and I was actually going to throw him out of the window! But they stopped me.

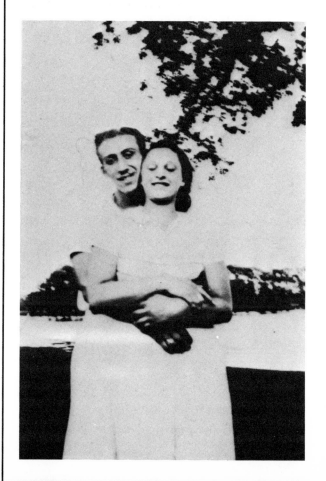

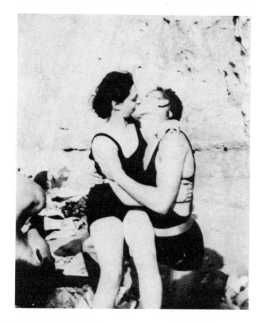

MARILYN: Once my parents said Manny could come to the house, he just *moved in.* He ate with us. He slept with my brothers. He became part of the house. From the time he was 17. But my father never approved of him. His parents were divorced; he wasn't going to college; he didn't have a career. But we *just had to be with one another.* In those days, you didn't sleep with each other —but we just—after *five years,* we just *had* to get married. We told my father. He said, "All right." But he never approved. He said to us, "A sack of salt takes a man and woman ten years to eat. If I see, in ten years, you're *happy* together, then I'll apologize." And he did.

MANNY: Well, we got married. but we had *no money.* We couldn't get our own place. Marilyn had been sleeping with one of her sisters. So all that happened was that her sister slept somewhere else and I slept with Marilyn. To her, it was nothing different than getting another bed partner.

MARILYN: That first year! It was a *terrible* year. It's a wonder we pulled through. I was married, but—there was my mother and my father and my seven brothers and sisters. My mother expected me to take care of the house—like when I wasn't married. And Manny resented that. I would come home from work. And *wash* and *iron* and *clean* for the whole family. Just like I'd done before. And . . .

MANNY: I was paying room and board there. I was paying for my keep. *Maybe* it wasn't enough. Maybe it was too much. *I* felt I was paying *more*; *they* felt I was paying *less*. Just dickering things like that. And. *My wife*—they wanted her to be just like before. All the cleaning. All the *everything. There's a limit.* I spoke up! They resented it. We used to have arguments. These little things got from bad to worse. Finally, we had to move.

See, you got to understand: My father had a mean temper. Vicious. Yeah, vicious. As a matter of fact—when I was a young man, I was very much like my father. I had a vicious temper. I would get riled up. At all sorts of things. I used to get mad, real quick. And used to get over it just as quick. And when I got over it, I didn't know what to do to make up for it. That's how sorry I was. It wasn't that I *wanted* to do it. It was something that was *inbred*. I never thought of controlling it.

People lose their tempers, but I was vicious. [MARILYN: "You weren't vicious."] I wouldn't hurt people. But I would usually yell and scream and get mad. And if it was a stranger, and it had to come to blows, I would come to blows. I wasn't afraid of anybody. I was a healthy man. I was the kind of man who was not afraid of anything. *I never was.*

And—if I *cared* for a person, and I saw somebody molesting this person or insulting this person—*in any way at all*—I would *go.*

I remember I always used to watch out for my youngest brother. One time, some big guy —taller than I was—was pestering my brother.

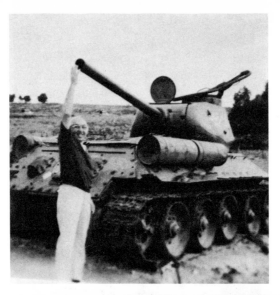

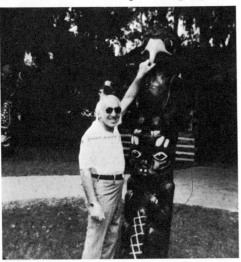

When I saw him crying—*I saw red.* And I tell you—we had a real fist-to-fist fight. To the point that neither one of us could almost stand up. We were throwing blows. But I *beat* this man! I just wouldn't give up. I beat this man. And later on this man came and said, "Manny, I *never thought* that you could beat me." And this guy was five inches taller than I was.

Sometimes I wonder how I made it. See, I'll tell you: As I grew up, I had nobody to teach me. I didn't have a mother. I didn't have a father. My mother was a very weak woman. My father—there was nobody there. I had *nobody* to teach me right from wrong. Or to take me under their wing and say, "Look! You're my son! Let me show you a little love." *I never had any love.* It wasn't until I met my wife [he speaks more and more rapidly], *until I met her family—they showed me love! They showed me* what it was to have a family. To be part of a family. *I never had that! Never!* Until I met Marilyn. Until I came to her house that I realized what it was [rapidly] to have a *home*; what it was to have *love*; what it was to *care* for each other.

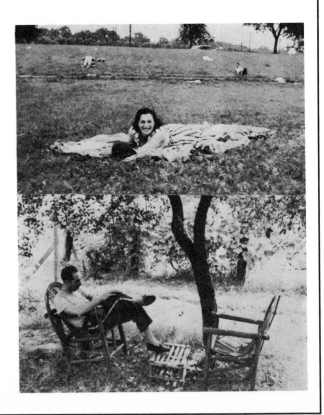

At first it was *hard*. You don't know what. I was always thrown around. I lived all alone. [He speaks rapidly.] By whatever I could pick up. Whatever I could scrape together. Whatever I could earn—*was for myself*. Living in this basement. With these rats, down there. And coming home—I used to have an egg sandwich—a toasted bread, egg sandwich I used to have every single night of the week. I couldn't afford anything. And a glass of milk. This is what I had.

A lot of this anger was coming out—because of the way I was living, see.

I remember, me and my boyfriend, we used to crash parties. I walked into this party and the father was there. He was standing at the door to see that only the people . . . We didn't know. We walked in. The father is at the door, and he says, "Where are you going?" I says, "To the party." He says, "Were you invited?" And I says, "No." One thing led to another. He started to push me off the porch. But I wasn't going to be pushed. I pushed back. And the first thing you know we were at blows.

I don't blame my father.

The only thing he broke up was a family. See, what he hurt was four people. Three brothers. And my mother. Not only *that*, but he hurt my stepmother also.

I *seen* this. I saw how he hurt *all those people*.

I forgave him for it, later. When I realized he was getting old and needed help.

I'll be very honest: I never liked the man. I never liked him.

When I was young—Oh!—I was an angry man.

I had *very little*. And I wanted *so much*.

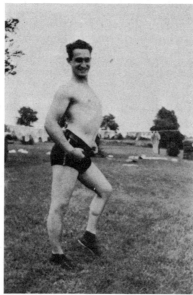

Merle

After we got married, I drove a bread truck for five years . . . Then the war came and I went to work for Marilyn's brother, Merle. He'd just started a machine shop. I came in there cold. Didn't know a thing. There was lathes. And there was shapers. And there was drill presses. *All these things*. I'd get in there at 7:30 in the

morning and get home at 6 o'clock at night. I watched. I learned. And pretty soon I was setting up machines; I was in charge of the whole production. I had maybe twenty people. Making gunsights and all sorts of things. Everything had to be precision. I was there the whole war.

MARILYN: The funny thing was that when Merle started his machine-tool business, we had just saved up enough money to buy a house. And I had my three children. And Manny was working for Merle, and Merle needed money. And he said to Manny, "Instead of buying a house, let's you and I go into business." [Her voice grows very soft.] Manny came home —*this was the mistake of my life*—and said, "Let's not buy a house. Let's give Merle the money. And I'll go into business with him." And I said, "No." I said, "I got my three children and I can't live like this *any more*." We didn't know that Merle was going to make it big! He was

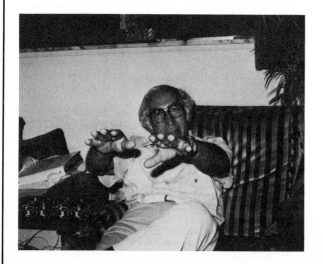

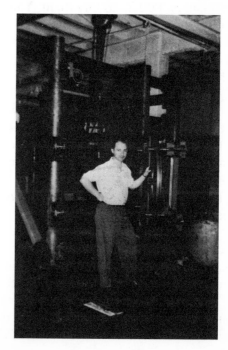

struggling. He wasn't getting many orders. He was in desperate need of money. And what'd we have? We had $2000 or $3000. At that time, it was a lot of money. And I said, "No."

MANNY: Merle and I never hit it off anyway.

MARILYN: They never got along. I don't know why. Merle and I used to go everywhere together. If we didn't have dates, we used to go to parties together. And then Merle and Manny and I used to go everywhere together. We were *very*, *very* close.

MANNY: He never thought I was *good enough* for her. And the shop was his whole life. The oil. The machines. The same thing over and over. I didn't like it. I felt enclosed. When the war ended, I was glad to get out.

I had a friend who was a locksmith. He came to me, and he says, "Manny, there are two key shops for sale. Both of them are *good* money-makers. I'd like to buy them. You want to come in on it?" I went to my Uncle Earl to borrow money for my share. He says, "How much do you need?" Just like that! Never asked me when are you going to pay it back. *Never* asked me.

So, I bought one of the shops. And when I went down there, I was very disappointed. It was a little shack. No running water. No *nothing*. But, my friend says, "This place is a money-maker." So I bought it. And *it was*. It was a *good* money-maker. Within a year, I had two people working for me.

We was doing *real*, *real* good . . . Then we moved into another place. Stayed eight years. We made a living. Then we moved again. But the guys in the shop kept emptying the till when I wasn't there. They'd keep on cleaning me out! It wasn't paying, so we closed it down. 'Cause somebody had sold me a bill of goods to go into the "insurance business." Well—my idea of going into the insurance business was having an agency and going out, selling life insurance and this and that. I was thinking of an agency, but what I got was a debit. A debit is where you have a book with so many names in there, and you go in once a week, to these different places, and you collect so much on the insurance. A dollar. Two dollars. And in the meanwhile, you try to sell them *very cheap* insurance. And most of this was in the ghetto. And most of this stuff, you had to work evenings. Nighttime collections. Because people were working. In order to *see* them you had to come after 4 o'clock and work till 9 or 10 o'clock at night. Well—*you* work 9 or 10 o'clock in a black neighborhood! You have to walk this stuff. You have to walk back into little alleys to find these people. And they always have an excuse for you.

Well, I'll tell you. I was *stuck*. Didn't know what to do. The *worst* year of my life. I was as close to a nervous breakdown as any man could possibly be. I used to come home at night, and [softly] I used to actually sit down and *cry*. Actually sit and . . . And I was *not* making any money. *Absolutely* was not! I couldn't take care of my family. I was 50 years old.

I tell you. I've had bad times in my life. But *never* [quietly] did I go under such pressure or tension. Because my family is so important to me. I couldn't buy them a pair of shoes; I couldn't pay my mortgage! I couldn't pay nothing! I was making *nothing*. I worked hard!

I used to come home with trophies! Because I sold so much insurance. But I wasn't making any money!

One time, it was about 9:30 at night, and I was in a dead-end street. And it was *snowing*. It was *cold*. And I pull up in my car. And, I see three fellows standing across the street. "Hey! Inshowance man! We need some inshowance!" Here it's 9:30 at night. And I can't even sell them insurance in a house! Here's people standing outside, calling me to sell them insurance! I said to myself, "This doesn't look too good." I said, "I'll be right over." I dashed into my car, locked the door, and turned around. And—you think they didn't come running after me? They *sure* wanted insurance!

So. I just quit. I took out an ad in the phone book under "locksmith," and we worked from the house. I used to get up in the morning, get my tools, get in my car, and go to the apartment houses. Find the custodians. [Quietly] Rap on the door. Say, "I'm a locksmith. Here's my card. Do you have any work that needs to be done?" I did this all day. A little bit here, a little bit there. And then a couple of calls started to come in. Little bit. Little bit. Little bit.

My personality changed. I found that if I could sell *myself*, if they liked *me*, there was no problem. I gradually calmed down, calmed down, calmed down.

I made them feel, "Here's a man I can trust!" People get locks for protection, like they buy insurance. Ninety-nine percent of my customers are women. I've gotten propositioned. A lot of service men do. Young women are alone. I'm not quite sure what their marital status is. They let you know in a roundabout way that they're interested, if you let them know. But I tell them, "No thanks. I got a family. I got a wife! What do I need? Whatever I can get here, I can get at home!"

If it's a choice between love and money, I would choose love. That's the reason I'm not a rich man today. Money has never meant that

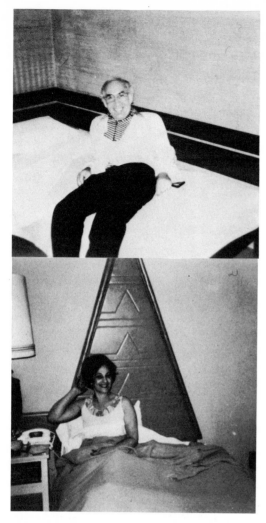

me when I was young . . . If Merle, in the shop, would have paid any attention to me. At all! Said, "Manny. Look. You're doing a nice job. You're running the whole thing." Show me *some respect*. Show me that I'm doing good. Tell me, one time, that "You're doing a good job." One time.

If I just would have had somebody to say, "Manny, follow this path," I think I could have been, as people call it, a "successful man"! Whether I would have been a dentist or a rabbi or whatever, I just feel the talent. I just *have* it! I just feel it in me. It's *too late now* for me.

If I could have had my life to live over again—there's so much I would do different. But—I'm not ashamed. I just feel bad for myself because I could have done so much more with my life. And I think I could have earned *the respect more* of people.

I always felt that my wife never had that strong desire, that strong, deep feeling of love towards me. She's not as passionate—I don't

mean sexually. I have a strong feeling for *love*. I like to be *close*. I like to *feel*. I like to *touch*. She does too. At certain times. But she isn't the demonstrative type. She doesn't show it as much as I would. Or as somebody else may. She's just more reserved. And I got to respect that. But sometimes I feel, "Jimminey! Honey! Come on, hug me. And kiss me. And sit on my lap!" This is the way I feel. I want that. This is what I miss. But this is how I feel. And I love my wife. And she loves me, very, very much. It's so important to have that feeling of "Boy! I finally, finally *belong*."

much to me. It's good to have. It's great to use. But I would rather have *deep love* than money.

I wanted a *home*. *I did!* I wanted a home that I never had. I wanted somebody to *care* for me. I wanted something that *belongs to me! My* home. *My* wife. *My* kid. To have somebody—see, I never had it! *I never had a home!* I had no one to tell me, "Manny, why don't you do this." Nobody to lead me. No path to go. If I would have had somebody to guide

MARILYN: There were eight of us, you know. I was in the middle. There was Lilly, Merle, Faith, and me. And then there was Bernie, Jerry, Jackie. And my brother Teddie, who got killed. He was just 9. And then there was my Uncle Mendel and my grandmother.

I was born in 1915, and I remember my father, in a horse and wagon, driving along the railroad tracks. And Merle and I throwing fruit at some soldiers. So they could catch it and eat it. At the end of the war. I don't know if they were starving or not. All I know is that my father said, "Here. Throw it to the soldiers." And we threw.

Merle and I were really the mainstay of the family. My mother did the cooking. My grandmother did the mending. And Merle and I did everything else in the house. Because, my father was a bootlegger.

It was nothing unusual. There were three ways of making a living: you were either a bootlegger, or you had some type of little store like Manny's grandparents, or you peddled up and down the street. That's the kind of living people from Europe made.

My father was a bootlegger. They used to make it themselves. They had some type of a garage or some type of a building where they used to make the *mash*. For the liquor. After that, I think he bought it. And we used to sell it out of our house. People around the neighborhood used to buy it. It was illegal. So it was sold in the houses. By bootleggers like us.

We used to have a little chain on the door. And—if somebody wanted to come in to buy a drink—they would knock. And my grandmother or I or Merle would say, "Who's there?" And they would tell us. If we didn't know the name, we would open the door part way, from that little chain, and we would see who it was, and

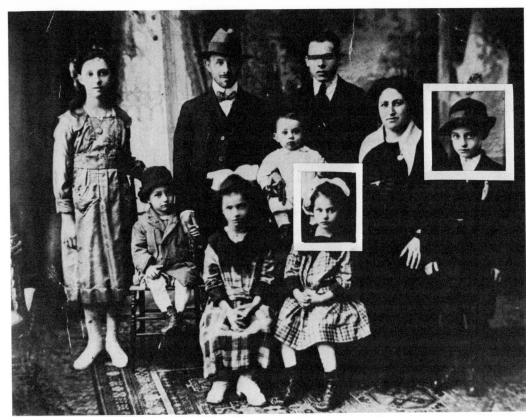

if we thought it was somebody who needed a drink, or wasn't the policeman, we'd let him in and give him a shot. Everybody needed a drink. Everybody. Everybody except the people who sold it—maybe. It *seemed* like we were *busy*. And, you know, I was 5 years old.

We moved about then. The neighborhood started changing. Colored people started *moving in*, and my mother was *afraid*, especially when the girls were walking to the school. So we moved.

When I went to kindergarten, nobody wanted to play with me. Even though their fathers may have been bootleggers, they didn't know about it. But *they knew* about my father. I was called the bootlegger's daughter. I was ashamed.

We had problems. One bootlegger would squeal on another. A lot of people were jealous. Or they wanted the business. My grandmother used to wear a big, long apron with square pockets. And she used to have a pint in *each pocket*. When somebody would come in the door and we'd let them in, she would take out the pint and fill them up a shot. We used to have a five-gallon jug for refills. Standing in the bathroom. If we thought there was somebody at the door that was a cop, my grandmother or I or Merle would run into the bathroom and dump the jug in the toilet. So there was no evidence.

I didn't like it. If I wanted to walk in the house, I had to knock on the door, then

somebody had to open it, look through the chain, and see who I was, when I came home from school. All I wanted was to just *open* the door and *walk* in the house and *be* like everybody else.

Merle and I used to deliver. Liquor. To another bootlegger. Five-gallon jugs, wrapped in burlap, in a little wagon. We used to cover it up with a blanket. I was 4. Merle was 8. We were a team.

One time, my father was squealed on. And he had to run away. We had to move to the edge of town, where the streets weren't paved. All of us. That's where we hid out. My father used to come in at night to see my mother. Through an open window. And it was an all-gentile neighborhood. And, when I went to school and had to stay out for a Jewish holiday, there was no excuse. And *the kids wouldn't dance with me*. I was *always left sitting there*.

When the heat was off, we moved back to town. I used to keep watch for my father. So the police wouldn't get him. My father and I were great pals. He *loved* his sons. He loved them dearly. But *I* was next. When he stopped bootlegging, I used to go with him, every morning, down to the market to buy produce. Then we'd come home. My mother would make our breakfast. We would set up his truck, and then go up and down the streets. Selling apples and potatoes. Together.

I did all the chores in the house. I was the maid! I *was!* I never minded it. My mother was the matriarch. If my mother said, you *had* to do *this*, there was no *question. I did it*. I cleaned and washed and ironed for four brothers and sisters. And I didn't resent it. This was the way it was.

I was 17 when I met Manny. And I didn't get married until I was 22. We were desperate for marriage. But we couldn't afford it. *Besides*

that! My mother wouldn't *let* me get married! Because my oldest sister wasn't married. It was an evil omen. If the oldest girl wasn't married first, then the rest wouldn't get married.

Then—Thank God!—my sister got married. And the rest—you know—it's been wonderful. We've had a wonderful life together.

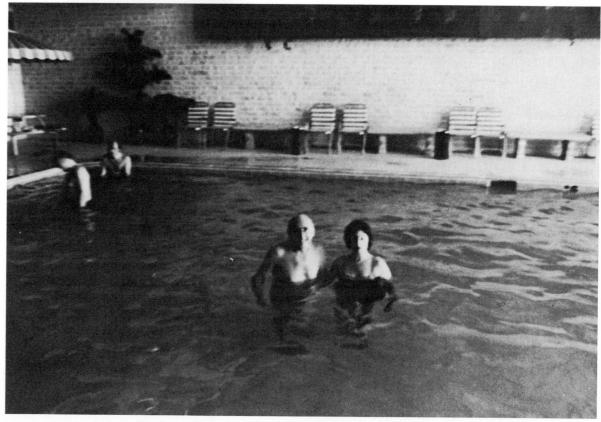

Herb and Lin

HERB: I was born here in Buffalo, May 19, 1926. That makes me a Taurus, Taurus the bull. I don't know what it means.

My father was born in Yugoslavia when it was part of the Austro-Hungarian Empire. My mother was born in Minnesota. I don't know how they met. I never knew my father and I guess there's a good reason. He lived away from the family. All my early memories are bad. The family was split. Three of us brothers and no father. We saw him once in a while when the visiting day was arranged. I was told he was nothing but bad. An alcoholic. I never saw him that way, though. My grandmother, my mother's mother, had a lot to do with the problem.

I once met my father on Christmas Eve. I think I was 7. We got on a streetcar at the end of the line, where it turned around. There was a bar there. And I saw two guys fighting. I couldn't believe it! On Christmas Eve! To drink and become uncontrollable on a day of that import! I said, "Boy! I will never get like that."

My mother was a cleaning lady at a school. It was a survival situation. If you got an orange at Christmas, you were fortunate. A pair of shoes had to last three years. The Red Cross helped us. When I was 15, my father died. He was 41.

LIN: It's funny how our stories are a lot alike.

HERB: We're both introverts. We both had a hard, sheltered life.

LIN: I was born in 1928. In July. My mother was Polish. My father was Italian. They were both born here. My father worked in the steel mills. He got blasted once.

HERB: Almost blown out of the place.

LIN: It just exploded. Someone overloaded the furnace. He was seriously burned. And we had to go on welfare. I can remember walking my little wooden wagon, going and

Remembrance of first Holy Communion

getting cornmeal.

HERB: I pulled a wagon, too, because I was the littlest boy. And, hey, I walked five miles. Somebody had to go or we didn't eat.

LIN: My father never went back to the mill. He became a commercial landscaper. He did hospitals.

HERB: He had some road jobs. I even worked with him sometimes. I loved it. He was a heck of a guy. Everybody liked him.

LIN: But, the thing was, my mother and father had problems. Marital problems. They were separated for a while. I remember them arguing. A great deal. I always wondered if it wasn't because they lived with my mother's parents. My mother was an only child. She never left home, until her parents died.

I was 6 and I remember my father meeting me after school to take me for an ice cream cone *before* I came home. Because he was not permitted to see me. He turned out to be an alcoholic. And he didn't straighten himself out until just before he passed away. It started when he was working in the mill. I think it was because he was living with his in-laws. That really wasn't what he wanted.

He'd come home intoxicated, and if my mother left him alone, everything was fine. But if she started to nit-pick him, he became violent.

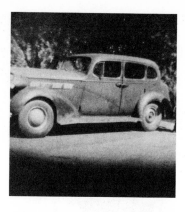

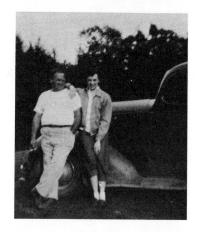

It was a sad time for me because I was so much closer to him than to my mother. I don't know why. Maybe because I felt deep down that he was being rejected. I sensed it. It was sad. I was sad. My mother was very domineering. Very. Very. I couldn't do anything on my own. I couldn't think on my own. Whatever she told me to do, I did. From the time I was 5 till I was 40. That was bad.

HERB: I *lived* for baseball. I played shortstop or third. From when I was 5 until I was 45. When I was very young, I found out I was a very competitive person. I was marbles champion. Then basketball in the backyard. Then baseball. By the time I was 5, I was playing ball with adults. I was fast and I could hit.

Then in junior high, I told the coach that I played shortstop. I never played shortstop in my life. He put me through a routine where I found out: number one, I couldn't field a hot grounder; and number two, I went out for a pop fly in short left field and there was a running track. I dove for the ball and I still got a scar on my arm where I hit the cinders. As inauspicious a debut as you ever saw. After the first day, the coach said, "You will never play shortstop or infield." And I said, "Oh, yes, I will." And that year I made the team as shortstop. I played infield the rest of my life. And that was a lot of years. It shows you the power of the mind. If you make up your mind you're going to do something, no matter how badly you start, if you work at it, you can do it.

I played in high school, and in college, and when I got out of the service, this was in 1947 or '48, I had this piece of paper in front of me from the Boston Braves. For $150 a month, in their farm team, up in South Dakota. Eating hamburgers and living off a bus. I'd played with a bunch of guys who'd gone into the minor

leagues and burnt out their arms and come back ruined in one fashion or another.

So I thought, "Well, that's my ambition." But I just didn't think I was big enough to play professionally. I had a good arm, but I didn't have the inches. And those guys slept in bad places. Or they didn't sleep at all. It was a second-rate way of going. And there was financial considerations at home. So I weighed it all and I said, "No, I don't think I want to do that." I got to my boyhood ambition, and I reconsidered.

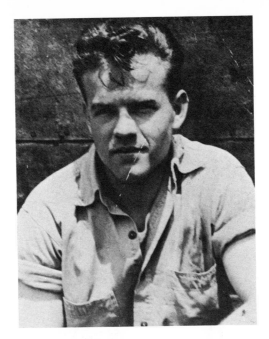

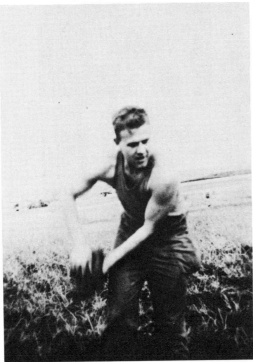

I graduated high school in '44 and went to work in a defense plant. In a machine shop. I had a defective eye, so I had to put a little pressure on to get drafted. I got in late, in '45. Into the air force. I'd studied aeronautical engineering in high school, so, with my bad eye, they put me in radio communications. We ended up on the Aleutian Islands. On the last island in the chain, with a direction finder and the longest airstrip in the world. We told the pilots where they were at. We had to guide the guys in. We used to lose a lot of pilots up there. The winds would actually curl the metal runways. A wind of 130 mph wasn't unusual. If you didn't bring them in rather accurately, they'd get blown off course and land in the water. It was the Arctic Ocean up there. They'd freeze to death in fifteen minutes. Or they'd go off the runway and land in the cemetery.

When I got out, I went back to work where I started.

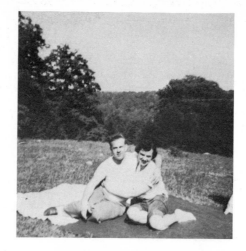

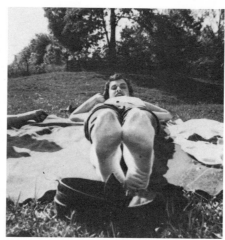

LIN: I was working in the same place. That's where we met. He was my first and only love.

HERB: We went out for three years and we got married. In 1950. The first wedding ever in the Croatian Hall. We had eight hundred people. Tons of food and drink and a polka band. We had a few brawls, I recall. Basically Polish. Stuffed cabbage and wedding soup and roast chicken and plenty to drink.

LIN: We had a lovely wedding. And a lovely honeymoon.

HERB: We went on our honeymoon and then my brother, who was an electrical engineer *and* a manufacturer's representative, told me that *that* was the place to be. I was lucky. I met a manufacturer's rep who'd just started out and needed some help. He needed a secretary. So that's where I started.

Three years later, my boss drowned and I ended up with the business because there was no one else. He'd been a commodore of the yacht club, and he had total confidence in his sailing ability. Our business was good, so he bought a power boat. Which is a lot different from a sailboat. One day he had a little bit too much to drink and he took the boat out. Everyone told him not to. The boat came back, but he didn't. That was 1953.

The trouble was that his contacts were *his* contacts. We were engineering consultants; we sold equipment to the forging industry and the casting industry; we sold dies and finishing equipment. And we sold machine-tool rebuilding. Which was *great* during the Korean War, but the war ended, he died, and all the work just dried up.

So I ended up in a forge shop on salary. I was an aircraft specialist. We were making jet turbine blades and rotors out of high-temperature alloys. Highly sophisticated stuff. We even forged pure tungsten, which had never been done before. We were involved with aerospace developments. Rocket applications.

I was there four years, and then I went with *what I thought* was a real fast-moving company, on its way up. They had their own steel mill and their own forge shop and they got me involved, *deep*, in the nuclear business. Which is where I ended up with a *real* sad case of ulcers. To start with, I had a boss, a vice-president of sales, who felt that if he pushed and ridiculed me enough, I would become more productive. I was supposed to be a Big Man with confidence, but at every sales meeting, all he did was cut me down.

Then there was Admiral Rickover. He was one of the most antagonistic people there ever was. He got my company into the navy's nuclear program. And he drove us to ulcers. At least half the people I worked with had ulcers. Major contractors and small guys, suppliers like us. We all had to deal directly with Rickover. If there was a problem, *he* got on the phone.

We were making 3500-pound valve bodies out of stainless steel for his program. For nuclear submarines. Stainless steel is pretty tough stuff. To forge it, we had to heat it up to 2400 degrees. So, some of our people decided to add a little bit of boron to the steel to improve its forgeability. The only trouble was, they never considered if it could be welded. And if you can't weld, you can't fit flanges; and if you can't fit pipe, you can't construct a nuclear system.

We found out that by adding one-tenth of 1 percent of boron to our steel, we'd made it non-weldable. Not just non-weldable but not safe. And that's the one thing that was *central* to Rickover. I had three days of grief, and then I passed out on the floor. My ulcers were bleeding. I didn't even know I had them. That same night, the man I was with, from my company, had a heart attack. That same night!

Then, about a month and a half later, the

Thresher went down and never came back up. That was one of our nuclear submarines. And Rickover said that *everybody*, including us, was at fault. That's when I decided to get out.

I quit in May of '63 and had two-thirds of my stomach removed in November. I had two months, resting up at home, to think things over. Where I'd been. And where I wanted to go. I wanted to become a manufacturer's rep again. So I did. I went to work with a friend and spent three years telling him what he was doing wrong. So I left him and went out on my own. That was about '67. That's when we built this house. I hadn't made any real money yet, but I decided, "Man, I want that house; I'm going to build it, and by God, I'm going to get the money to pay for it!"

Lin and I always talk things over. She knows all about my business. I tell her too much, probably. An eight- or ten-hour day becomes fifteen minutes of conversation with her. You can't say everything, but I've always been

ridiculed for telling my wife *anything* about business. By other reps or other salesmen or company owners. They say don't take it home with you and don't tell your wife anything. Since I've been out on my own, I've had two partners who both did me in to their total satisfaction. We'd split fifty/fifty but it was really ninety/ten in their favor. They'd just sit and watch me. Lin has come to the point, now, where she says, "DO NOT TRUST ANY-BODY."

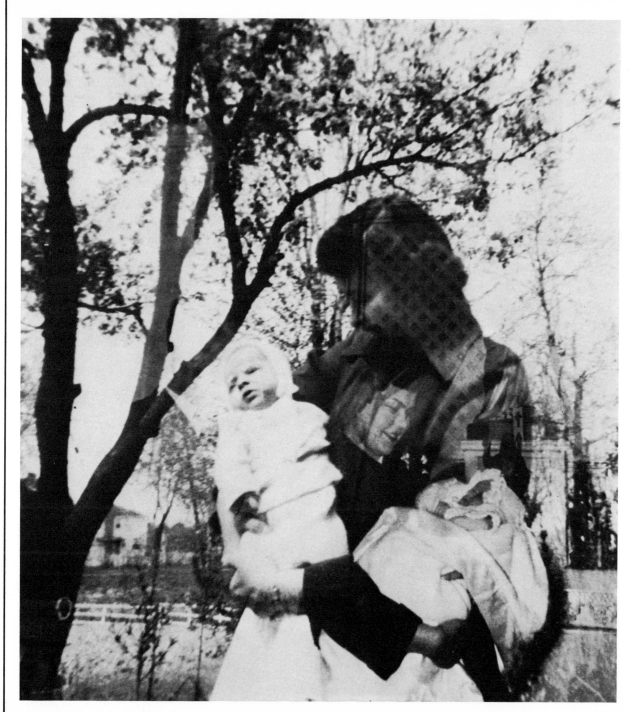

LIN: Herb always traveled a great deal. He'd leave on Sunday night and return home on Friday evening. But we always had Family Night on Saturday. And then he'd go out of town on Sunday. So basically, I was with the children all of the time. I was mother *and* father for at least fifteen years. All the while we lived in our first house. It was difficult. It was difficult because most of the neighbors there thought it was great to be alone and not to have to cook a big dinner when your husband gets home at 5 o'clock. They used to envy me. But it was very depressing not to have Herb around and to be both father and mother when something happened at school or the children were sick. Problems came up, I had to make decisions. I really was on my own all the time. Herb was never around. But we had a good marriage. I had a lot of trust and understanding.

There was real brotherly-sisterly love between the children. Kay had a little trouble in high school. She got in with the wrong crowd and dropped out. But she's doing fine now. She's working at the Hunt Club; she's the groom of a champion jumper. And Dick [HERB: "I always called him 'Sunny Dick.' He always had a smile!"] is teaching the Bible and getting his pilot's license. The kids helped each other a lot. Even today, if they have a problem, they'll talk to each other before they take it to Mom and Dad. I like that.

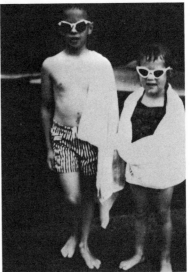

Since I didn't see Herb very much, when I did see him, I appreciated him more. And *vice versa*. I think that really works out quite well. He'd come home on Friday evening and we'd really have a nice dinner, and then Saturday, we always did something with the children. We always gave them their choice of what we should do. What games we should play. It worked out well.

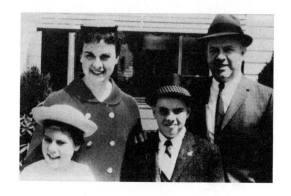

Richard was 12 and Kay was 9 when Herb had his operation. It was a very difficult time. Very difficult. My father got sick. He was sick exactly six months, and he died. Of cancer. Stomach. It was a very trying time for me because I was very close to him. It was Christmas just before he died. I remember coming home from the hospital very depressed. Cancer. Thinking how many more days would we travel in there to see him die. He was really in a lot of pain. And I started to put up the Christmas tree all by myself that day.

HERB: We had it tough when we started. We started with nothing. And we lived with her parents. Bought a home jointly with them in one case. It didn't work out at all. So we made up our mind, we're going to have our own place or nothing. We had to borrow money and pay it back, along with all the day-to-day bills. It was tough, but we pushed together. We bought a nice little home. It was small, but it was well planned and it was very sound. We

lived there fifteen years. It was *hard* to leave that home. Then I decided we were going to move out of the city. And build this house. This is a copy of a 200-year-old house in Rhode Island. It's not bad, but, for instance, it should *not* have carpet on the floor. It should have wide planking. We're thinking of selling it and building a smaller home with everything in it even more Early American, the way we want it.

Lin and I have been interested in Early American for a long time. We started taking the kids to Williamsburg when Richard was 9. The eighteenth-century pieces we own mean something to us. They're not just investments. They

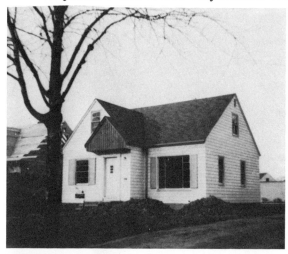

mean security. They mean extreme craftsmanship. They have charm. I don't like plastic things. I don't like contemporary-looking things. I like solidarity and longevity. I think we're more proud of our American heritage than anything else. Should we have Polish or Italian furniture? I think we're Americans. I *know* we are.

Frank and Cathy

FRANK: My grandfather, when he came from Sicily, was supposed to go to Rochester, New York. But he ended up in Rochester, Pennsylvania. He had cousins that lived in Rochester, New York, so he was supposed to go there. But he ended up in Pennsylvania.

CATHY: They were foreign. They didn't understand.

FRANK: They were foreigners, couldn't understand, so the first stop was Rochester, and that's where they got off. In the wrong state.

It's a small town. One side of the bridge is Rochester. The other side is Menaca. They ended up in Menaca. It was a steel mill. Joseph Lockwood Steel. Twenty-five miles west of Pittsburgh. It's a small town.

CATHY: A nice small town.

FRANK: And then we lived fifteen of us in the house. My grandmother, my grandfather, and my aunts and uncles. All lived in the same house. A duplex. Side by side. The boys slept in the attic. There were five of us in the attic. And there were—what?—five girls in one room.

CATHY: The interesting thing was that his mother and his grandmother were having children at the same time.

FRANK: My uncles.

CATHY: He has aunts and uncles that are five or six months older than he.

FRANK: My grandfather worked for the railroad. He was making 40 cents an hour. A laborer. Putting tracks on the railroad.

He was an odd guy. He said he had an "in" with the Devil.

CATHY: His grandfather was shot to death over a 30-year-old woman.

FRANK: Yeah. Well. Like I said. He worked on the railroad. He had varicose veins so bad, I remember he used to wrap his legs with the cloth. And he got hurt on the railroad one time

and they told him he was finished. He was a strong man. He said, to show them how strong he was, give him a pop bottle and he busted it with his teeth. He used to drive my grandmother bananas. He'd make about 40 cents an hour on the railroad and then wear suits with spats and a cane and a white hat . . . "

CATHY: He was neat . . . white gloves . . . He was a real dude, a real dude.

FRANK: He was a dude. And he had the mustache, you know, he would dye the mustache black and he'd have a stick pin. He'd go to the jewelry store and he'd buy a stick pin. My dad and him used to argue like crazy because he'd spend all his money for clothes. That's the reason we lived fifteen in a house.

My grandfather claimed, when it used to lightning and thunder outside, he used to go play the guitar on the porch and he said he was playing for the Devil. And he used to get snakes. And he'd pull the fangs out and put them in his shirt, and let them go around his body.

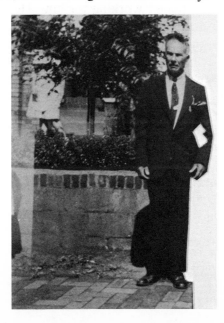

Then, when my grandmother died, he refused to live with my dad and mother. He lived with my aunt for a while, and then he left there and he wouldn't live with no one.

When he got up in the morning for breakfast you used to have to bring a bowl of coffee and he used to dunk the bread in it. That was his breakfast. And you had to say "Good Morning" to him when you got up in the morning and "Good Night" when you went to bed.

CATHY: *To him.* And they used to have to say it *in Italian* to him. He demanded *respect.* He did. He *commanded.*

FRANK: When he wouldn't stay with none of his children, he moved in this house with this guy and they had a girl in there and they used to fight who was going to sleep with the girl. And he was about 72 years old then.

CATHY: They were both very old men. She was 30 years old and they used to take turns with her in bed. And they used to sleep in the same bed, the three of them. They used to put an ironing board between them. [Laughs]

FRANK: And then they claim my grandfather pulled a knife on this guy and the guy turned around and shot him. The guy got six months in jail.

CATHY: And his grandfather went to the Devil.

FRANK: He said he would live by the Devil and die by the Devil. He said he would never die a natural death.

CATHY: Of course, it was a scandal.

FRANK: He was as strong as a bull. Boy, he used to drive those spikes.

CATHY: Frank's father was the opposite. His pants would be real baggy. The jacket would be a different color from the pants and . . .

FRANK: He just didn't care for clothes. He was a bricklayer. He belonged to the Lockwood Steel Corporation.

CATHY: And he worked in those big furnaces.

FRANK: The ovens. Where they heat the steel. They used to put a wet sack over him and soak his clothes. He'd go in for only a couple of minutes at a time. He'd patch the furnaces while they were hot. With bricks. This one time he had to go on top of the furnace and some gas escaped; he passed out. Someone got him and brought him down.

He was a bricklayer for forty years.

CATHY: Never missed a day. Just a marvelous, kind, beautiful man. Hard-working and very devoted to his family and just a wonderful, wonderful man.

FRANK: I seen him drunk one time. Not drunk but feeling good.

See, my mother and father and my grandfather . . .

CATHY: They lived together for *years and years and years*.

FRANK: My folks slept in the living room. There was three rooms downstairs. Our family ate in the dining room because there was nine of us. My grandmother and grandfather and his family, which was three girls and one boy, slept and ate in the kitchen, 'cause the kitchen, well, the kitchens then, sometimes, were pretty nice-sized. The upstairs was two bedrooms. My grandmother and grandfather occupied the one bedroom. And the girls were in the other bedroom. And the boys had the attic. We slept up there. We didn't have no heat or nothing. Cold, oh my God. [Laughs]

My dad did the best he could. He worked pretty steady, but then the Depression come and that just about finished the steel. So we went on relief. I remember them taking us a box of food. Mostly you used to get powdered eggs, and beans, dried beans, and that lunch meat they grind up . . . But we had a couple of gardens. And that's how we made it. We used to grow corn. And my dad got a little work on the side. He did everything he could.

CATHY: Now *my* father was a different story. My father was married to my mother for thirty years, and the only thing I remember about my childhood is that my father was very strict and mean. He drank. And my mother was only 14 years old when she married him. She and my aunt. The two of them were both 14 years old when they got married. And I can remember my aunt telling me after the husbands would go to work in the morning, the two sisters-in-law would play with dolls or . . . they would play house. *They were children!* My mother had her first child when she was 16, and she had six of us within ten years time. She had six children by the time she was 36 years old.

My father was always kind of a showoffy man. He always wanted to live like a millionaire or tried to impress people that he was "in business" or that he had his sons-in-law working or somebody else working for him. He had a beer garden. He drank . . .

All I know was that my father was born in Italy. My mother was born in this country. He came here as a young boy. He met my mother and they had three children, and then he went back to the old country so his family could meet my mother. And at that point, my aunt said my mother was such a beautiful woman that when she got off the boat everybody thought she was the queen. She was absolutely beautiful. When they got there, the police nabbed him 'cause he was an Italian citizen and had to serve in the army.

They were there for three years. Fran and I were born there. That gave him a total of five children. He tried to leave us there. He tried to leave my mother and the five children there. But my mother was an American citizen, so he couldn't leave her. He was forced to bring us all back. To Rochester, Pennsylvania, near my grandmother.

FRANK: See, I've known her since we were kids. Her parents and my parents came from the same hometown in Italy. My dad and her dad were the best of friends. Most of her mother's side was living in Rochester, and her family and mine used to visit back and forth.

CATHY: Then, I don't know what the reason was, I don't know why, but he moved us to Buffalo. He never did plant roots anyplace. He went from job to job. And then my mother always had boarders in the house. We were never without food. We were very poor. And, every summer, I used to go and visit my grandmother in Rochester.

FRANK: So one day I seen her walking across the bridge. I was going from Rochester to Menaca and I seen her. So I turned around and I picked her up . . .

CATHY: That was it! I WAS A PICKUP!

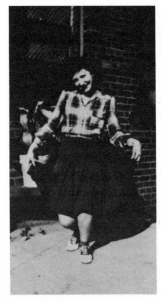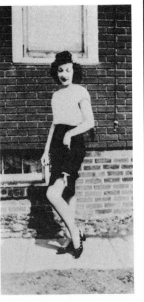

FRANK: Then we dated each other for a while. We was going steady. Well, you know from Buffalo to Menaca, that was a long way off for us kids. Thousands of miles. We was 16. You know, if you went to Buffalo, you figure you was going to Europe, actually . . . Like stepping off the edge of the world!

CATHY: It was.

FRANK: Then I got drafted. And I was in the navy and I seen her address in my billfold and I wrote to her and she didn't answer and I figured . . .

CATHY: I was playing hard to get.

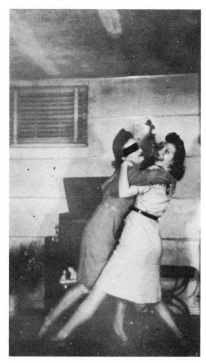

FRANK: I had the wrong address. So I wrote again. And she answered . . . And I said my brother is getting married. Are you going to go to the wedding? I was still in the service, but we started going together and six months later we were married.

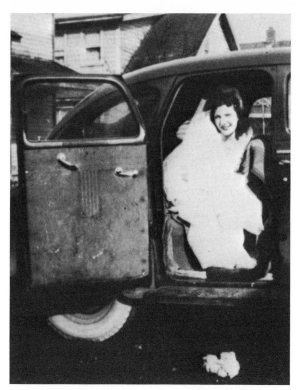

I was drafted in '43 and got a notice to go to Pittsburgh. I was 18 years old. I never been away from home. We was all close. I think that was the first time I ever been in Pittsburgh. And Pittsburgh was only twenty-four miles away! I got out of high school, I worked six months in the steel, and I got drafted.

We got to Pittsburgh. And we was walking through these corridors, naked, everybody's naked. Nobody has any clothes on. And you get your examination and you got a navy man, there, a marine man, an army man. Join the army, join the navy. They was trying to talk you into joining their outfit . . . The guy asks me, "Navy or marines?" I says, "How about the army?" He says, "Navy or marines?" I says, "Oh, my God." I don't know how to swim. I said, "If I go in the navy, I'll drown."

So then I says, "Well I'll go to the marines." I sat down. As I said, I was stark naked. And I says, "Marines, that's rough." So I went back to the guy and I says, "How about changing that to navy?" He looked at me and he says, "I shouldn't." I says, "Well." He says, "Okay, navy." I was surprised they did it for me . . . And that's the first time I was ever away from home by myself.

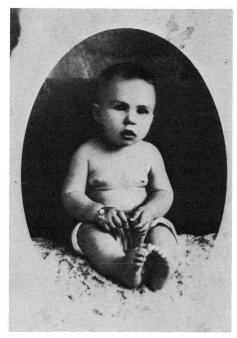

I went to boot camp in Sampson, New York. Walter Winchell said that that was the hellhole of the world. It was. All you did was train. They taught you how to swim. You had to swim fifty feet. That's in case if the ship sinks, it won't drag you under. After that you go on this board, it's about thirty feet high, and you got to jump off. We had one guy that was afraid of water. He was crying; he was calling for his mother. Something must have happened in his earlier age. He cried . . .

I didn't complain. I did what they wanted me to. I figured it didn't do any good to complain. I had to do it and I did it. I enjoyed it.

They had more men than they actually needed on the ships. So they wanted to know if anybody knew how to drive a truck. So I said, "Yeah, I know how to drive a truck"; so I ended up in transportation. I drove a truck about a week.

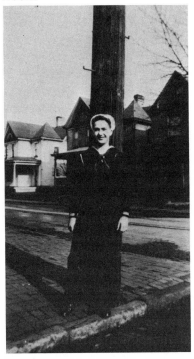

I got married on a three-day pass. We canceled our marriage three times on account of every time we was supposed to get married, her mother went into the hospital. So the third time she says don't cancel. So I have to ask her father . . . So I went up to him, and I says, "Cathy and I want to get married"; and he says, "Well, can you support her the way she's been living?" [Laughs] I says, "Well, I'm making $66 a month." Navy pay.

CATHY: He was so happy to get rid of me, honey, if you were on welfare he would have said O.K.
FRANK: Her mother threw us a little wedding. We got a little money as gifts. And we blew it all in Norfolk in six months.
CATHY: Sure. We went out and had a good time.
FRANK: We spent $50 at a carnival trying to win a $5 radio.
CATHY: Teddy bear.

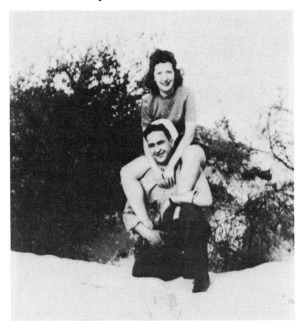

FRANK: You know, you're young. You've got $500 in your pocket. That was a lot of money.
CATHY: We lived in Virginia Beach.
FRANK: There was like six cottages, three on each side of the roadway, and we lived in one of them . . .
CATHY: The one couple that we shared it with had been married eleven years, and she had never been able to get pregnant. She'd tried everything. Had every test. Gone to every doctor. The month they came to live with us, she got pregnant. It was the change of air.
FRANK: Well, anyway, we were living together for six months, and Cathy got pregnant. And then her mother died.

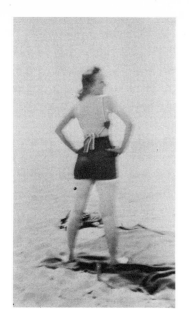

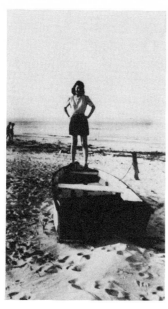

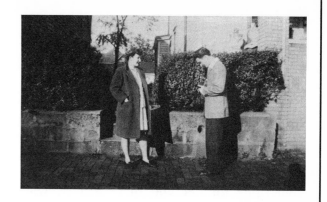

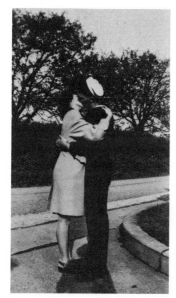

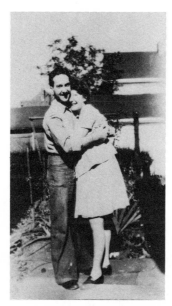

CATHY: I wanted to be with my family when the baby was born, so *I* came home before Frank was discharged. I came back to Buffalo and then when Frank was discharged he came to Buffalo and started working at General Electric.

FRANK: I been there ever since. Thirty-two years.

CATHY: In the meantime, my father married a second time. And she was a real . . .

FRANK: Humdinger.

CATHY: He married six months after my mother died.

FRANK: My father-in-law had this beer joint, beer garden, and right behind it was a house. It was a three-story house. He was living by himself, so we decided we'd live with him.

CATHY: To take care of him. We also needed a place to live. We couldn't find anywhere else. There wasn't anyplace to rent.

FRANK: I paid the rent. I bought the food. I paid the electric, gas, and water. She cooked for him. And he thought he was doing *us* a favor.

CATHY: Then he got mixed up with this woman.

FRANK: She just came out of the woodwork.

CATHY: She wasn't born. She just happened. Really.

FRANK: She was bad news.

CATHY: She was. She admitted very, very plain to us that she was . . .

FRANK: Out to get what she could.

CATHY: Because he beat her and everything. And I can remember one time he threw her out of the house and she slept out in the cold in February . . . He treated her very bad, but she stuck it out because she knew that in the event he died first, there was going to be something for her and that's exactly what happened.

When he became involved with her, he wanted us out of the house *so bad*, he would—the only way my father could tell you anything was if he got drunk and then his tongue would get loose. Otherwise, he was never the type of man that would sit down and talk to you, like say, "Look, I want to get married and I want the house; you're just going to have to leave." He couldn't do it.

FRANK: He used to wake me up. And we both was up and we starts talking. He starts talking about the stars and everything. He'd always be loaded. He couldn't sit down and be sober and talk to you.

What happened, we was living with him downstairs, and we would go out of town and this woman would come in with her daughter. They would eat all our food. She would make phone calls on my phone bill and—my wife had some luggage she got as a gift—she turned around and sold the luggage to her daughter and some friend of hers. Finally, I had an argument with him. I said, "I don't want nobody in this house when I'm gone." I says, "I'm paying you rent"; I says, "I'm paying for everything"; I says, "I don't want anybody in this house that don't belong here." So he threw us out of the house.

Then I went back. I said I want my wife's luggage back. I said, "I'm coming to get it tonight." He said, "Okay, come and get it. I'll have it for you." So we walked over, I knocked on the door, I said, "Where's the luggage?" He threw it out on the porch and he slammed the door in my face. I pushed the door back and I said, "You're not going to slam no door in my face." Meantime, my wife left a box of Kotex there, so she got this big box of Kotex, I grabbed it for her, she'd left it in the bathroom. So I give it to her. But when I was pushing the door, I pushed him and knocked him on the floor. So he comes out with a shotgun. He comes after us . . .

CATHY: He chases us down the street, and me with this big box of Kotex. [Laughing] . . . And he's after us with a shotgun. [More laughing]

FRANK: Finally, he got married again. And he mellowed out. So we moved back into his upstairs. For $25 a month. See, I was only making $1.25 an hour, $40 a week. We couldn't afford anywhere else. We stayed there for three or four years and saved enough to make a down payment on a little house.

CATHY: I started working at Fisher body. Assembling car doors. Very hard work. I worked night shift and Frank worked day shift, so we didn't have to have a baby-sitter.

FRANK: I used to hitch to work. We couldn't even afford to pay for streetcars.

CATHY: I worked at Fisher body for five years. Second shift. Until things got bad. Things got very bad. I don't know why. And they eliminated my shift. I could have gone on day shift,

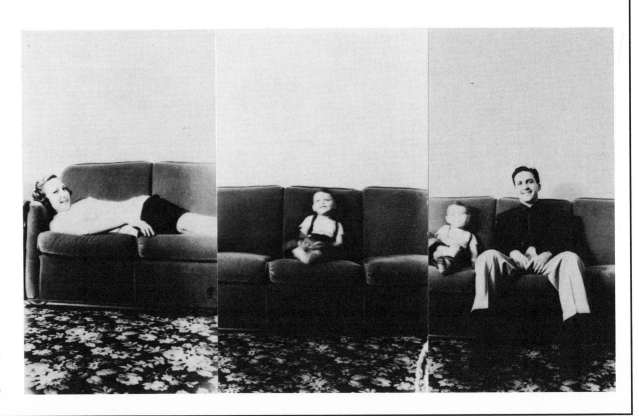

but I had no one to leave my boy with. He was 5. I couldn't leave him, so I quit.

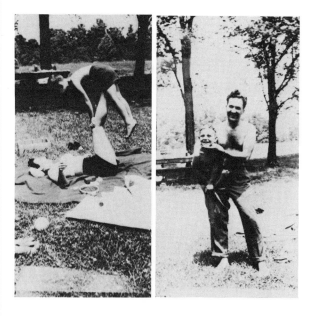

Then I worked third shift at Westinghouse. Like I say, I never wanted to leave my boy alone, unattended or with a stranger. So, I worked there for three months. A very short time. I quit before they could fire me. I would be so exhausted when I would get there at midnight that, come 3 or 4 o'clock in the morning, I used to go into the john and stretch out on the *hard* bench and sleep. I can remember Frankie was just a little boy and I had to sleep one day. It was the middle of July, and I said to him, "Frankie, you go stand by the picture window because it's going to snow today." [Laughs] He went over to the window, and I lay there and I felt so guilty that I got up and said, "Oh, no, honey, it's summertime, it won't snow today." [Laughs] It went on for ten years.

FRANK: I would go to work in the morning and I'd come home and she'd have supper ready for me and then . . .
CATHY: I would do all my chores. And leave for work.
FRANK: And I would take Frankie and we'd go for a ride or we'd go to a show.
CATHY: Frankie was going to school.
FRANK: Then the only time we had was the weekends together on Saturdays and Sundays. Then we used to fight half the time.

58

CATHY: You know, maybe it's because we didn't have anyplace to go. Where were we going to go? We were forced to live together. I mean, of course there's love, there's a bond, but even if I wanted to go, where would I go? My mother was dead, my father had died. It never occurred to him to go back to his mother. They lived fifteen in a house, who needs that!
FRANK: Oh, we was in love.

CATHY: Sure. Because we had the housework to do. We had the laundry to do. Then a lot of times there wasn't enough money, you know. There were times when it would have been very easy to just go our separate ways.
FRANK: We said, "Well, let's break it up." I said, "I'll take Frank." She said, "No. I'll take Frank." I said, "No way." So we says, "Let's sit down"; and we talked it over and we said, "Well, let's try it all over again." We was married maybe seven years at that point. Finally, Frank got older and she went on days. She started working days. We stuck it out.

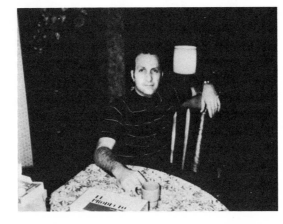

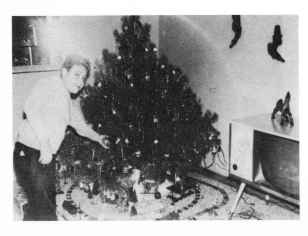

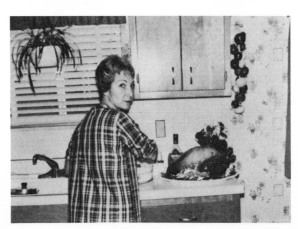

John and Fran

JOHN: O.K. We'll start there. That's the beginning of my life right there. That's a picture of me right there. That's me: John George Tario. Born: 10/4/21.

My mother and dad were from the Old Country. Naturally. They did farm labor. All they did was farm labor. They worked and they harvested their wheat and stuff. And that's how they got by. Grapes and wine and wheat. Nothing too elaborate. Everyday living there, everyday life there. Just struggle.

My dad came to this country when he was 11 years old. He came with his dad. His dad made several trips here. One boy, one time: his first trip. Then, second son: another trip. And: the two boys.

My dad settled in West Virginia. My grandfather was working, at that time, for the B. & O. Railroad. In West Virginia. As a matter of fact, all my folks' people came to this country—*they* all ended up in West Virginia, worked on the railroad. They lived in boxcars. Worked five or six days a week. On the seventh they gambled! And played! Got cards, got drunk.

And then Dad came to Buffalo. He finally found work here. He was a machinist—without a schooling. Without an education. He worked for Timkin Roller Bearings for forty-five years. He retired, got sick, and passed on.

I was born in '21. The Depression hit in '29. The Depression was *quiet*. I mean, nobody worked. My dad was fortunate enough to work. One day a week [carefully pronounces each word]. I can remember that, he worked one day a week, that's how we survived. Dad used to take us the other parts of the week to look for wild stuff: *food*. You used to go up through the woods and look for wild poke. And mushrooms. And dandelions. We survived on dandelions. Dandelions and beans was the *main*

course. We had no linoleum on the floors. *Bare necessities.* That's all we had. We got through that! Thank God! We got through *that* alive!

Well, let' see. The banks went under in '32. My dad lost some money in the bank, to the point of depression. He never got over that—really. It was his heart, I mean *heart-earned money*, that they had *lost*, that they would never *regain.*

As far as growing up. We were a bunch of boys. Everyday boys. We'd get home from school, get up on the corner, set on the corner, chew the rag all night long. Till 9:30, 10 o'clock. Just—*honest,* clean-talking. Bothered nobody. Bothered no one at all. We used to get into some stuff: we used to hit the parish, the priest's parish, for a couple of tomatoes. He had a nice

garden back there. And, what the hell, you're kids, and you do things like that, and you don't realize what you're doing. And, the priest, he knew what we were doing. What the hell! *That's life!*

I was an altar boy. And I drank a little of his wine. Nothing wrong in that. We never got into *bad* trouble. Where we had to have the law, the police, our parents were embarrassed. We never got into that kind of problem. We *knew* what was in store for us—at home—if we *did.* My folks said, "If you get into trouble, *don't come home. Don't come home!* If you bring police, *don't come home.*" When your parents talk to you *that way,* it sinks in your head a little bit. We were *afraid* of our parents. You daren't *lie* to them. That was a *ta-boo!* "Don't lie to me!" Don't lie. I was scared of my dad, I feared him

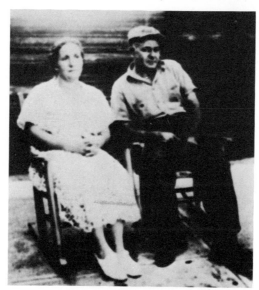

—just his looks. He very seldom put a hand on me, but his look was *just enough* to tell me that I better keep quiet and take what I got coming. A lot of times I just as soon he slapped me in the face than look at me. The looks he used to

get me. [Long, high whistle] I wish he would have beat me up many, many times rather than take the looks that he used to give me. *I'll never forget them looks.*

All the boys in the neighborhood out of school would go to work for Walker Aviation. In the neighborhood. That's what I did. I started when I was 16. I was there thirty-five years. I *worked.* That's what I want to say. In my lifetime. I brought home a paycheck. And I *never cashed one in my life.* My wife'll tell you: I never cashed my paychecks. I've always brought them home. Right? [Fran nods.] Never cashed my paycheck. And my mother would give me my allowance. All right? So I'd get—what? $10? $5? Whatever. You'd blow that. I used to go home and ask Mom for more money. And she'd say, "Ohhh! I have no more." And my father would get teed-off, you know. Say, "What are you? Broke already? A week isn't over already." "Pop," I says, "what the hell do you want? I go out with the guys, we go out, have a little shooting gallery, have a little fun." And

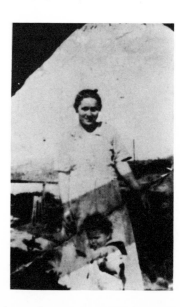

my mother would say, "Have no more." And she'd go upstairs and come back down; she'd have her hand, closed, with the money, was rolled up in a ball. She was afraid of my dad, too. He was—he wasn't *mean* to her. His—noise and actions were enough to scare her. Then she'd give me this money, and I'd blow; I had another $5 bill. I cared less what went on in the house.

But—Mom and I got along real well. She was good to me.

I was good to them, too. I never mistreated them. I worked. I brought my paycheck home. I ate. They put my money away. Then things got worse, as they went on. What the hell. I met Fran at a picnic. I got married.

We were going to get married three or four times, and something always happened. I kept on getting sick. And then my mother died. Like that! [Snaps his fingers] Right before the wedding. It wasn't a happy wedding. I'll give it to you:

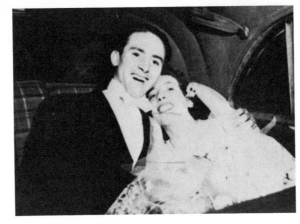

Eighteen years old, I worked at Walker for two years. That was 1941. In 1942, I broke down with tuberculosis. I was alone in a sanitarium for twenty-seven months.

I been sick all my life. I just fall apart when I get sick. I mean, what else would you do? The older you get, the worse it gets. I've been operated on, I've had ten or fifteen majors. Majors. All our married life.

Like I say, I was in the sanitarium for twenty-seven months. Never knowing that I'd make it. They told me I was going in for three months. At the end of three months I *expected* to get off the bed and *get the hell home!* But it didn't work that way. I realized, after three months, what was in store! Tuberculosis! Who had ever heard of tuberculosis? I never paid no attention to it.

That's just a rest cure. That's all it was. After two years being in there, I had surgery. They couldn't do nothing for me. As far as arresting

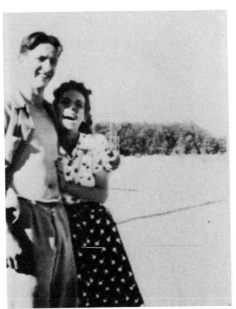

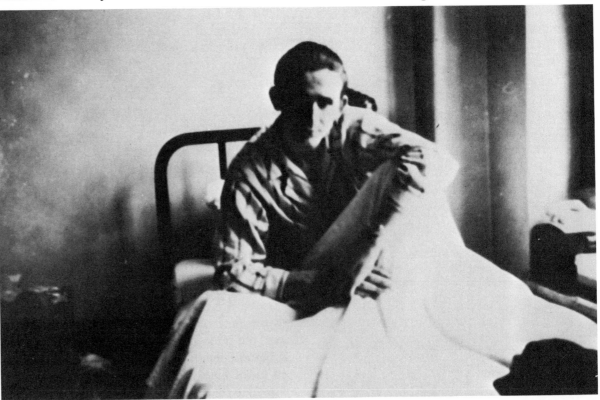

the case. I had eight ribs removed! They collapsed my lung. I got a 60 percent collapse on one side.

After that, they let me go. I was free to go home. Home! Let me tell you: when you're down and out, nobody wants to look at you any more. O.K.? At the age of 18, at that time, if you got tuberculosis, that was like a plague. Nobody wanted anything to do with *you or your family*. They daren't come—this is the Gospel's truth—they daren't come in your house, and if you offer them a cup of coffee or a glass of water—oh!—they'd be afraid to handle it. From fear that they'd get tuberculosis. Well, I come out of the sanitarium, I had very few of my friends. They all disappear. I never saw them! *I never saw them*. At work—they see you gone for a week or two—"Well, he's quit. He don't want to work. He don't want to do this and that." So [in a sad voice] you go along with that.

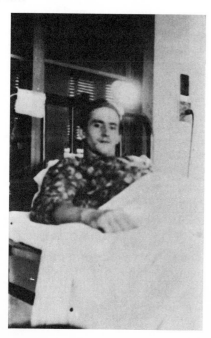

The guys used to go around saying, "He didn't want to work. He was *lazy*." Which was not true. I was *ill*, at the time, and I didn't know it, and it was getting to me, and I *couldn't even get up in the morning* to get out of bed. And when I did get out of bed and started motivating, I was *all right*. But, it was just—*to get out of bed*—the disease was getting to me, worse and worse—I had a hell of a time.

And then you went to work and guys stayed away from you. [Sad voice] When they found out I had tuberculosis, everybody and his uncle went to the doctor and got X-rays! Because I worked with them, they figured this guy is . . . That hurt me [voice trembles] more than the disease did! That really hurt me [sorrowful voice] more than the disease. The whole family . . . [voice breaks]

My friends! I lost track of all of them. I never saw one. Or sent me a card. Or called. If you're sick, they shy away from you! *What the hell?* It was not my fault that I was ill! That's a Godsend. It was sent to me.

I want to tell you! Even when I was sick! I *never*, as long as I was in the sanitarium, I *never, never* thought [voice breaks] life was ending for me! I always *fought* and always looked at the better part of it. I never looked *back*. Even now! All right, I'm ill now, O.K. I'm always looking *forward*, I don't want to look *back*. Because it bothers me to look back! I have this disease. I *know*. But I *don't want to think that way!* I don't want to think that way. I want to think ahead: I'll make it. God's will. Whatever He says.

FRAN: We were married only three years; we were married in '45, and in '48 he had a tubercular infection of the spine.
JOHN: I had a spinal fusion. I had a hospital

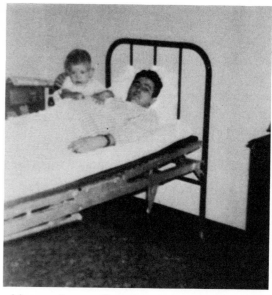

bed in our home. Between '48 and '49.
FRAN: We had to go on charity at that time. He couldn't work, and I couldn't work. I had to take care of him. He was strictly a bedpan patient. He didn't get off of his back for twenty months. And at intervals, they would take him to the hospital by ambulance. The doctor had stressed that he was not even to put his foot on the floor because it would undo whatever they were trying . . . They were trying to arrest this tubercular infection in his spine. He did beautifully. He had a spinal fusion and never any more trouble from that.
JOHN: This was a very bad period. I was on relief. You get $90 a month. *You* tell the city you can't live on that. That was my food, rent, coal.

That made me bitter, and I mean *bitter*. I worked all my life, I paid into this, and when I went for *help*, all they give me was $90 a month. I was *so* hurt, I was *so* aggravated, I didn't care. At that time I was *bitter. I was bitter.*

I had this one caseworker. She used to come

to my house. Once a month. This one time, I said to my wife, "Look, I'm hungry." I said, "I would like to have a slice of salami." I says, "A slice, or two [voice slow, words very exact] of salami." O.K.? So, she went to the store. And she bought four slices. I couldn't afford any more. Four slices of salami. She put them on the table. We're having dinner. Pushed the table up against the bed. My son and her. The dining-room table. We would eat supper together. I would be eating supper on my back for sixteen months. And this caseworker happened to come in that afternoon, we're eating dinner.

She came and sat down and says, "How're youse getting along?" I says, "Well, we need—we need money." I says, "We're just not making it." On $90 a month. I couldn't even afford to buy the baby a pair of shoes! "Well," she says, "well [in a simpering, insinuating voice], I see you have *salami* on the table. You don't have to buy salami." I hope to tell you, that's the Gospel's truth! And I couldn't say nothing.

FRAN: I got very provoked because he started to cry. And I thought, "Well, it's not fair to us." So, I says, "Four slices of salami! If my husband felt that he wanted it, *I* will do without something else."

JOHN: Now every time I buy salami or I have a salami sandwich, it takes me back to *that.* I can't get that out of my mind!

But she paid her dues. She paid her dues. She got married, and she had children that were—abnormal. The children did not deserve it, though. They were not fully grown. It's not good that the children have to suffer, but I feel that the Good Lord repaid her in *His* way! I am a firm believer in this. There's hell *on this earth*, and there's hell *in the other.* I always say, "Sooner or later, They pay their dues."

FRAN: And yet, there were people who were

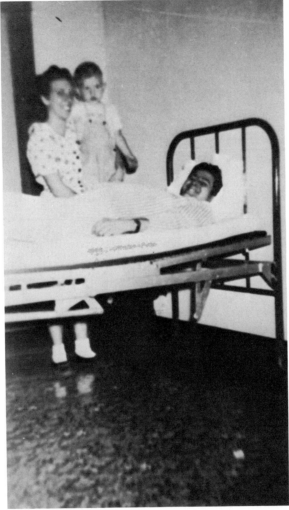

very, *very* good to us. He had just got sick, two or three months, and I was working at General Electric. The girl that I worked with said to me, "Fran, we're having a collection for somebody that's sick. I know you can't afford it, but would you like to bring in a can of something? Just a little something?" And I said, "Well, look, I'll bring in whatever I can, but I can't bring in that much because you know my situation." So, this day, I worked second shift.

And, they brought in cans and cans and cans of food. And I thought, "Oh, my God! Isn't this wonderful? The poor people *really* must need it." So, they piled them all up. And, at lunchtime, we sat there and ate. And the one girl says to me, "Fran! Come here!" And she handed me a card. And she said, "Here. This is for you." And I said, "What are you talking about?!" And I started to cry. They had $50 in there and—I swear!—there was enough canned food there that lasted me all winter. It took three carloads to take me home that night, for the canned stuff. And they didn't make me feel like they were giving it to me because they felt sorry for me. When we brought it in the house that night—I had someone baby-sitting for him —he started crying, and I said, "John, they mean so well." Those boxes lay there three or four days so I could show them off to anybody that came over.

JOHN: And now, I got a malignancy.

This one doc said to me—and I'll never forget it—"John, you got to be the unluckiest son of a bitch ever born. You must have been born under a dark star." This is one thing I always ask myself: "Why me?"

I mean, don't misunderstand me. The Lord's given me this cross to bear. Fine! Maybe He sees something. But, I mean, can't it change, a little bit? I'm not complaining. But! [Silence] I look at it this way: sooner or later, my luck is going to change. Someplace.

FRAN: Oh, John, it *has!* I feel we're fortunate because with what we've been through, we could have been dead, many years ago. If we can stay the way we are now, I just say, "Thank God." I want no more. My sun is shining, as far as I'm concerned. I'll be very truthful. I'm not looking for millions of dollars.

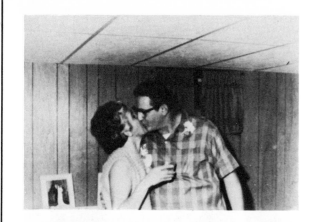

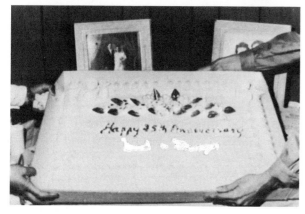

I went looking for work in '49. I'd gotten so tired of this charity. And I heard they were hiring at G.M. I said to John, "I've got to get out. I've got to get to work. I *cannot* take this poverty any more!"

So I went to work. And, luckily, I was hired the first day I went in. I came home, and I said, "John, I got a job as a sewing machine operator." He says, "But that's such a hard place to work!" I says, "I don't care. I'm going to *try*."

When I first started working there, I felt it was like a family thing. I enjoyed my job; I worked at it; I did the best I possibly could. I would do there what I would want in my own home. I wasn't wishy-washy about my job. When

I did it, I did it to the best of my ability. I don't want to blow my own horn, but I would say they called me one of their better workers. I was working on a power sewing machine. Upholstery. Trim. Sunshades.

The people I worked with—we all felt about the same way. We were all married women with small children, and everybody's struggling to raise a family, to pay for their houses. We gave them a good day's work for a good day's pay.

We had a lot in common. We were all looking to build our lives. We were all looking to work! We weren't looking for *no men*; we weren't looking for fooling around! We were there to

work our day's work and go home to our families, keep our houses, and that was it. Now, that went on for a period of ten, twelve, fifteen years. It was the same bunch of women.

On my particular job, it was all piecework. And for some strange reason, this department I was in was considered a "bad girls" department. If you didn't behave, they would send

you to the sunshade department. I'm talking twenty-two years back. Before I retired. Sunshades was, for some reason, taboo. And nobody could understand why.

One year, there was no work for anyone, and we all got transferred up to sunshades. We found out why it was so taboo. The particular operation which we did—which was the original stitching—you could not make your day's production quota in it! Say they wanted six hundred sunshades. There was *no way* that we could make that many. And I knew that if I was trying my darndest and I couldn't make six hundred sunshades, then there was no way those six hundred could be made!

We tried it. There were fourteen of us girls doing this particular operation. We were all married women, some younger, some older. And we said, "What's the matter?" We'd get together. "I can't make it." "I can't either." "Are you really serious?" "I can't do it!" We talked to management. We talked to the union. We says, "Something is wrong with this job. We *cannot* make our *standard*." Well, the company thought we were just goofing off.

So, they had people standing over our heads. They had "white shirts" hanging over us. That went on for three or four months. And no one would listen to us! So we said, "O.K.! We're going to fix *your clock!*" We took some drastic measures. We got together—the fourteen of us—and we said, "Tomorrow, we're not coming in to work. None of us!" And I was one of the ringleaders. There were three of us that were the ringleaders.

So! Fourteen of us stayed home. Naturally, our doorbells started ringing early in the morning. My doorbell rang, and a "labor relations" guy was there. He says, "Fran Tario?" And I say, "Yes." And he says, "Why aren't you at

work today?" And I says, "I know you! You're from labor relations. Why are you here? I've been off of work before, and I've never had anyone come to my home." He said, "Why are you not at work?" And I said, "I'm not feeling well!" And he says, "Do you know that there is fourteen girls in your department that is absent?" "I don't know that! I don't live with fourteen people. All I know is that I don't feel well!" And he says, "Why aren't you working?" And I says [voice rises], "*I don't feel well! And* to be truthful, I had an argument with my foreman yesterday, and it upset me so badly, I couldn't go in there today." "You don't know about anyone else being home?" I said, "I'm sorry! I don't."

As soon as he left, the phone buzzed all day long. "They're coming to the houses! Beware! Beware! Beware!" All fourteen of us were alerted.

So, the next morning, when I hit the door, there were two foremen standing there. I had one I called The Jolly Green Giant. Standing there, with his arms folded. And he said to me, "*O.K.! Tario!* Goddamn it! You asked for it! Now you're going to get it!" I said, "What am I going to get?" He said, "You're getting a *time study.*" I says, "O.K., fair enough. How long a time study?" "You're getting an eight-hour time study!" I thought, "Oh, my God! What are they going to do to me?!"

I knew it had to be done, because there was something wrong with the job. So, they started time studying me at 7 o'clock. And, finally, as I was working, I looked around me, and I saw eight or ten white shirts around me!

Before I started to sew each sunshade, I had the habit of opening up the wrapping to see how each piece of fiber board was placed. Then, I would take it and sew it around. After

the time study had watched me for an hour, he went to the foreman, and the foreman says to me, "Fran. Why are you opening it?" And I said, "Look! You have been watching me for *months! You* know my procedure!" I was so upset and so hyper, I threw my scissors away! "*Goddamn* it!" I said. "Time somebody else. *I've* had it." I threw the scissors and *started to cry.* And I can remember the Big Shot, running down, "Call the committee man! Call the committee man!" Well, it became a joke. Because we even had the Big Shot calling the committee man.

I went down to the nurse. I was hysterical. She said, "*What* happened?" I said, "I don't know what they're doing to us up there! But something's got to be done! They're driving us *all* crazy!"

In the meantime, they picked up another girl. And started timing *her.* They gave me a pill to settle me down. And I went back upstairs. And I started to work. And I said, "Look. I'll consent to a time study, the rest of the day, if *only* the time-study man is there. With my union representative." He says, "Nobody else, no white shirts allowed."

Halfway through, the time-study man said to me [in the voice of an amazed 6-year-old], "Does this happen all the time?" And I said, "This is a normal day." Finally, at 3:20, I said to him, "Pardon my French, but are you going to give me a chance to go and pee today?" And he looked at me and says [in an embarrassed, nasty voice], "O.K., O.K., I'm done. I'm done." I said, "Look, if I were making *$100* a day, I wouldn't be working *this late!*" It was really torturous.

We finished our time study. And four or five days later, we kept on saying, "How did that time study come out?" "Well, we haven't fig-

ured it out yet, we haven't figured it out yet." So, finally we said to the union, "Look! We gave them a fair time study! Whatever the results, we feel we have a right to know about it." They cut off twenty-three pieces an hour. That is *how bad* the standard was on that job. After that, we made our production every day . . .

I worked there pretty steady until '72. When I had a mastectomy. The same year, I had both of my breasts removed.

My doctor felt that I should work. He felt that being with people would help me. So, O.K., I went back to work, but it was a very heavy job. It was a piecework job, and I didn't feel that I could go in there and goof off. I was just that type of person. When I got in there, I asked if they would put me on a lighter job. Because I couldn't handle it.

At the time I went back to work, I was one of the oldest women there. My seniority called for a high-paying job but also a heavy job. These sunshades would weigh maybe thirty pounds when you piled up twenty-five of them on a little skid. And I would have to push them down a conveyor. You'd have to make maybe a thousand, twelve hundred sunshades a day. I knew that there was no way I could handle that kind of a job.

So I asked if they would put me in a corner, give me a sewing machine, and give me anything they had. I'd take my average earnings. And just let me work on my time. Because my doctor wants me to work.

There were three or four of us in the whole plant that had mastectomies, but I was the only one who had a double mastectomy.

Between the union and the company, they agreed to put me on a machine where no one would bother me. But the new women, the young, colored that had come in said, "No! Your seniority calls for you to go to *that* particular job. [JOHN: "In other words, you got to *die* with that job!"] If you can't do it, go on home."

So, I fought it for six months. I went to the union and I went to the company. I said, "Please! [JOHN: "No compassion for nobody."] I'm not able to do it. I don't want the money. I cannot hack it." It finally got to the point where they said, "If you're that sick, go on home." They closed in on me. And it was the people *who were my friends* that did it to me. So, I went on disability and went home. But I say, "Thank God for G.M.!" I worked there twenty-five years. And I collect a pension.

JOHN: You talk about dog eat dog. Let me tell you. I used to bring my paychecks home to my mom. All my paychecks. And she always said that she was going to put something aside for me. That *some day*, when I needed it, it'd be there. *I never got it*. It was $900. My savings. She died. And it just disappeared. I asked my dad and he said she spent it.
FRAN: His mother died, and his dad remarried. Then his second wife died. Fifteen years later. And he started working on his third wife. He was courting her. And he decided he was going to sell his home and all his belongings.

So, he says to me, "Come on over to the house, Fran. I have some linens. I want you to have *first pick* because you're the oldest daughter-in-law."

I went over and picked out a few sheets and a few pillowcases. John's mother used to be a seamstress for the church. She did embroidery. And she used to crochet. Altar cloths. So, there were five or six of them. I said to him, "Dad, who made these? Your second wife or my mother-in-law?" "Oh," he says, "your mother-in-law." "I know John would love to have that one for remembrance." He says, "Go ahead! Take it! I was going to give it to the Salvation Army, if nobody wants it." [JOHN: "Mind you!"]

So, I took it home. And put it on my dining-room table. It lay there for two weeks. One night we were sitting there. And I says, "John. Did you see that altar cloth your mother made? I got this from your father."

I picked it up and opened it. I felt one corner, and I says, "Oh, my God! A *little mouse* must have *died* in here!" It was bulky. I said, "Oooooh! Something's in here, John, and I got the wheenies!"

I felt the other corner, and—the same thing. So I says, "My God! There's something in this hem!" We took a little scissors, and we cut the hem. And—in each corner—there was folded $500! All in ten- and twenty-dollar bills! Wrapped up in Bill Durham tobacco bags.
JOHN: The bags was so old that the rubber band around it fell apart.
FRAN: There was $500 on one side and $500 on the other. And I says, "*Oh, my God*, John! This is the money that your mother had kept saying was yours."

John got on the phone, and he says, "Pa. Don't go to bed. I'm coming over!" So we went over. We brought these bundles of $500—all in

tens and twenties and *one fifty-dollar bill*. John says, "Here, Dad. Here's the money you said Mom spent. Here's what she did with it."

He was so taken-aback. I thought that man was going to get a heart attack. He says, "Where did you get this?"
JOHN: She'd put that money away for me. *That was my money!* She knew that if something happened to her, that stuff would eventually go to Fran!
FRAN: John's father took the money! And he *walked off*. I stood up and says, "Hey, Dad! There's one fifty-dollar bill in that. At least give us *that* to remember her by!" He says, "Oh? Oh! O.K., O.K." And he gave it to us.

I *still* have that fifty. I said, "If I'm down to my last penny, I *will not* spend it."
JOHN: *That was my money*. Every paycheck went home. I lived under his roof. He fed and clothed me. What could I say?

I'll tell you how my father was: he used to tell me one story, that I used to think about, *often*. He worked here, in this country, with his father. His father worked for the railroad, and he got his son a job as a waterboy, when he was 14. My father got paid 40 cents a day. At the end of the week, he'd give his father all his money. And his father gave him *two pennies*. *Two cents*. And he says he wanted to throw it in his face, but he thought better of it. He took the two cents and put it on the railroad track. The train went by and flattened them out. His old man caught him. He gave him the beating of his life. He says, "WITH THAT TWO CENTS, I COULD'VE BOUGHT MYSELF A CIGAR!"

But he didn't have to take it out on *me!*

Irene and Bernie

IRENE: I used to put Frank Sinatra on. Just lie there and listen to music. I can never do it when Bernie is home. He walks in. He says, "*Turn—that—goddamn—thing—off.*" And I get *sour* inside [in a high-pitched whine]. I even went out and bought him "Jerusalem My Gold." And I can't even *talk* Jewish. But I heard it at a wedding. And it was so *beautiful.* And I thought, "Maybe! He'll like *this!*" [Frowns grotesquely, shakes her head] Hopeless.

He comes home from work. Eats. You can't talk to him. And reads the paper. Then he'll sit over there. Push the chair. Back. Plays solitaire. Solitaire. Solitaire. Shuffles them. And slaps them down. One time I said, "You're going to drive me *crazy* with *those cards.*"

I'm born. I was born. I was born.
Irene. Angela. Fox.
April 16, 1922.
Would you like to know what my middle name stands for? Angela? [Starts to cry] Excuse me.
Before he married my mother, his first [coughs], his first wife's name was Angela. There was a

flu epidemic. First World War? And she died. They had a boy, Roger. Who is my *half*-brother. Yes. And, when *my* father married *my* mother, Roger was 8 years old.

I don't know how she ever allowed them to give me that middle name. Had it been me, I think I would have been deeply hurt. To have a daughter named after my husband's first wife would be kind of a sock in the head, to me.

My dad was the first movie operator. It's like you have to have country club blood. It's very restricted. He was a movie operator before they had movies! He used to do the spotlight when they had vaudeville. And then the silent movies. I used to go see them a lot. Oh, what a job. *Hands of gold.* I can't begin to tell you what he *did* with his hands. He was incredible. He could fix a toilet. He could repair anything in gas. Anything electric. He was . . . Ask my mother-in-law. Ask Rose. She always says [in awe], "*Your* father! *Your* father!"

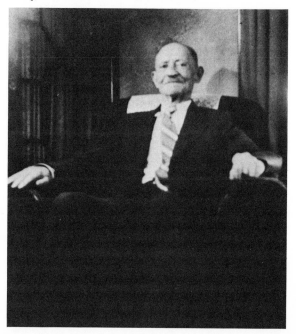

My dad . . . was . . . like a mother to me. My mother, ah. I would come home one night, and my lip would be swollen, and he would say, "I don't like the way it looks." Very devoted father. Weak. Weak. As weak as could be. Sweet. Simple. Very simple. Forgive me. She's a very simple-minded person. It's not her fault. She scrubbed floors. She didn't have much schooling in those days. And they were poor. But during the Depression—and Bernard hates me for this—it's not my fault—we were never hungry. Because the movie operators always got paid. And we *lived well.* We got a new car every year. We went to New York every year. And he bought her *the best.* China. And silver. And crystal. But he was very domineering. And my brother—my half-brother . . . I never *knew* he was my half-brother until I was *13.* I had an Aunt Edna who used to come over and *eat,* whatever she could find. Her husband was at

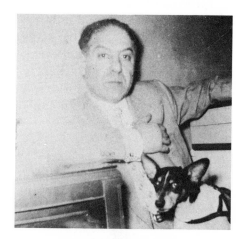

the Hippodrome. Movie operator. A very Big Man. And she told me that Roger was not my real brother. And it was quite a shock.

My brother . . . Well, he got married to a wonderful girl. Thank God. Because they had a child. And they named it Angela. And she was

really very beautiful. *Very, very, very* beautiful. What happened? My brother's wife's brother's wife—her sister-in-law—had T.B. And, I guess they left Angie with her a lot. And she would taste the soup. And give some to Angie. And, anyhow. At the age of 5—I, ah, ah [gasps for air, chokes, cries]. I was in Kentucky with Bernie. We weren't married yet. [Speaks as she cries] We were engaged. I was engaged to his mother—she picked out the ring. She said [in a catty voice, through tears], "Don't forget! Bernard doesn't have a lot of money." And, he said, "Do you want to get married or don't you?" [Sniffles, weeps] And she, ah. She had, she had meningitis. And [cries] she died. [Weeps] And I [in pain] didn't know. Whether to come home. Or get married. Because I thought that if I didn't get married, maybe I'd never see him again. [Sobs] And I never forgave myself [in a choked voice] for not coming home. [Lights a cigarette, sniffles] She was my niece. And she was only 5 years old. I don't think my brother ever really forgave. . . [Sighs. Sighs again] My sister-in-law had a nervous breakdown. [Sniffs] I'm sorry. It's been a long time since I cried.

Anyhow, my father never liked Bernie. Being a father—well—he didn't think he was good enough for me. And I was very, very much in love with somebody else at the time. And Bernard said, "Make up your mind. Make a decision."

I married Bernie because I guess I thought I loved him. It was really, really strong. Yeah. No. In the beginning, it didn't seem to me he had a lot of personality. He's a great person. He'll get up at 3 in the morning to help anybody. He's a—Do I have to tell you? [ironically]—what a wonderful *son* he is! To the point of lunacy, really.

I guess I fell pretty much in love with him.

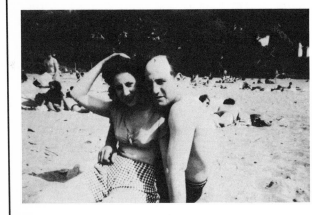

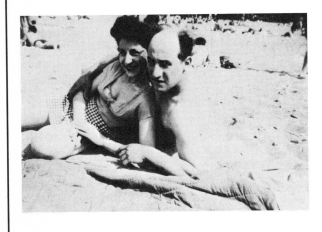

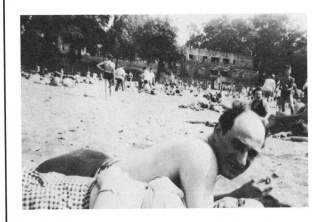

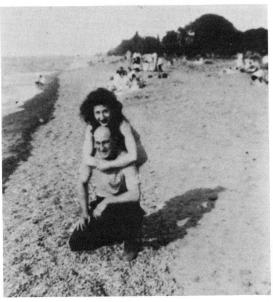

After a while. We didn't know each other long at all. I don't remember. We got engaged because I thought it would be a good idea. We wanted to get married. I loved Bernie more than the other boy. I don't know why. There was something about him. Completely different. Then he went off to the army. And when he came back, he was so changed, it was like somebody I didn't know. Completely changed. Full of hate. Because of what he saw.

I had a cousin who was going with a friend of Bernie's. We got very friendly. And we all went down together to visit them at Fort Campbell. And one night Bernie showed up with this big Polack. This very big Polack. And he sat on the edge of the bed and he proposed [in a hard, brisk voice]: "Do you want to get married or don't you?" And that was the proposal. Very romantic. And I sat on the bed and didn't know what to do. Because I didn't know whether to come home or get married. And I was *so* [sarcastically] prepared for marriage—I had a flannel robe. I didn't even have a *nightgown*. This was a 1-2-3 [snaps her fingers] thing. Because he was going overseas. He was on alert. He could have gone any time. And we wanted to—you know—before he went away—*be together*. I mean—we didn't want to hold hands!

The wedding was *something!* The people were sitting on the steps in overalls. Eating popcorn. In the courthouse. We had to wait for the blood. We had an awful lot of ice cream sodas while we were waiting. For the blood and whatever. And it was all good. And we got married! We all had dinner. Me, Bernie, and that big Polack. Anyway, I have the napkin we used that night. And my bouquet. And the place we got married. The room we shared. There's the postcard with an arrow.

We were in love. Very much in love. We were so—we were so in love! When he came to where I was living! In *this room!* I lived with him in a garage. With no window shades. In Kentucky. With rusty, dirty things to cook in. That I never used. And. *I was so happy.* I was [softly, tenderly] happier with him *there* than I've ever been *here.* [Lights another cigarette] When he—came—"home"—you know—from camp—I wouldn't wait for him, I used to run up and howl—when he *kissed* me [voice trembles] and hugged me. I was so in love. I couldn't wait. I can't tell you. It was to the point of *lunacy.* And then we lived in another house that they rented to soldiers and their

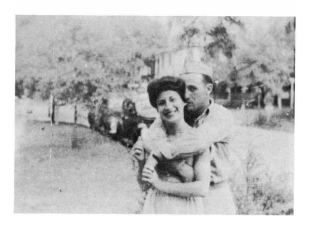

wives. Roaches. Everywhere. We had a hammer in one hand. And a fork in the other. . . . [Laughs]

All of a sudden. After we were married. The first night that Bernie and I had. [Softly] He hit something. That's when I got the pain. He *hit.* Something happened. And my stomach got very hard. And I got very sick. I had a cigar box with my toothbrush in it. I was walking back to the room. And Bernie came up behind me and scared me to death. All of a sudden. The cigar box. And I got very sick.

And I went home. I took a train. I don't remember. And Bernie said, "Go to my uncle, the doctor." Who said, "You're pregnant. Five months." I said, "What?! I've got my period!" He said [in a deep voice], "You are pregnant." I said [outraged and amazed], "Doc! I am not pregnant! I just got married, three weeks." It was *three* weeks. And I *had* my period. I said, "Are you sure? How can you be *sure?*" He says, "Am I *sure?* If you were with Bernie, I am not *sure!* I am [slams the table with her fist], POSITIVE!" Well? I'm going to argue with *him?*

Then one day his uncle said to me, "Tomorrow we're going to [in the voice of Count Dracula] cut into your belly." And I said, "Why?" And

he said, "We want to see what's in your belly."

So, the next day, his uncle is standing next to me as they give me a spinal. And I saw two legs

going up. I didn't know they were mine. My girl friend was a pathologist—standing in the doorway—waiting for whatever they took out. So she could cut it up. And—I'm talking to her. Finally the surgeon says, "Irene, *if you don't shut your mouth,* I'm going to put you to *sleep.* Then I felt *something* scraping. I don't know, I say, "Doc, what are they doing?" A twenty-million-dollar stare I got. The surgeon said, "This is not a pregnancy."

May I drop dead where I'm sitting when I tell you that that *thing* was bigger than a teapot. It was a dermoid. They held that thing in front of me. On forceps. And I said, "You didn't take that out of *me?*" I thought they were kidding.

"Yes, we did." And I said, "You did *not.*" "It came out of *you.*" It was an ovarian cyst. It had [her voice trembles and weakens] *teeth.* It had *hair.* Some doctor explained it to me: in the

cycle of life, where—if you were going to be twins—I don't understand this myself—in the cycle of life, when I was in my mother's womb, somehow maybe, *something* got into *me!* I don't know. It would have been maybe my brother or sister? The surgeon said had they not cut me open, I would have been dead. [In a whisper] I don't know. All I know is that if that thing would have broken open, I would have been—[Snaps her fingers and lights a cigarette]

What else? [Sighs] What else can I tell you?

I can remember—I ate a book in the first grade. Not the whole thing. Just a little bit. A little bit at a time. And then, my father made me a mummy case to take to school. It was beautiful. Two feet long. We were studying about it then. I think he was trying to bribe the teacher for the book.

And, oh! My father caught a little mouse one day, tied a little string around its neck, and I walked up and down the street with it.

Then, when I was 13, one night I walked in, and my brother and the maid were on the couch. I was kind of shocked, and I went right back to bed. 'Cause I didn't want him to know I was there, because maybe he would kill me.

I must have been in high school when I met Bernie's sister, Jackie. We walked home together. She'd always bring pictures of her brothers.

So, one day, I'm standing in front of this store where I worked, and Jackie walked by. And she says, "What are you doing tonight?" "Nothing." "How would you like to go out with my brother? On a blind date." I said, "A blind date?" She says, "Well, *he's my brother.*" I said, "All right." So we went out. And. You want to know what happened? We went to an *icky, icky* nightclub. And he's [sarcastically] *very debonaire.* He says, "You're so, ah, ah, light on

your feet." Which meant I was probably killing his feet. And then, I remember, he took me home. And went back. And started talking to the waitress. [Sighs] Yeah. He was something else. Go back with the waitress? You know, he could have stayed with m-e-e-e.

After Bernie went overseas, I worked at Douglas Aircraft. I was a riveter. I worked on the plane that bombed. . . I worked on the B-29. I *never* knew what plane I was working on. All I know is that they searched us when we came in and when we left. I know I was working on the plane that bombed Hiroshima. They told us later on. They told us what it was. If I would have known, I never would have worked on it.

[In a very quiet voice] When Bernard came home from the army, I had saved some money. And I took an apartment. They'd cut off the front part of the building 'cause it was in quicksand. But you couldn't get anyplace to live then. So, it was in quicksand, and it had roaches. And I ripped my hand; I ripped up the linoleum and fixed it up. And I bought a bedroom set. And I slept on a mattress on the floor, in the front room. With a hammer. Because there were rats. [Shivers] Oooh! When I think of it, I don't know how I ever did it.

Oh! *I was so happy*. I was so young. Twenty-one. And the girl next door said, "I think somebody's coming up the stairs." I *run* out on that porch! [Tenderly] And there's Bernie. With his sack. Ahhh! It was *beautiful*. [Voice quivers] I just—*ran*. And—he—he put his arms around me. And, then—what do you think he said? "Come on. We got to go see my mother." *This* is where it all started. I said [tenderly], "O.K. But why? Right away?" "I got to go see my mother." O.K. We go over there. And his mother's running around. She couldn't find her teeth. [Hoarse

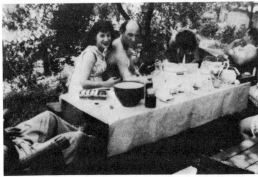

laugh] Couldn't find her teeth!

Then we come back from his mother's, and he walks into the building. And he says, "From one foxhole to another?" I said, "Bernie. There's nowhere else to live." [Lights a cigarette] Then we moved in with his mother. [Long drag on the cigarette] Ohhhh. It was horrible. Ab-so-lute-ly HORRIBLE. No malice in my heart. I tell you, it was HORRIBLE. HORRIBLE. She thought I married her son for his money. He didn't have a penny to his name. But I married him so I would get money from the army. [Laughs]

One time, later on, his mother was making supper and she said she didn't know what I was going to have. And I said for my part, she could open up a can of sardines. Ah! She called all the girls in. All the daughters. Everybody came running like storm troopers. Because

I spoke to her in a "tone" she didn't *like*. I *meant*: "For me, you don't have to bother." But. You don't *talk* to her in this *tone*. Marilyn says, "You can't talk to my mother like that!" Like *what?*" I was working, and I said to Bernie, "This is *ridiculous*." I said, "Bernie, *please*. We'll get an apartment. I'll keep kosher. I'll do anything. But I can't *stay* here. I can't [in a trembling voice] live this way." His mother's *a demon*.

He'd changed in the army. He came back different. *Bitter. Hate*. I never saw anybody *hate* black like him. Hate. Hate.

Maybe, it wasn't him that was different. Maybe it was me. Because I wasn't as happy as I'd been in Kentucky. We were so much more in love. It was bad, bad, bad. I wasn't used to this mother, mother, mother, mother, mother, mother, mother. But what really did it was after I was pregnant. I got in the car. And I was going to buy a highchair. And there was this hanky in the back seat. A handkerchief. Full of . . . you know . . . full of semen. And I got crazy. I remember driving home going, YAAAAGH." [As if she were vomiting and suffocating] I was so . . .

I came home. He was sleeping in the room. The baby was in the crib. I woke him up. I asked him, "Where were you?" And he said, "You know where I was." I accused him. He denied it. I threw the hanky in his face. And he was speechless.

When he was overseas, people would say to me, "We know what he's doing over there." And I said, "Not *my* husband." I meant it. I meant it. I was so naïve. I believed *so* in him. I said, "Not him." With [in a trembling voice] my *heart*. I wouldn't *believe* it. *He* wouldn't touch another girl. *Not Bernie*.

It just came as such a . . . I, I, I don't know how another woman would have reacted. But—I—got *crazy*. I mean, I really thought I was going to lose my mind. I didn't want to live. I was so [breaks into tears] *unhappy. Miserable*. If a person lies to me, I don't trust them any more. I lose *faith*. I *don't lie*.

I was never the same after that. It was going on and on and on . . . I got phone calls. A man called. He said he wanted to talk to my husband. I said, he wasn't home. And he said, "*That* [she spells] *P-R-I-C-K* had better keep away from my wife or I'm going to come up there and kill him." And then [in an exhausted voice] I got a call from a girl. "Is Bernie home?" I said, "Who's calling, please?" She said [exasperated], "Is Bernie home?" I said, "If you will be kind enough to give me *your name* . . ." She said [briskly], "Never mind, I'll call back when he's there." It was never the same after that.

And then he would come home from work. And I never thought anything of it. It never entered my mind. But there was always something *white* on the fly of his pants.

Then my father passed away. I went to a doctor and he put me on some kind of a tranquilizer. That's when the pills started.

I used to wait up for him. He used to bowl. For the company. I was going *crazy*. I think a normal woman would have said, "I'll go to bed. Let him sow his oats." I don't think I was normal any more. I was half out of my mind.

It went on for eight years. It started when I was pregnant, the first time, when I was in my ninth month. I was in labor eighteen hours. He went home and slept. Another man would have been waiting, waiting, hoping, excited. He figured, "Eh!" And—that was the most beautiful moment—outside of loving him—when I *held* her. Oh! It's the most *beautiful*—ah! Oh! God!

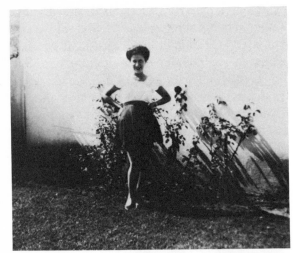

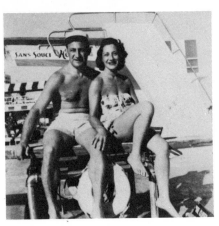

cigarette] I went to Bernie's oldest brother, Merle. He sat very still and didn't say anything. He must have thought I was nuts, that I was imagining it. But I wasn't. I wasn't imagining. It was happening. It was just happening.

Then I went to his uncle, the doc. Before I could say anything, he said, "I don't want to hear another word. *Unless* you have proof. If you don't have *proof*, don't talk to me!" I know him. The way he is. And he is a pussy cat inside. Bernie is *afraid* of him. But I'm not. So I said, "You want proof?" And I gave him a letter I'd found in Bernie's pocket. And he said to me, "I don't blame you. And I know Bernie." And I said, "What am I going to do? [Voice trembling] I'm going crazy."

One thing's for sure: I *loved* my sex life. It wasn't because Bernie wasn't getting any here. Because he was getting it pa-len-ty. I don't know how he got up to go to work! *Plenty*. I didn't think I left anything for anyone else! But, obviously, he's quite a man. And *he still is*. *Oh! God!* He is a *horse*.

When I held her! Of course, she was born, and three months later, he was screwing around.

I was unhappy. *Terribly* unhappy. Everybody in the family could see it, I think. [Lights a

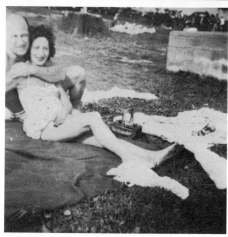

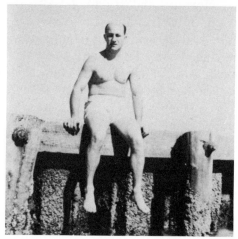

Bernie didn't know nothing about my first baby. I just didn't slip my diaphragm in that night. [Clicks her tongue] *I* planned her. A big surprise.

Then. When she was 3 years old, my obstetrician said, "You're pregnant. But it's a bad pregnancy." I was in labor for three months. I don't know how the hell I got in the cab and got to the doctor, because when it happened [laughs], the baby was stuck in the cervix. So I got out of the cab sort of bow-legged. [Hoarse laugh. Persistent coughing] I said to the cab driver, "Would you hold me up?" [Laughs] That moron just sat there. I'm on my knees. With the baby in the cervix. Bleeding. And bleeding. [Persistent, racking cough] I'm just clearing my throat. You should hear me when I *cough*. The house shakes. [Lights a cigarette]

Bernie wanted a boy. So we tried again. And I had a *girl*. Terri. Bernie still wanted a son, so—one morning I got up. Terrible pain. Hemorrhaging. Hemorrhaging. But I'm making *him* breakfast. And *all of a sudden* I drop to the floor. And I'm not a complainer. I'm on my hands and knees. And I can't even speak. Bernie came running down. He carried me to the

couch. And being Bernie, he never knows what to do. He never knows what to do. He borrows some paragoric from somebody and he took me to the hospital. And they took me in the elevator and he wanted to come in and I said, "Relax! Wait here! We'll have another one. Wait here. I'll be down in a couple of minutes." This baby was in the tube. What happened was the tube exploded when I dropped to the floor. The *pain!* It was the most HORRIBLE, HORRIBLE, HORRIBLE! I can't, I can't, there's no way to describe it, no way.

They took it out on cotton and showed it to him. They showed it to him—and it was a boy. Five days later, he starts telling me, they took out my tubes. They'd taken out my ovary from the dermoid. It took me fifteen minutes before it hit me: "We can't have any more children." And he said, "Yeah." And [in a hoarse voice] I cried.

I got onto Equinol. I got very hooked on it. In fact, when my father died, and when all this happened, I got *so* hooked on it.

I dropped down to ninety-four pounds. *Skinny.* Very skinny. One day, my daughter said, "Mom?" And I said, "What?" And I felt strange. Very strange. I thought I was perfectly normal. She says, "We're going to the doctor." I said, "O.K." I have to laugh. I went to the doctor, and I sat on the table. And I was *smashed.* I was *stoned.* I was—I would have been dead in a month. That's how bad I was. I remember the doctor went, "Ooops!" when I almost fell. He saved my life. He said to my daughter, "Get me her purse and see what she has." O.K.? She took me home. I guess I kind of wobbled out of there. I was in a jumpsuit. *Skin-ny!*

My doctor called Bernie. He said, "Your wife will be *dead* in one month. You must get her into a hospital."

I was *weird.* I thought I was perfectly normal. I was sitting on the floor in the small bedroom upstairs with one of those candles that keep away bugs. I had [laughs] rolled up a newspaper and I was trying to light the *wick.* And lie down and listen to music. And Bernard thought it was pretty strange. [Laughs] I don't know why I was doing it, but I was. I had this little record player. And I'd just lie down and listen to the music.

Bernard was beside himself. And didn't know what to do. He went to his brother Jerry. Bernard brought him home. I was wearing wigs. Faye, Jerry's wife, came upstairs. It was about 1 o'clock in the morning. And she was dressing me. And my wig was on backwards. And I *knew* they were going to put me somewhere. I knew. So I went to get my wig. I wasn't going to go without my wig and makeup. Really!

They took me to [sobs] Lakeview [sucks in air]. And. They took everything out of my purse. Except my eyebrow tweezers. Oh, thank God they left my eyebrow tweezers! What would I have done! They took a urine sample from me. [Lights up a cigarette] The urine. Looked. Like. Pudding. It was *thick.* You could have cut it. I'm not exaggerating. I'm not *lying* to you. I think—you—could—have cut it with a knife.

[Laughs] This was the funniest part of my whole life. This place was a snake pit. I didn't have a doctor. They took me in there. I was *stoned* out of my mind. *Drugged. No* doctor. Nobody to care for me. So, I just sat there. [Giggles] And I thought, "What the hell is this?" I knew.

[Lights a cigarette] The weekend went by. They have one room for women. And it's a big circle of beds. Before they put me back there, they put me opposite the nurses' station. A black—I guess you would say—"nurse." Male. Came in with a needle. A foot long. It was *so long* and I was *so tense.* I cannot forget. He couldn't get it out. From my rear. Because I was so—[Makes a tight fist] Then he gave me another one. [Whispers] Then I went out of my mind. [Sighs] Oh. I hallucinated. I can tell you everything I saw. Everything.

My daughter came to see me. And I said to her, "Time to go to bed now. So you better go to your room." [Laughs] She said, "What are you talking about? *I'm* not here. *You're* here." I said, "I wonder where Daddy is? He must be on the other side, with the *men.*" Well, *that* was *nothing.* [Giggles] That wasn't *anything.* We'll get to the *good* stuff soon.

They took away my clothes. I got out of bed. I was in a little white thing with my purse. I went down. [Laughs] And the head nurse said, "Yes, Mrs. Gauge?" I said, "How do you know my name?" "Ah, Mrs. Gauge, sit down. Where are you going?" I said, "Well, I'll tell you. My daughter doesn't have any food. And I did all the shopping for her. And they're *very* hungry. I have all these groceries. But every time I get in the elevator and try to get off—I'm in Lakeview. Is everywhere Lakeview?" And it was *sad.* And she said, "Mrs. Gauge, stay here. I'll be right back." I sat there. And she said, "Go back. And get in bed." And I said, "Where?" And she said, "*Anywhere.* Just get in and *go to sleep.*" [Laughs]

Bernard came up. And I finally got a doctor. And she said, "Mr. Gauge. Your wife—don't be alarmed—is a little strange. [Laughs and laughs] They overmedicated her." In other words, I was so full of drugs—when I went in—and then they gave me [laughs] those two big needles!

I was in for two weeks. My doctor and I had our "talks" in the laundry room. [Laughs] She locked me up. All I said was "I can't sleep." That's all I said. *Whoosh. That's* how fast she took me by the wrists. Into the lock-up room. And I thought, "What the hell? I can't sleep." They are rotten. The way they treated people. *Everybody* was sleeping with everybody else. The staff. Everybody.

I couldn't eat. I was getting thinner. Who could eat. There was a black lady there who couldn't find her mouth. She threw the food past her ears.

Every day, I put a little plate on the floor, for my dog. And I had a friend who was very fond of me. And when no one was looking, she'd pick it up and put it back on the table. Because she didn't want anyone to know that I was feeding my *dog*. Who wasn't there. His name was Lucky.

They brought a guy in. Someone had tried to cut his head off. He was slit across from ear to ear. I was scared to death. He kept *looking* at me. They'd lock him up, and he'd beat his head on the door. You could just hear him pounding his head.

I ran through the hall, screaming. And a doctor came out. And he said, "What's the matter?" And I said, "I heard this banging," and I said, "They're beating up my husband. They're hurting my husband. *Please!*" And the doctor said, "Mrs. Gauge, I just called your home. Your husband is home and he's safe. He's all right. Go back to bed." I wondered if I really said that to him. And I said, "Thank you."

That was all the first week. *Then.* The staff had a meeting. And the patients went in, one by one. And then it was my turn. And I sat down, and they said, "Well! Tell us about your-self!" And I said [laughing], "Well, I went on this trip." I can be very funny. Of course, they all knew about me. Then my doctor took me into this little room. She sat on the bathtub. I sat on the wheelchair. Delightful. Delightful.

Then I had a caseworker. And I told her that I thought my husband had other women. And she told me she had asked him if it was true. And she said that he told her it was true and that he felt partly responsible.

When I married Bernard, I never knew about his hate. The hate came from how his mother brought him up. She says, "A *fire* on you! A *burning* on you!" It's like "the hell with you." With everyone but the family. She brought her children up—my impression is—if they weren't Jewish, I'd swear they were the Mafia.

Bernard's mother is very, very difficult to understand. How can she say, "You can always get another wife. But you can never get another mother"? Or she'll say to Bernie, "Your wife comes first. You should go home to your wife." Then Bernie comes home, and she'll call up and say, "Since when does someone come before *me?*" Now, how can you hate anybody like this? Right? It's *cute.* But it's *sad.* Because, after all, he's a grown man.

BERNARD: It's a different world. A completely different world.

My name is Bernard Gauge. It used to be Gauch. I was born in Buffalo, New York. March 30, 1917.

The earliest thing [lights a cigarette] I remember is drinking out of a pop bottle. Instead of a baby's bottle. I must have been 4 years old. All I remember is drinking it and then *smashing* it. I was told, "You're a big boy. You don't drink out of bottles now." That's the earliest I can remember.

I was not a good pupil. I was a troublemaker. I used to put little tacks on the seats. Or drop my pants, in the back of the room. [Laughs] I wouldn't dance any of the maypole dances. I thought that was kids' stuff. I'd pick a lot of fights. Whatever reason I could. [Lights a cigarette] I was a troublemaker. The only one in the family, really.

I know we must have slept two or three in a bed. Two on one side of the bed and one on the other side. Winter or summer really didn't bother us. If it was too hot, so you sweat. If it was too cold, it was too cold. We didn't have too much money, so when they'd unload a truckload of coal, we'd pick out what was left over. And we'd go out and scout wood. And I guess I started to sell papers when I was about 6 years old.

I couldn't stand on a corner and sell. If you worked the corner, they'd *kill* you. They'd run you off. So, you stood about half a block away. Caught the people coming in. I didn't have enough sense to rake off. I gave all my money to my mother. That was before the days of being smart.

All four of us sold *The Jewish Daily*. That's Merle, Jerry, me, and my brother Teddie. He

was 9 years old when he was killed.

The four of us sold papers in the neighborhood. We used to go into the temples and sell papers while they were praying. We'd develop our regular people. My mother used to wake us up between 5 and 6 in the morning. Winter and summer. We'd have Saturdays off. But Sundays we'd collect. We must have had four hundred customers. Which, of course, supported the family. 'Cause my father never made any money.

I remember staying with my father one day, when they were making whisky. I fell asleep on the bags of sugar. They were boiling whisky. They made it and we'd sell it by the glass to neighbors or whoever it was. They always kept it in the bathroom in case we got busted. But one time, when my mother was pregnant, the police jumped into the dining room, Saturday morning. And my mother got so scared that she had a miscarriage. That stopped the bootlegging.

Then my brother got killed. I was pretty close to 13. What happened was: we all went to Hebrew school. From the day we were born. And he and I were supposed to go together. And I had come home late from public school and I didn't want to go. So he waited for me for a while, and *then* he gave up and went ahead. Ten minutes later my grandmother sent me out the door. I got to the intersection, and I saw a crowd of people, and they told me "some kid" was killed. By a *truck*. I finally found out it was my brother.

I remember running all the way to the hospital. And I said, "I want to see my brother." And they said, "You can't see him now." He was lying over there and he was *dead*. And *I didn't know* [contemptuously] *what death meant.* Not really. And they said, "O.K., you can go over

and see him." And I remember before I got to where he was lying, I passed out. I never got to him. So, I must have known something about death. I'm sure I didn't know too much about it.

We were pretty naïve. We didn't know about sex. We didn't know we were too crowded. We didn't know that our food was no good. We didn't know our living conditions were lousy. We didn't know we were poorer than mice. We didn't know this. We were buried within ourselves. For some reason, my mother and father and my grandmother kept us happy in our own little world. We were *very close*. Family. Very close. We didn't have many friends. We didn't bring in many outsiders. No one would play with us. Later on, a lot of guys were even afraid to date our sisters. We had a reputation. The reputation was "You don't mess with us. We're tough." And all that kind of shit. It was mostly me. And, of course, Jerry would back me up. Never *had* to. But he would have. No question. *Now* we have a lot of problems, basically because we have a lot of in-laws.

My father used to be a rag peddler. One of us used to go with him. Myself or Jerry. Mostly, it was *me*, for some reason. And then, my father was a fruit peddler, and we *always* went with him. Myself or Jerry. Merle was going to school. Merle sort of led a different life than us. He was six years older. He went to school and he worked. But Jerry and I—I don't know when we got real tight. See, Jerry was a very shy kid. He finally broke out of it in high school. He was an all-scholastic football player. And

that broke him out of his shell. Till then he was backward. He always followed me. I always broke the path for him. Now he mothers me. He figures he owes me something. And all that kind of *shit*.

Back then, our biggest thing was to steal food from my father before he came home at night. We'd steal fresh stuff so our mother wouldn't get the garbage. If my mother said, "We need potatoes today," we'd steal potatoes from him. He never knew the difference.

She always fed us well. Which probably accounts for me going on 62 and being in fairly good health. Because when we used to go with the papers, there'd be this high snow. See, the snow wasn't broke like it is now. Like with tire tracks. We'd have to do our own breaking. Jerry was always right behind me. We'd dogtrot the whole route. We used to jog a couple of hours at a time. Just to deliver the papers. That's why Jerry and I got to be so strong.

That work made my life a lot easier. 'Cause I wasn't the ordinary type of Jew. Which meant: I didn't mind *butting heads*. I enjoyed it, as a matter of fact.

When Sabbath came, Friday night, my father would come home and get cleaned up. Then he and my mother would take a "nap." They would close the door. And do their thing. Then *she'd* come out, and a little later, *he'd* walk out wearing one of her dresses and maybe a pair of her shoes. We didn't think anything about it at the time.

You don't think your parents are doing anything but taking a nap. When *we* were told about it—*God! That's terrible!* As a matter of fact, when I was told about *sex*—God! I was 13 and the guy next door told me about *sex*. I remember—for the first time in my life—I *cried*. Because, it was *just so impossible*. Mother and Father. ESPECIALLY.

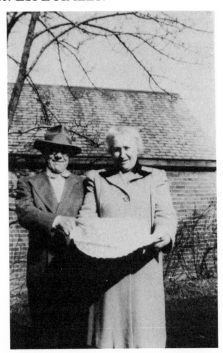

[Lights a cigarette] All my father did with the clothes was sit around and sing his songs. Nothing else. Except, he'd wear a dress. He *liked* women. He liked women. He was a real talker. Beautiful talker. He could sell horseshit to a horse. If he'd had some ambition, he would have been a *very excellent* salesmen. But he had *no* ambition.

During the week, when he'd get through work, he'd go and play cards up at the corner. That was it. *You'd know where to find him.* Every minute. Every second. Smoke cigarettes. One right after the other. Without using a match. [Exhales a cloud of cigarette smoke]

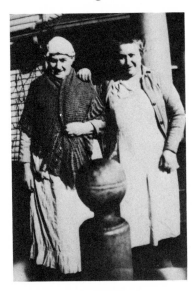

My grandmother ran the family. My mother, second in command. My father would not talk to my grandmother. Because she interfered. It was peace and harmony—*really*. My grandmother was the *smartest* of the bunch. A strong, domineering woman. And, *my mother*, being her *baby*, said, "O.K., Ma. What are you going to do?" That type of thing. My father—so long as you didn't bother him too much—O.K. As

far as I know—he didn't "fool around." His big thing was playing cards. And that Saturday business. He'd come out with the dress on and sit around the kitchen table. On Sabbath. Which was a damn good life, really.

We went to technical high school. We learned the trades. It gave us a chance to mix with Italians, Hungarians, you name it. *Very few colored.* Very few colored. Jesse Owens went there. He ran for class president. And I remember us all getting together to stuff the ballot box so he would be president. That's the only reason he ever made it.

I was always in trouble. I picked fights. If they had a fight between the Jews and the Italians, they'd call me. Of if they have a fight with the Polacks, *I'd* go over there. 'Cause I had respect out of them. *They* were afraid of *me* because *I* wasn't afraid of *them.*

I had some good fights.

I fought a guy who used to be the middle-weight champ. 'Cause he wanted to use my towel. And I said, "No nigger's going to use my towel." So, we went into the gym and we fought there.

I had a lot of fights. I *looked* for trouble. I never lost.

I was very belligerent. I resented the way Jews were treated. It *bored* into me. I was 18 and I still didn't have anything to do with girls. Maybe that was part of it. Picking all those fights. But I don't know, I don't know. I'd find a reason. If somebody'd bump into me, I'd double bump. I *still* do it.

I graduated in '36. I never had any ambition to be anything. I drove a truck for a couple of years. I was probably making a hundred bucks a week. And all the money, of course, went to my mother. Naturally. [Laughs]

Then I started to date girls, goddamnit.

The first girl I ever laid was when Manny and Marilyn got married. Manny was so much in love with Marilyn, it was *pathetic.* It was *sad.* If she'd whistle, he'd be there. I don't know what she did to him, but she got him. Big deal! [Laughs] It was a *sad* thing.

Anyway, there was this girl, this kitchen maid who lived next door, and while the wedding was going on, I was over there hanky-pankying. [Taps the table lightly] I think she called me in, but I'm not sure. I must have been 21 or 22 at the time. [Taps the table] My whole theme in life was how strong I was going to be. Body building. I heard that if you got laid, you would ruin your strength. Samson-Delilah, cutting the hair off? Don't ask me why, that's what I thought. The reason I remember so vividly [taps the table]—I finished on her somehow. And I'm *pretty sure* [taps the table] I never got into her.

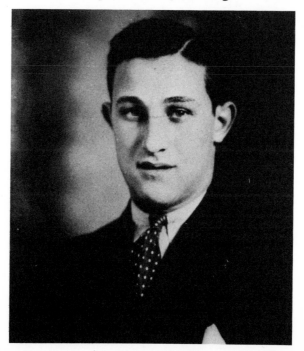

'Cause I don't remember it. And I think that if I *did* [taps the table] I *would have* [taps the table] remembered it. Anyway, a week or two later, she told me she was pregnant [taps the table] and I was the father. So I told Manny. Manny told Marilyn, and they both started to *laugh* [taps the table] at me. And all this kind of crap. They wised me up, you know. [Coughs] So she disappeared. That was my first experience with life.

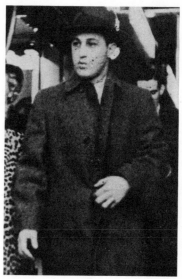

Then the draft hit. Jerry and I decided we had to get into some kind of war industry or we were going to end up in the army real fast. Merle knew some guys in a tank plant in Chicago, so that's where we ended up. And that's where I broke loose. I probably screwed everybody in the country there. Maybe I missed one or two. Or three? I didn't drink. I didn't smoke. I was 26 when I learned.

Then, I got a call from home. One of the neighborhood girls worked in our draft board. She says, "One of you guys will have to go in the army, or we'll take *two* or *three* of you!"

Merle was married already. Jerry was married. And I was the only single guy. So. No problem. Naturally, I volunteered after they drafted me.

Number one: I decided that everybody could know I'm Jewish. Number two: I decided I'm not going to be a private. So, when they had classes, I sat in the front. And I gave them whatever answer they wanted to hear. When we went to the obstacle courses, I made sure I was in first.

Nobody would fool with me. I was a private for about a month. Then I made acting corporal. Then I made sergeant. Then I went up from there. I got up to first sergeant. Which is what I wanted. Because you're a go-between, between the regular army and the officers. They all *kiss your ass*.

All the Jews would flock around me. I'd *protect* them. Somebody'd give a Jew a lot of detail work, dirty work? I'd call them out. And then I'd settle whatever way I had to settle.

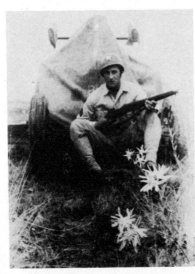

When we passed in review on parades, I carried the pole with our company flag. And I'd *set the pace*. The company ahead of us had this little, short, Jewish lieutenant who was counting cadence. He's marking it a little too loud. The captain was walking next to me, and he says, "You little Jew bastard. You're counting *too loud*." And the little lieutenant kept counting and counting. So I figured, "*Fuck you*, Captain." So, I broke cadence. Which means that everybody was out of step. [Laughs] After we get back, it's, "What happened, Sergeant?" I says, "*Nothing*." He says, "You broke cadence." I says, "*Me?* I wouldn't do that." He says, "*You did!*" He says, "O.K. Off the record, why did you?" I said, "One Jew bastard deserves another."

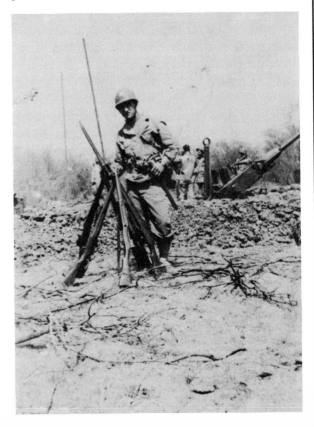

I had a squad of twenty-three men. Artillery. I used to let the corporal train them. And I'd go into the hut. And go to sleep. And one day, I heard a lot of noise, and I went out there, and there was this big *Bohunk* from Detroit. A good 250 *solid* pounds. Six foot two or three. He had picked up this guy named Eisenhower and was bending him over his knee. Breaking his back. So I said, "John! Drop him!" He says, "*I can't.*" I says, "Why?" He says, "He called you a 'dirty Jew.'" I says, "That's all right. I didn't take a bath. Let him go." John was one of my so-called "shagus" [gentile] friends.

Then we went overseas. We went in a convoy. We were scared shitless. What the hell are you doing to do? You had to go down in the bottom of the boat. I never stood in the bottom of the boat. I stood on top.

We came to Ireland. Then to England. Went across the Channel in one of those little shitty boats. We walked through the water. I'm not sure what beach it was. Whether it was Omaha Beach or what. We had to get into a town called St. Marie, Englaise. The big guns were silent. But there were *goddamn* planes overhead. I tried to get under the ground. But the ground wouldn't open up. This little Jewish lieutenant—I found him hiding under some stuff. And I said, "You son of a bitch! Get up! You're Jewish. You *can't* do that!" I dragged him with me. We dog-trotted into this town. The 82nd Airborne was stuck there. There was fighting in between the hedgerows.

We moved through France, Belgium, Holland. Our casualties weren't too bad. Only about 25 percent. Lot of deaths, but not too many casualties. "Incoming" did it, and sniper fire.

We got caught in the Battle of the Bulge. We had to break up our troops. Half had to go into infantry. Half had to stay with the guns. I stayed with the guns. We sent the jerks to the infantry. The weakest ones. Most of them came back. I'd say a good 50 percent came back. I wouldn't have gone with them.

What I remember was being scared shitless all the time.

During the Bulge, when that fog set in, we didn't know where the hell we were. We were shooting, but we didn't know what in the hell we were shooting at.

We went into one town. I'll never forget it. It was deserted. And a train was there. It was still huffing and puffing. I went to the throttle. I couldn't make it go.

During the Bulge it didn't make any difference if you were alive or dead. 'Cause you were part of the vegetation. You were *beat*. I used to break up aspirin tablets and give them to the guys as "no sleep pills." The only thing was *I* knew the difference. *They* didn't.

Just about near the end of the war, we saw a big barracks. One-story building. Ran for sixty yards. I had my guys surround it. And I walked in. And there was a bunch of women in there. All *kinds* [taps the table] of women. D.P.'s. The Germans had used them for whores. We had a ball there for a couple of days.

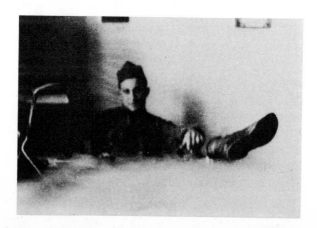

Then in one of the seaports in Belgium, I ran across a woman who was married to a Jewish guy. And, there was a small concentration camp. I found him and brought him home. And—the old story—in the basement, bricked up, they had prayerbooks and a Torah. So I wrote home to my sister or my mother or somebody and had some food sent to her. He had all his fingers broken. We had a lot of V-bombs there.

I remember going into a town in Holland. They had some German hospitals there. [His voice grows very tense.] A lot of amputees. People would knock them off the sidewalk. [Exhales sharply] They just hated them.

One day we were on patrol. And I saw a farmer; he had a horse and he had his feet tied. He had a big pair of wire clippers. I walked over to him and I said in Yiddish, "*Was ist doss*?" He knew a little English. He said he was cutting the balls off the horse. Then he did it. The horse got up, shook itself, and went over in the corner. And I said, "*Why'd you do it?*" He says, "Well, I've got a mare; and this is a stallion. He's pulling the plow and killing himself. The mare's laying back." So he cut his balls off to slow him down.

We bivouacked in one of the concentration camps. We saw German soldiers who'd deserted—they were *hung*. I saw a couple of mass graves. I don't know *who* was in them.

I remember riding through Nuremberg. The smoke was *still*—from the air strike—*still* coming from the ground. But the Germans were picking up bricks, cleaning them off and laying them down. And I remember making sure our driver stopped—we were in convoy—so I could laugh at them.

After the war, we were in Bremerhaven. We were M.P.'s. I had it made. I used to cruise the country a lot. And beat the shit out of Germans.

I found one guy in Schweinfurt. Who was supposed to have killed [his voice trembles] the Jewish butcher there. I beat him up pretty good. I don't know if he lived or not. I didn't care.

I had this one guy in my outfit who must have belonged to Murder Incorporated, because he was so violent. If he saw a ring on somebody that he wanted, he'd chop the finger off. If he saw a wounded German, he'd kick him. If he saw a German walking along the road, he'd either *kill* him or *beat the shit* out of him. He and another guy, who'd lost a brother on a raid, they'd go around and just *beat the shit out* or *kill* or *whatever* they could do. Very destructive. Worse than I was. I did it because I was taking revenge.

I really loved the army. Because I was powerful. Because I could do what I wanted. I never thought I'd come home. You had no future. *Absolutely no future.* I never thought I'd make it. I didn't think I was *that lucky.* You know, *how lucky can you be?*

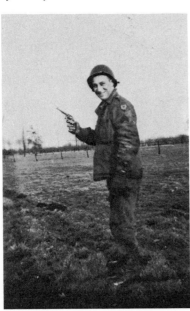

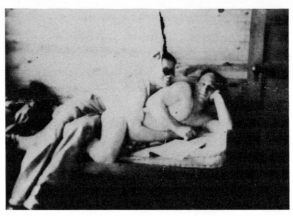

In '45, my grandmother died. And my mother had a heart attack. So I came home real fast. I left everything behind. I left a trunk full of money I'd picked up. Maybe a hundred thousand bucks in different currencies. I just left it.

I drove a truck for a month or two. I didn't like it.

Then there was an ad in the paper that this muffler shop wanted a mechanic. I didn't know a thing about it. So I went down and was interviewed by the owner. "You a mechanic?"

I says, "Yeah." "You know all about cars?" "Yeah." So, I installed mufflers for a couple of months. And one day he came out and said, "How would you like to be in charge of our factory?" I didn't even know there was a factory. He says, "You know all about factories?" I said, "Yep!" [Laughs] I didn't know *shit.* I didn't know what it was all about. Anyway, that's how I got started with Big Ed and his mufflers. He knew even less than me about them. I found that out later. But for some reason, I gave him the right answers. In two years, he'd talked Sears and Penny's and Ward's into selling them. And then he started opening shops up all over the country. He was a super salesman. I ran the factory for twenty years. Ed took care of the business. I took care of production. One other guy took care of the office. At that time, there were thirty people working in the factory. I told them what to do. I was supposed to be the expert. I knew everything. I didn't know *shit!* I told them what to do. Ed bought it, that's the important thing.

Pretty soon, the factory grew to one hundred people. I hired an engineer. The guy was a genius. While he was doing all the work, I had

Merle check on it, so if he had a question, I had the answer. So, I was an engineer, right? With Merle's help.

Then we got bigger. And Ed decided he needed some smarter guys, so he shuffled me out of the factory and into the front office. They put everything on computer. And they told me, "You're designed for bigger and better things. What would you like to do?" *And all this kind of shit.* I *knew what they were saying.* It started off as "Do what you want to do." And I figured if I wanted to stay, I'd better find it. And I found it. I made my own job. I created a lot of things. I did a lot of *bullshit.* Bullshit like how smart I was: I kept my mouth shut.

They're just two tricks: keeping your mouth shut, and learning how to use people.

You want to know about my mother? I'll tell you about my mother: she makes us all feel guilty. I know it. But I don't care. They say why do I go there every night or call her every night? *Because I want to.* Guilty conscience? *All right!* I got a guilty conscience. I don't care what it is. *I want it.* My mother wants to take advantage of me? *I want it.* Go ahead, Ma. Fine. I don't care. I know it's not the healthiest thing in the world. But who in hell wants to figure *that stuff* out? I don't. I don't want to figure that out. It's *my mother.*

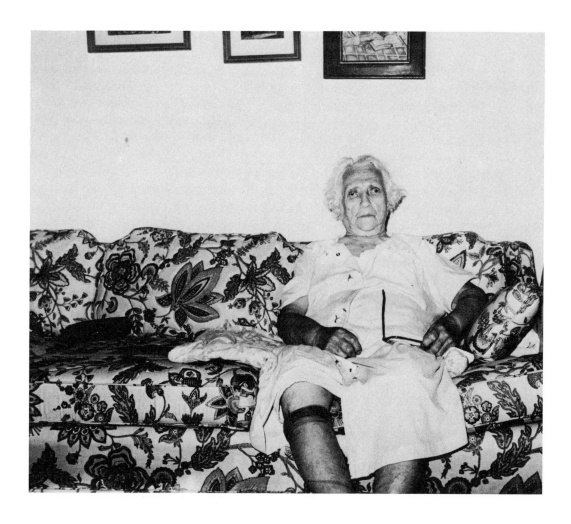

Jerry and Faye

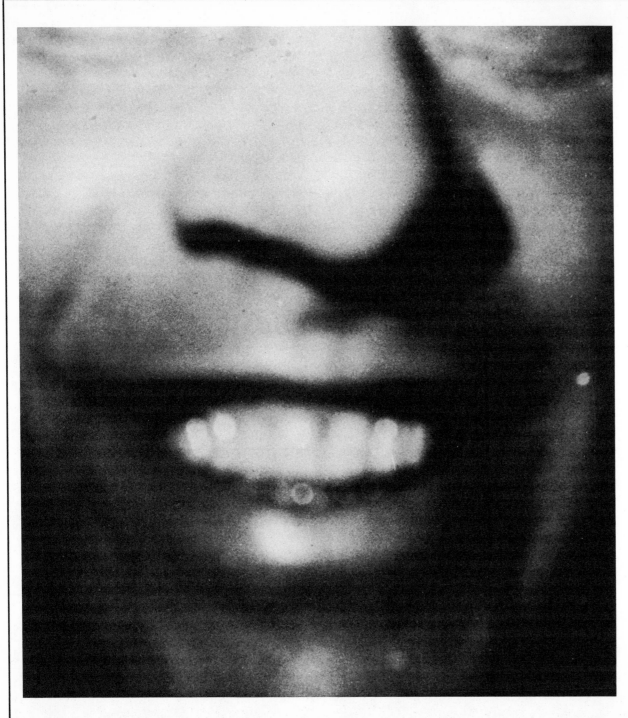

JERRY: I was born here in the year of 1919, the nineteenth day of January. I am now 59 years young. It makes me an Aquarius. A man of notable esteem in the field of nothing.

Of course, I don't recall any of my childhood days. I mean, those infant moments. We moved very frequently. We had discovered the adage of the times. It was cheaper to move than pay rent. 'Cause we didn't have the money. We were a very wealthy family in a state of poverty to the nth degree. I recall very vividly the ruckus of a big family life. Those were my youthful days, during the Depression years. We all worked to keep the family in a state of survival. My brothers and I carried newspapers. We knew that if we didn't bring our 18 cents home, at the end of the week, *there wasn't any money to eat on.* We used to run after coal trucks and *steal* coal off the truck to have something to burn. Or we'd go up to the corner fruit store and pick up boxes to bring home, so my dad could have something to burn in the furnace. Those are the things that are always in the back of my mind.

It wasn't pleasant, but it unified the family. There wasn't dollars to play with and go places, so we found enjoyment in our little home.

I don't recall any moments that were not enjoyable.

It's a funny thing. I think about it when I drive. I recall my elementary days in school. I remember the teacher because her name was Mrs. Junk. I remember a song that we used to sing. [He sings:] "Good morning to you, good morning to you. We're all in our places with sunshiny faces. And this is the way we start a new day."

We did a lot of walking and running with our newspapers. So it was only natural that we got

involved in athletics. It wasn't a matter of skill. I enjoyed it. I wrestled and I played football. I enjoyed the contact.

We always got into fights. Always had problems. Brother Bernie and I. At least once a week. He'd get into fights and I'd have to help him. It became a grand muddled mess. We were the terrors of the goddamn avenue.

When we were kids, Bernie and I were very, very close. We were known as the Gauge boys. "Don't ever go near the Gauge girls because those Gauge boys will knock the hell out of you." My poor little sister Jackie used to get her hind end beaten more times. I was always intervening because Bernie liked to pummel the hell out of her. She always got in the way. Always wanted to get into the baseball game or kick the football around. I didn't have the heart to haul off and punch her, but Bernie used to whip her hind end every once in a while. We had a stairway that went down into the basement. Jackie wanted something that Bernie didn't want her to have and he just hauled off and punched her and she fell down the steps and he felt so bad he laughed all the ways until he ran outside. Those were the days.

To me, Bernie was the *greatest* and always has been. Bernie always was the ice breaker. He was a bundle of terror. Always was. Always wound up behind the eight ball. Always got the roughest part of the deal. He was always my idol. Everything that he did—our closeness is still intact—was very unique. There was only a year and nine months difference between us. It made us very close. We had an overwhelming amount of clothes between us. We had one coat between three of us so we could exchange trousers and things like that. Coming from a family of such wealth.

I made all-city guard in high school. I was a big knocker. I made the all-scholastic team, so I was a Big Man in school and president of my class and all that other garbage that goes with it.

What it means is that I could do things that an ordinary student couldn't. For example, when I was a senior I had to get a job to offset my monetary needs. My teacher said, "Let's go up and talk with the principal." So we went up to see the principal, who was a very marvelous, wonderful friend to me. He said, "I think that you ought to go to college" after we had talked about looking for a job. He says, "I'm going to get you a job and you'll work, and we'll have somebody tutor you on the weekends to keep you abreast of the class and then we'll make arrangements for you to get a scholarship to go to college." And I was overwhelmed. I thought he was giving me a cock-and-bull story, but he was very sincere. Following week, I got a call for a job. It was [smiles] a fantastic job. I never worked so hard in my life. I was 17 years old. I was a metal spinner. I used to press a flat piece of metal against a wood form. I did that for eight hours a day at the fantastic salary of 37 cents an hour. Worked my ass off. It was an ungodly job, but my wonderful principal kept in touch with me and arranged an interview with a notable alumnus from the state university, and he made arrangements for me to go there on a scholarship.

My college days were the most exciting days of my scholastic endeavors. There was an entranceway, a little archway, as you walked into the university, and inscribed was "So Entereth Thou That Thou Mayeth Grow in Knowledge, Wisdom and Love." I'll never forget that. I can't remember my name, but that I remember. Then I remember when Faye and I walked through the campus, there's a big Civil War cannon there. And she says, "Boy, look at that cannon!" And I says, "That cannon only goes off when a virgin goes by. And it hasn't gone off once in this university's history."

I was on a football scholarship, so I had to find some way of subsidizing myself and help out at home. I got a job serving tables at a women's dormitory. I worked in the kitchen and played with all the girls I could find. It was heaven! Of course, you got to understand I

was a very virtuous young man and I didn't let girls upset me but I tried like hell. I knew they were there for a purpose, and it wasn't only for education. So, consequently, I felt an obligation. I mean, most women needed a healthy young virile man like myself to lead them into the dens of iniquity. And consequently, working in a girls' dormitory you were forced to accommodate them in every conceivable way. What the hell else could I do? All the guys who worked there had to participate. It was a horrible experience to wait on tables and wash dishes and cater to all these young girls from 17 to 22. It was disgusting. It was horrible. I was a straight-laced individual. I was prepared. I had an older brother. I had a brother that was prepared before I was and properly introduced me into the worldly ways of life. Bernie was in charge of all sex manipulations in life. I was forced to participate. He forced me to. I did not care to indulge, but he insisted that I become involved with women from a sexual point of view, and . . . [Laughs]

I carried this horrible burden for three years.

My wife didn't begin to keep tabs on me until my senior year. We met on this blind date and I saw that she needed some guidance. I took her in hand because I thought this girl was running off onto the wrong path. So I had to straighten her out, and I tried like hell for a long time. Couldn't do it. I liked her and I figured [smiles] her dad had a lot of money and it might be worthwhile getting attached to her. I didn't seduce her. I induced her to go to college. We held hands and went for walks.

FAYE: That's a lie. He was known as the campus wolf. What happened was: I had been going with another fellow. Everyone thought we were going to get married. But we had a fight. And this friend of mine knew about it, so she calls me up and she says, "I wonder if you'd be interested in going out." She starts telling me all about this guy who's coming in for the weekend. "Handsome. He's on the football team." A football jock, the whole bit. And I'm sitting there

thinking to myself, "Yeah, if you're fixing me up with him I can imagine what he looks like." Because she was a very, very homely gal. But, on second thought, I thought maybe I could make my steady jealous. So I accepted. And, needless to say, my husband walked in. His first words to me were, "Hmmm. Sweet." That was the first thing he said when he saw me. And we just . . . I never went back to the other guy and I never dated anyone else. Neither did he. And my mom says, "This is ridiculous. You just don't fall for someone that quickly. When a flame burns quickly, it burns out." But it didn't. I'd just entered as a freshman and my husband said, "Do you want me to put the yoke on you?" And I says, "The yoke? What are you talking about?" He says, "Do you want to go steady?" He couldn't come right out and say it. He gave me his high school ring, and I wrapped tons of string around it so it would fit. JERRY: And that started this love affair which is overwhelming and involving as the years commence. Thirty-six years! Would you believe it?

FAYE: I don't know. He's a very giving kind of guy. I just *fell in love* with him. We were married in '41. We just both felt this *something* the first time we met. And it *has not changed.*

When I was a sophomore, he graduated. He left and got a job in Chicago, and he called and said, "Set a date. I want to get married. I can come in two weeks. We'll get married." My mother was not too thrilled. But my father said, "O.K." So my mom and I went over to his mother's house to set a date. That's when the problems started. With his mother. It's been going on ever since. He's 59 and he still jumps through hoops. I think, "Darn it! Break it! Cut the cord!"

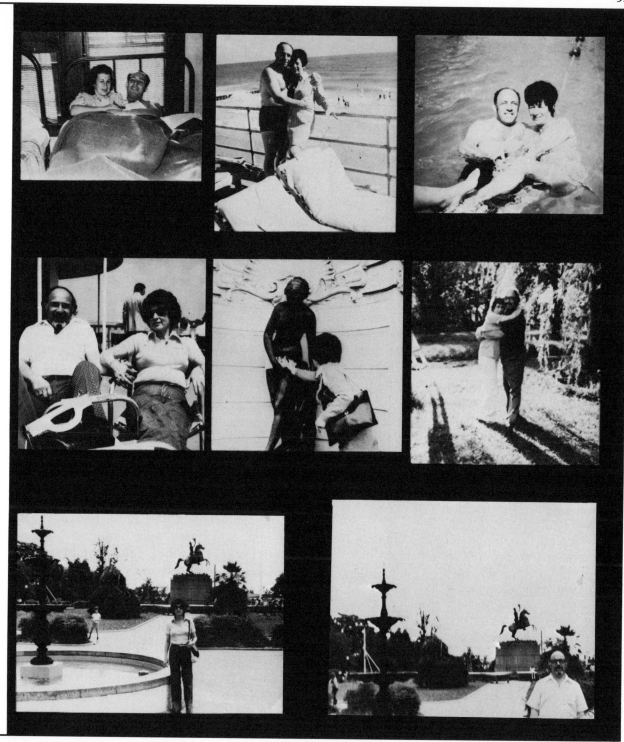

It was just before some kind of holiday where you're not supposed to have any kind of ceremonies, and his mother says, "No. It's not good. You'll have to make it another time." I got upset 'cause it's bad luck to change a wedding date. And besides, I was anxious to be with Jerry. My mother saw how upset I got. She said to my mother-in-law, "O.K., then, there will be no wedding at all. Come on, Faye. I'm not in a hurry for her to get married. I think she's too young. It's too soon. Let's go." At that point my mother-in-law says, "Wait a minute; wait a minute; let's talk about it." So my mother says, "There's nothing to talk about." And my mother-in-law backed down. We got married. It started then.

With my father-in-law, it was a different story. There was some kind of chemistry between him and my mother. He *loved* my mother. He used to call me and say, "Faye, I want you should arrange me a date. Tell your mother to come to your house Sunday and we'll play cards." They'd play cards and they'd fight. She said he was cheating. 'Cause there's no way a person can win every game. He *did* cheat. But they couldn't wait until next time. He used to tell me that my mother-in-law was selfish. And

then, when he passed away, he was already in a coma and I walked into his room and he wasn't talking to anybody. He opened his eyes and he looked at me and he says, "Oy! Eva, Eva, Eva, Eva, Eva," my mother's name. "Eva, Eva, Eva."

JERRY: We better go back to Chicago. I went there just when the great World War Two started. Fifty percent of my class went right into the service because we were all offered commissions. I didn't want a commission, I wanted to live a little while. I wanted to build a little life.

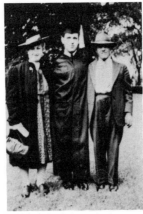

I had a friend who was put in charge of a tank arsenal in Chicago. So I asked him if he could find me a job. I knew he was a stupid ass who needed somebody to speak for him and write for him. So he was quite enthused when he heard from me. I went out there, and I became the chief machine-shop inspector. We were building American and English tanks. I became a big knocker, a follow-up inspector; I worked with Army Ordinance. I got deferments. It was one of the largest tank arsenals in the country. The plant ran a mile long! It was run by the company that made Pullman cars. After I was there a year, I got Bernie a job in the machine shop.

Then my best friend got killed in the navy. I went down to enlist. He was a genius. A Phi Beta Kappa. From a very impoverished family. His father was a steel worker and *he'd* worked in a mill. He graduated magna cum laude. He got shelled and I wanted revenge. But they wouldn't take me. I got to the last test, this maze of colored dots in a circle, and they told me I was color-blind. The doctor said, "You're so color-blind you saw things the ordinary color-blind guy would have missed." I was so upset. Shit, I thought I was the greatest thing! It knocked me off my haunches. It took me twenty-two years to find out.

I went back to the tank arsenal and waited to get drafted. We didn't know from one week to the next if I was going to go or stay. There was this old guy, head of our draft board back home, that was after me and Bernie and Merle. He was the only gentile on our board. Ninety-nine-year-old anti-Semitic bastard. He was after my ass from the time I started at the tank arsenal till the end of the war. So, since Faye and I didn't know what was going to happen next, we decided to go to a doctor to find a sex preventative. We wanted to do everything according to Hoyle. The aspect of pregnancy being predominant in our minds. As knowledgeable as we thought we were about sex, we thought we would have it told to us by a person of note and learning. He introduced us to the rhythm form of protection to keep her from a state of pregnancy. But *that ass* forgot to check her menstrual cycle. And so, one month to the day after we saw him, we were blessed with our handsome, big son.

Our second boy was born in '45. The war ended with Germany and I got a letter from my dear friend on the draft board, "We are inviting you to enter the Armed Services . . ."

So we sold everything, took our two kids, went back to Buffalo, and moved in with her folks. I was ready to go. The night before I'm supposed to get sworn in, a directive comes from Wash-

ington: "All men, twenty-six and over, with dependents, are hereby exempt..." And that night, I'd just hit 26. I went down anyway and *this mother* says, "I'm sorry to tell you, but you are exempt from the service."

I stood around with my finger in my hind end, doing nothing for a while. There wasn't any work. I wanted to teach phys. ed., but at that time, an exaggerated salary was being paid to schoolteachers. It was about $1995, and with two kids, the janitor was making more than I

would have been.

I went to work for Faye's father. He had this sort of general store, clothing store, where you put a dollar down and a dollar a week. He was making a pretty good livelihood. And we were living with them. I didn't like it. She didn't like it. But things were at a low ebb.

I don't know how many years I worked with him—four or five years, something like that. Which I felt was years lost of my life 'cause I accomplished nothing but working and making a livelihood and supporting my little family.

I *hated* it. What got me was the clientele. We dealt mostly with black folk, and I didn't feel that I was gaining anything. I was gaining dollars, yes; but there was *nothing* of any consequence to better myself. I did not see any goal to strive for. It was merely working for dollars day in and day out, and it became a monotonous routine with no ultimate goal to strive for.

It was an honest living; it was a hard living. It was ungodly hours. We'd work late into the

day. We had to not only sell, but we had to personally go out and collect, and that was very degrading and very—well, it was a dangerous way of earning a livelihood, let me say that. We ran into persons that, of course, did not care to pay their bills. We were always...we had occasions of threats, and we had to make sure that we protected ourselves.

I very seldom carried a gun with me, but Bernie—when he came back from the service, he had a beautiful little small-arm, a .32, a foreign-made, small-caliber gun...and he thought I should have it. So I carried it with me as a matter of protection. Not thinking I'd ever use it but as something to frighten people away with...

One time, late on a Saturday night, I was driving, making my collections. I had quite a few hundred dollars with me, so I had my gun handy. And someone cut me short. Cut me off. I got very provoked and I cut him short, and this went on for four or five blocks and then I thought, "Well, what the hell. I'm going to frighten him and get the hell out of here." So I pulled my little gun out and I pointed it at him and I voiced some words of love and encouragement and he swung away from me after that. I thought nothing of it, and I went on to my next stop. Parked my car. Went in to make my collection. And I came out, and, lo and behold! there was a great big burly cop standing there with his big .45 pointed at me and he says, "Did you point a gun at that guy there?" I says, "Yes. I did point my gun at him." I says, "He was trying to molest me." I don't know, I made up some cock-and-bull story. He says, "Let me see your gun." He says, "You intimidated that man and you had no right to," and he took me down to the jailhouse. That was my first experience in being locked up. Merle

got an attorney for me. And I got out the next day. I worked for another year and then Merle gave me a chance to get out.

Merle and our uncle, the doctor, were partners in this machine shop. They were doing pretty well, and Merle wanted to start manufacturing screen doors. So, they asked me if I wanted to sell for them. It was wonderful. It was such a thrill getting the hell out of the field of endeavor I was in.

But it was slack times in the door business, and I didn't know too much about it. It lasted about a year, and it didn't work to anyone's advantage. So I had to find some other means of livelihood. It was my first job of selling in the field.

I began to learn that one of my greatest attributes was my outgoing personality. My ability to project my feelings and thoughts to other persons in the profitable way called selling.

And I learned that I had the ability to be a salesman.

When I was with Merle I had the occasion to meet persons in the building field, so that when this went by the wayside I got an opportunity to go to work for a lumber company that represented a door manufacturer in Detroit. It was called the Eva Door. It was a basic door used for prime construction. For complete, new, all-metal apartment construction. The door, the frame, and the thing along the what-have-you. That started me selling and dealing with builders. I stayed with the lumber company three years. And then I went to work directly for Eva. I became their state sales representative. FAYE: When he came home and told me he had this offer from the company, I says, "What's the name of this company?" And he says, "Eva." I says, "Take it! It's got to be good!" [Laughs] And it's funny, because the company was named after *the owner's* mother.

I got to know builders . . . They're *hard*. They're vicious. They're *merciless*. I always referred to them as *animals*. I've always said that *God* didn't breed people like this, that the *Devil* must have created them. That was my *first* insight into the builder.

I was *naïve*. I was running up against people who were mercenary in the sense that they would keep you dangling before a contract was given to you. They would never pay their bills on time. They would always *chisel* you for prices. They would make life *miserable* for you, as far as deliveries and service was concerned. It took *years* until I learned how to cope with this. I still find that they are some of the hardest people in the world to sell.

I've been selling them now for twenty or twenty-five years. I have learned to become a psychologist. I know the various idiosyncrasies of my customers. I know what they like me to do.

Now, I have a "captive market." These are builders that *continually buy*, year in and year out, from me. I lived with those first evil impressions of builders until I learned how to cope with this vicious group. I learned to break down the barrier of salesman and customer. *I* have become *personal* friends with my so-called captive market. *I* am just not "the salesman," I mean a salesman who sells and forgets. *I* am interested in *their* life as much as *they* are interested in *mine*. I have built up a rapport with my customer so that we know each other. It's become a personal relationship. Our lives are intertwined. *I* will socially entertain them, not merely to get a *job* but to convey my feeling of friendship with them. It consequently has changed my attitude a *great deal* from what my *initial* reaction was. But it took a good eight or ten years until I reached the point where I was able to cope with them. *For years and years*, I didn't know if I could cope with it. I had to fight to keep myself sane. And I'll tell you how I did it: with dollars and cents. The *ultimate* mercenary compensation of *dollars*. I knew that I had to sell a certain amount to earn a certain amount. And I consequently had to hold my tongue in check and bear the brunt. My customers were feeding *my family*.

I got to tell you: to this day I think any aspect

of success that I have is because *I* am still a virgin salesman. What do I mean by a virgin salesman? *I* am a virgin salesman in the sense that I'm still thrilled to sell. Every job that I sell is an accomplishment. And I get a lot of jobs because *I'm a goddamn good salesman.* I sell over a million dollars a year. Have for the past seven years. But getting back to the virgin aspect . . . I will still be so *down* that if I lose a sale I could cry. And *I* have found that sometimes when *I* have left a customer's office so downtrodden, so upset, because I've lost a job, the customer will feel worse than *I* do. I have customers that call me back and say, "Jer, I feel horrible for not giving you that job." But it's not a matter of my own ego. *Maybe it is ego,*

but to me [his voice trembles] every job that I sell is an accomplishment. It stimulates my ego. I'm gung ho. I will fight for a job. I will fight for a job *so desperately* that sometimes the customer will say, "*Goddamn it*, I'm going to give you the job and get you *off my ass* because I can't *stand* you *bugging* me any more. TAKE THE GODDAMN JOB. You *got* it! Don't bother me any more!"

I have accomplished a relationship with my customers, even though I don't sell them, *I* can go back to *any man* that I have sold in the past twenty years and *walk in* as a friend. And a lot

of them are *bastards*, like I say. But they know me. I know them.

I like people that like me. I try to instill that in them. It's a warm relationship. I have done crazy things, like take a builder friend who I feel intensely close to and kiss him on his cheek because *I* like him. *Really* like him. And that feeling is, consequently, relayed between the two of us. I like my selling. I like the talking. I like to gab.

FAYE: He's a tough competitor. I remember the first time I saw him play football at State. I never realized he could run that fast. He went *tearing* across the field. He doesn't hold back. He gives it everything he's got. He's that way in business; he's that way with me, with his children, with his mom. That's how he is. It's his nature.

JERRY: A good salesman is a man that understands personalities. I can walk in, cold-turkey, to someone who's going to build an apartment house. *He* doesn't know me. *I* don't know him. I'm just another salesman to him. *But.* I can tell you in a ten-minute period whether he's going to buy from me or not. I HAVE A GUT FEELING. There's a certain rapport—that *electrical wave*—that seems to carry through. And you can bring it out in a man.

If my company says to me, "Jer, you're the greatest contract man we have," and they offer me titles, you know what I tell them? I tell them, "Stick your titles up your hind end. *All I want is money.*" A good salesman is a man that can go into anything and SELL. *I don't give a goddam what it is*, I can *sell it!* I don't care *who* the guy is, I'll face him. If he's president, vice-president, or chairman of the board.

I'm outspoken. I'm *gregarious.* I'm *effervescent.* I have been asked, for example, "Why do you smile all the time, Jerry?" And I say, "Well,

hey, shmuck, it's the old colloquial expression, 'Cry and you cry alone. Laugh and the world laughs with you.' So I smile. I'm a Good Joe. I'm a buddy-buddy." I don't have to give people presents. I don't have to bribe people. I give ME. ME. I GIVE ME. They know *me* intimately, and *I* know *them intimately*.

Let me give you an example. I worked for Eva Door for eighteen years. *Eighteen years.* And they went bankrupt. They didn't just go bankrupt—they took about $200,000 of *my money* that had been put aside as part of a pension fund—and they spent it. Lo and behold! they went bankrupt and here I was. Fifty-two years old. What does a 52-year-old salesman do who had the world by the proverbial balls and suddenly his company goes down the drain and now has *nothing?* Well, I discussed it with a dear friend of mine. A customer. One of the biggest builders in the whole country . . . His annual earnings are $15 million a year. His empire . . . you can *imagine* what his empire is. He buys from nobody else but me. But that's beside the point. This is a down-to-earth, wonderful guy. I had contracts with him that amounted to $300,000. But they were for Eva Doors. I was *down*, I was *dejected*; and he says, "*You* hold those contracts. *Nobody* else is going to sell doors to *me* but *you*." Now he said, "You find a door company that you want to

sell." So this man's purchasing agent and I sit down, and we come up with a door that looks good. Made by Sunflower Building Components.

I meet Tony the next morning at the office, along with the purchasing agent. We sit down at this conference table and we set up a three-phone tie-in and we get hold of the president of Sunflower Building Components. A fellow by the name of Joe Gold. Tony starts the conversation and says we're interested in his door product. Joe Gold goes into a dissertation about how much he thinks of Tony and all this other garbage and he'd love to have the business. And then Tony, who's a very *dynamic*, *forceful*, *overwhelming* personality, says, "Joe. I have Jerry Gauge on the phone, on the one end, and I have my purchasing agent on the other end, and I'm going to tell you how I'm going to buy your door . . . If *you* want to sell your door to *me*, *you're* going to hire *Jerry* as your representative. And you're going to pay him the top commission. If you're interested, Jerry will represent you and we'll sign the contracts and you've got the job." He says, "*If you don't want Jerry, then you haven't got the job.*" And this guy says, "Well, I've always wanted to hire Jerry." [Laughs] Previous to this they wouldn't talk to me. Suddenly Joe said, "Jeez, Jerry! *Where in the hell* have you been? I wanted to talk to you *for a week!* I'm going to give you my *personal* phone number. I want you to call me tonight. We'll make all the arrangements right away." Tony says, "Jerry is the Man. If you can work it out with him, you've got the deal." I became Sunflower's sales rep, and that's the way it's been ever since.

FAYE: It's just a shame what happened to Tony, though.

JERRY: Yeah. They say he tried to bribe some guy from H.U.D.

Merle and Gloria

MERLE: We make parts for carburators. We make parts for submarines. We make parts for airplanes. We develop machines to manufacture a certain part at a certain speed and feed. A machine that's supposed to produce a part every ten seconds *has to produce* a part every ten seconds. We produce manufacturing equipment for the Trident submarine. We're involved with

a machine that will be drilling holes through the walls that surround the nuclear engine compartment. Right now, it takes them three days to drill a hole through there. We proved to them that we could develop certain cutting tools that can do it in three hours!

We're involved with another type of work that has to do with getting rid of the waste—the sludge—that comes out of nuclear reactors. All this is handled by robot arms in a completely isolated area. We make all the robot arms and handling equipment. Everything we make has to be *absolutely guaranteed and certified* that it'll last forty years.

We just delivered a big job to General Motors. It's a machine as big as a house . . . One man

does nothing but keep it supplied with parts. The other watches the controls. It's all automatic.

I told G.M. that due to the Christmas holidays, I anticipated meeting my schedule, but I did not anticipate them meeting their commitments. I told them that if they did pay promptly, I would give them a certain amount of money as credit. Which they're always looking for. They'll always grab what they can.

I finally got them to agree to pay on or before a certain date. I said, "I will personally be there to collect it."

Well, for one reason or another, I went there earlier; I thought I might be able to get them, due to the holiday season, to make payment maybe a couple of days sooner. But they said, "No, we're still shooting for the twenty-third." I said, "Why can't you shoot for the twenty-first?" "Well, you don't understand." I said, "I don't understand because you're the one that says so, so naturally I don't understand." So, still, "Will it be the twenty-third?" "Well, we're shooting for the twenty-third." I said, "I have to know because I'm going to be there." "Well, all right. But don't you trust us with the mail?" I said, "I trust you, but due to the weather, isn't it possible that maybe you won't be able to come to work on the twenty-third? I'm going to make it my business to be there. Can you tell me what time on the twenty-third?" "Well, we have a lot of checks to sign on the twenty-third. It'll probably be late Friday afternoon." "How late Friday afternoon? Friday afternoon starts at 12 o'clock, and dark sets in at 5. So it'll have to be from 12 to 5. Can you tell me when?" "You call us, and we'll let you know."

So, I get there Thursday night, and I call Friday morning if I could come in. "Well, we're still working on it. Come in after 1 o'clock and you'll have it."

I came in there at 1 o'clock. In fact, I came in at five minutes to 1. I was afraid I would be turned away. But they didn't turn me away. They said they'd check. So, a half-hour later, "O.K. We'll go down and get the check." After we got the check, I had to sign for it. So I just signed my name. "That isn't sufficient. You'll have to sign 'received' by your name, and put the date on there." There was also a bill of sale

that had to be signed. So, I signed that in front of two other people, and it had to be notarized. We called the notary down. And the notary refused to notarize it because he didn't see me sign the paper. So, I asked the other two people if they could witness the fact that they had seen me sign the paper. Well, it couldn't be done because on this particular piece of paper, the only witness that could sign would have to be an outside person. So I said, "I'll sign my name on another piece of paper and I'll also sign my name again under my existing signature. Will that be satisfactory?" That was satisfactory.

Then there was a meeting held telling me what an unusual and great thing they had done for me. Which was just fine. But then this one fellow says, "Would you mind showing this particular man the check you just got?" I said, "No. I don't mind." He was one of the people on the management committee. So, I took the check and I showed it to him. So, the first guy said, "See, didn't I tell you? Jews have all the money!"

When I was a little boy, this place was a city of churches, quiet on Sunday, wooden sidewalks. I remember my uncle coming back from the World War, him holding my hand, walking down the street with his uniform on. And my mother's brother, who lived with us, who died at our home. Of the flu. A handsome young man. Like a big brother. The black hearse wagon. The sleighs in those days. Few cars. I remember driving with my father, outside of town, where the troops were boarding on the main street. We stopped alongside and threw apples over the fence to them. Country living. Surrounded by anti-Semitic Polish neighbors; the same attitude: "The Jews have more than we have. Watch them. They're mysterious people."

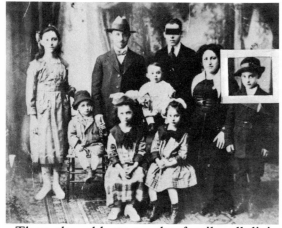

Then the old story: the family all living together in a Jewish neighborhood, transportation by streetcar, school, not worrying about anything but learning.

Lilly was the oldest. She was born in Europe. I was born in America. In 1912. There's five years' difference between us. So first Lilly, then me, then Faith, three years later, then Marilyn, who's five years younger than me, then Bernie, who's seven years younger, then Jerry, who's nine years younger, then comes Jackie, who's

eleven years younger, and then came Teddie. His name was Theodore. He got killed.

Lilly was working as a secretary, and Teddie took her to lunch. He was crossing the street, and he went behind a streetcar, and a truck came from the opposite direction and killed him. I was in high school. I got a call to go to the principal's office and I was told to go downtown, and he gave me the fare to go downtown, because he knew what had happened. I had to go to the coroner, and I remember Teddie displayed in a case with his head bandaged, and I couldn't believe, looking into his eyes, that he was dead.

We delivered the Jewish paper every morning. I got the distributionship in the area. I kept working until I got control of the whole neighborhood. Between my brothers and I, at the height of our deliveries, during the Depression, we would deliver eight hundred papers a day. I would get up, sometimes 1 or 2 o'clock in the morning, take my father's truck, pick up all the papers, come back, and start delivering them. Then my brothers would go into the dif-

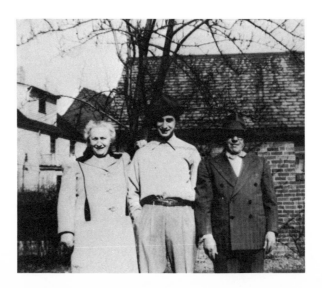

ferent synagogues, because they had at least three services in the morning. They would go in there. It meant cash money right away. We were supporting the whole family during the Depression. With tips, we brought back $60 a week.

My father made very little. He was a huckster. He had a truck. He had regular customers. But because of the Depression, he had to give a lot of credit. Everybody gave credit. The people were closely knit. But the credit always went sour. He'd get rid of all his merchandise, but he never had any money at the end of the day.

My mother and father came over here from Poland. They lived here almost ten years, and then my mother pawned everything she owned and sent for her brother Mendel and her mother. That isolated her from my father, because she put them ahead of him. During the holidays, my father was king in the house—but other times my grandmother ran the family. He'd go away at night and play pinochle . . .

I started working with my father in 1925. He made whisky and I helped deliver it. I learned how to drive so I could pick up the sugar and deliver the whisky. I was only 13 years old. My father bought a car, a Ford touring car; I would have the whisky or the sugar in the back seat, or sometimes my mother would sit in the front seat, and she would have a five-gallon can or a couple of cans of whisky under her skirts, and I'd drive and make deliveries. One time we even sold whisky out of the house, by the drink. Prohibition agents would come around and arrest you. But we always paid them off.

Then I started to repair and overhaul cars on the weekends. I learned the mechanics of the automobile in high school. Nobody else

knew how to repair an engine or repair any-thing, even repair a tire. But I made it my business to repair all those things.

I went to a technical school. That was something very unusual 'cause there weren't any other Jews there. They all went to aca-demic high schools so they could go to college and become doctors and lawyers. All I wanted to do was make sure I could always earn a living. I didn't see how I could possibly, at any time, ever afford to go to college. I saw there was always ads in the newspapers for the mechanical trades. But I wasn't interested in working as an automobile mechanic. Repairing cars is dirty, heartbreaking work. I was used to that, and I didn't care to be crawling under a car and getting a blast of oil in the face. The building of equipment was cleaner and more interesting.

The instructors at school offered me 40 cents an hour to teach math part-time. And then, four times a week I stayed and tended the tool crib for night classes for another 40 cents an hour. I used to get home pretty late. And I still had to get up early to deliver papers. I needed a car. So I went down to the junkyard with my father and we bought an old Ford for $10. I overhauled it myself. Then I picked up another job delivering meat for a butcher on Sundays. I'd get through at noon and help my brothers collect for the paper. I remember I used to play the violin a lot. I could get a lot of emotion out of it. At night, I'd open up the windows and people would listen.

Like I said, there weren't too many Jews at the high school, so, one time they pulled a gag on me. They pinned me down and tried to get me to eat a piece of ham. Big, big joke.

I graduated in 1930, and everybody got a job as an apprentice except me and a young col-ored kid named William White. We were called into the assistant principal's office and we were told point blank, "You'll have to shift for yourself because you're Jewish and you're black, and nobody wants to hire you."

My father knew a junk dealer who knew someone who had a machine shop. And he took me in as an apprentice for four years. My first job in the industry. The fellow was a Dutchman. He made automotive parts and he had a machine shop that made the tools to make the parts. The people who worked in the tool room were German, Polish, and Hungarian. They were all *tremendous*, *great* mechanics. Highly skilled, highly trained specialists. They maintained all the machines, and they made all the forms and shapes that went into the machines to manufacture a new part. To be an apprentice in those days was like being an intern to a surgeon: if a man was working by a machine, repairing something, you had to antic-ipate what tools he wanted and what he wanted done. If he had to ask you for anything, you were no good.

I went back to high school to take more chemistry and metallurgy. Then I enrolled at a vocational school to learn plumbing and heating and electrical work. And then I enrolled at another night school to take math and chem-istry for college. I was going to three different schools during the week. Sometimes I'd fall asleep driving to class. I drove myself. I don't know why ...

I got to know quite a few people in the Communist party. I was interested, but I was careful. I used an assumed name. I went to the Communist school and listened to lectures on class and labor and Marxism. Years later, when I was in business, my personnel director hired the head of the Communist labor group. I came in one morning and saw him there, and we passed each other without nodding. I gave instructions to make sure that he didn't stay, and he knew enough so that he left.

I did a lot of reading on psychology and communism and the id and the libido and Marx and Freud, and I joined the CIO under John L. Lewis. I was one of the first ones. I joined secretly. I was given 50 cents a person to get the people where I was working to join.

I was almost through with my apprenticeship. I couldn't tolerate the bosses because they were stupid. They didn't know anything about math-ematics. They always wanted to know how come, as a Jew, I was working in the shop. I told them I belonged to the Elders of Zion and my business was to find out how these different places were working so I could report back and eventually take over. I don't know how they found out I was a CIO organizer. Somebody I signed up must have squealed on me. They found out and they fired me.

I went out and got another job as an appren-tice. I was cheap help. It was 1936. Hitler was coming up, and there were a lot of British and French war orders. I was one year short of finishing my apprenticeship, but I was very skilled, and I went right up the ladder. I was a special machine operator, then an inspector, and then night foreman.

Mendel, my uncle, met Sophie Green one summer when he was back from medical school. He brought her over to the house. She was a beautiful, dark-skinned woman. She had olive-brown skin and almost looked like an Indian, with very black hair. She had a lot of drive in her. They were a perfect match.

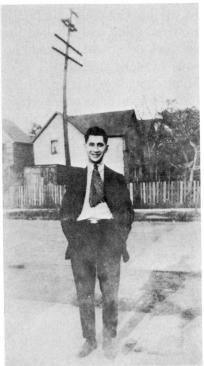

Sophie's father was an avowed Communist. Not only an avowed Communist, but a tailor by trade, so he had capitalistic ideas and became very wealthy by acquiring property.

I started dating Sophie's sister, Flo. One time, we went to a wedding together and she introduced me to this beautiful girl named Gloria, who was a friend of hers. The only trouble was that Gloria was going steady with a college boy. She intrigued me. She was a beauty, *and* she was a very good speaker at radical meetings back then. I used to observe her. I finally asked Flo to take me over to her house. I was going with Flo, but she did it anyway.

Gloria and her sisters were very popular but they were poor as church mice. Gloria's father was a radical. He abandoned his family and took up with another woman.

The strange thing was that Gloria used to take the streetcar to work the same time I'd be driving to the Dutchman's. So, every morning I'd pass her up on the streetcar and I'd wave to her! Then, after I got fired and I got another job, *she* quit where she was and went to work

at her uncle's drugstore, about a block away from where I ended up. The drugstore had a lunchroom. I used to go up there every once in a while for lunch, and I'd see her.

One thing led to another. We started keeping company. One day, I was going to work, and I was thinking what my next step would be, and I thought, "It's about time I started going steady with *somebody*." I thought it all through, and Gloria came out number one. So, I told her I wanted her to make up her mind. Whether it was going to be the college boy or me. I said I didn't want her to give me an answer right away: I'd wait for a day. [Smiles] I called her up the next day and told her I'd changed my mind. I wasn't going to wait till I saw her that night. I wanted my answer *now*. So, she said, "Yes." As far as I was concerned, she was the epitome of womanhood.

Things were pretty rough then. I was only working part-time. I didn't have a ring. Sophie had an old ring she didn't want. It was just a nothing ring. So she gave it to me to give to Gloria. We got married in 1936. I worked part-time; she worked full-time. Between the two of us, we made enough money to live on, and then things started picking up. I became foreman. I was making $100 a week or better, but there was a lot of jealousy. I was ambitious, and I was training a lot of young fellows over there. I brought in some of my uncles and cousins. I was training them, and they didn't like Jews working in the shop. And I made a lot of big changes. If I didn't like something, I'd change it to make it run better or faster. They accused me of producing too much scrap. And they fired me.

We had a union. And I was on its committee. The shop steward was a Swede who didn't know anything except "Strength in Union." He went into the boss and told him he had exactly until noon to take me back or everybody would go out on strike. The boss decided to take me back, but they also decided I was *persona non grata* from there on in.

I started looking around. One day, I saw an ad in the paper for a shop for sale, somebody going into the navy. This was in 1941. I went down there. The guy wanted to sell out and he wanted $1500. We already had our first child. We were living comfortably. I told the fellow I'd buy the place. I gave him a deposit, and I took every nickle and dime that I had. I gave my boss two weeks' notice. Two weeks later, Sunday afternoon, I was going to work on the night shift for the last time, and I heard on the radio that Pearl Harbor had been bombed. That *very* day! I took all my tools out, and the next morning, I was in business for myself.

Precision Machine Tool Company. That was almost *forty* years ago.

I was in business for a year, struggling along. I needed money, and I couldn't get any loans. That's how my Uncle Mendel got in. He invested some money . . . Then I needed some more help and I needed some more money. In the beginning, I'd asked a guy called Patrick O'Connor if he wanted to come in. O'Connor was day foreman when I was night foreman at the place I quit. I asked him, but he didn't want to 'cause he was making good money. But one day I was coming into the shop, and *there* was Pat O'Connor, standing outside, in front of the door, and he said, "I made up my mind. If you still want me, I'll be your partner." So that's how he got in.

I took my father in. I taught him how to run a machine. I worked seven days a week, seven nights a week, in a little double garage with a pot-bellied coal stove in the middle. It was so damn cold in there sometimes. I'd have that thing red hot, the wind blowing in there, and the machines creaking, cold hands and everything. It was [softly] really something. And in the summer, it was just the reverse.

Things progressed after Pat O'Connor came in because I had more help and a bigger volume. We needed a bigger place. I found my old boss was moving out of his place, so I leased it. I was back in the building where I'd originally started.

Pat O'Connor became the outside salesman. I did the inside work. Mendel would come in and visit and look at the books. He wasn't knowledgeable about engineering. He just had money invested. What he did do was get involved with the legal end and the banking end . . .

Pat was out on the road because customers

would accept him much easier than they would accept me. In this business, it helps *a lot* to be Christian. Pat was a good Catholic and a good drinker and a very good host—this goes over great with these guys, especially if you're a good drinker . . .

During World War Two, the Cadillac plant was making tanks for the government. We got heavily involved there. Pat did it for us. He got very close with some of the top people over there: dinners, drinking parties, personal contacts, clothes, and other things. We were involved real deep with them. Very profitable . . .

We made all types of tools, and we trained their help to run machines to make tank parts. We did a lot of engineering work for them. It was a tremendous operation. They were hiring anyone they could get their hands on. We paid for people's vacation trips to New York and California. From the top on down . . . That was

the only way you could deal with them . . . But that was the only way they could get it done, since there was so much to do. You couldn't do it normally. You had to be with them twenty-four hours a day, seven days a week.

There was one company we were dealing with—we could have ended up millionaires, but we were naïve. If somebody ordered from us, we sold it to them. But other guys took advantage, made a lot of money, and cleared out. A lot of people were selling them steel and accessories. Say someone would get an order for a ton of steel from this company—call it Company A. Instead of shipping them a ton, they'd ship ten tons of steel. Said it was a typographical error. Company A wouldn't ship it back, they'd pay them off, and that was that. But no one actually weighed ten tons of steel in there. Maybe they got five tons of steel. But they paid for ten. And then they split the money.

Or a company would change the standard specifications in the blueprint so it would only be to their standards and no one else's—which were all fictitious. Like instead of printing "phone" they'd get Company A's engineer to print "telephone"—which was supposedly supplied only by Company B. It didn't mean a goddamn thing. But every time the plans would call for "telephone," Company B would make it big. They still do it . . .

After the war, there were a tremendous number of things that went on. The government closed the war plants and started to sell the plant components to private industry. You'd come to buy a piece of machinery that had never been used, and you knew the officials that were going to sell it. They'd have to put a classification on it. You'd offer them $1000 to classify it as scrap. Pay $500 for something worth $50,000. Meanwhile, no one else could buy it because the guys you'd paid off had pulled it from the inventory. The Russians were even paying people off, so a lot of stuff left the country under false pretenses.

I went to one plant here in town that had closed up. I backed a truck up and took out all types of small equipment, thousands of dollars' worth, that wasn't even in the inventory. All I did was pay the shipping clerk something.

Or the government would move the stuff out, pack it in cosmoline, and put it in the warehouse. Then, let's say, Comstock Machine Tool would start selling the government "new" equipment. Maybe all Comstock would change would be a couple of minor specs. But they'd say it was "new." So the government would declare all the unused stuff in the warehouse "obsolete." Then Comstock would buy the equipment for a depreciated amount of money, update it with a few minor changes, and sell it back to the government as "new." Stuff sold and resold! Oh! Some of these things were *unbelievable!*

In 1946 the CIO Electrical Workers Union tried to organize my shop. They figured the place would be easy, since I'd been involved with the union before. Once they got the place organized, they called me downtown to the Labor Relations Board to negotiate with them. I was the only one who got involved because I'd been in the unions and was able to talk with them on a common level. They refused to show me the membership cards. All they did was show me they had them. This one organizer, who was a Commie and later went to jail for it, got up, walking up and down, and making speeches and carrying on. So I got up and said, "I'm leaving." The labor negotiator said, "What do you mean? We're negotiating!" I said, "We're not *negotiating.* I'm listening to a lecture that I've heard before!" I walked out. He followed me out and said, "Let me calm this guy down and we can talk." I said, "I'm willing to recognize the union, but not the way they're going about it." I went back in.

So I had a union. But only for a while. Because I fired the shop steward and made it stick. I kept a pretty good log on what he was doing and what he wasn't doing. And then I fired him. I said, "Jack, when you punch out, don't come back." So they appointed another shop steward, and this shop steward said, "I'm going to teach you a lesson. You're not going to fire me the same way you fired Jack!" I said, "I'm not looking to fire anybody. All you've got to do is your job, and I'll recognize you." Well, he didn't do his job. One morning he came in, and I said, "Frank, you're fired." You had to strike at the head, you couldn't strike at the individual. So I fired two shop stewards, and that settled that. I broke the union.

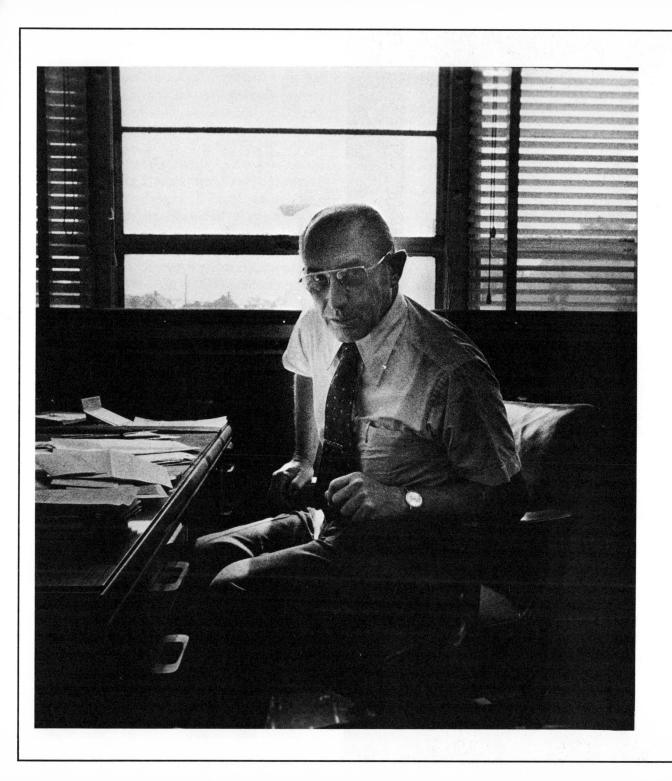

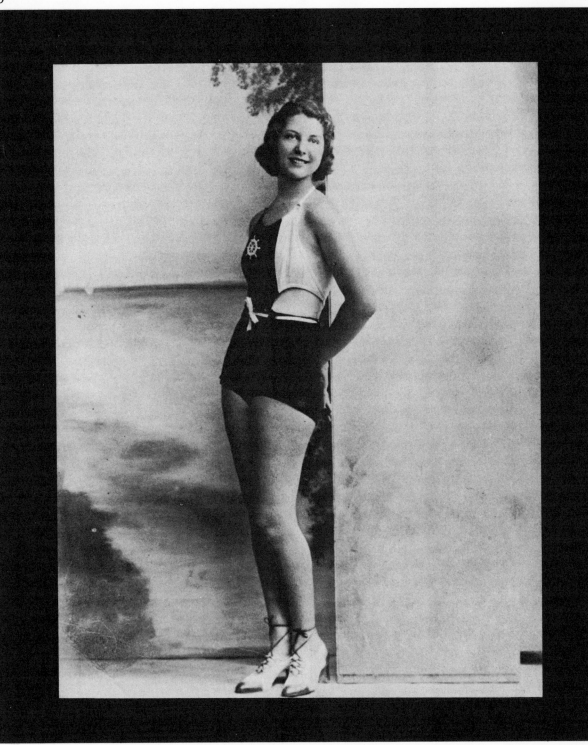

GLORIA: As far as I can recall, Merle and I met at a wedding. Sophie Green's cousin was getting married. Her whole family was there. I was there because Sophie's brother, Nathan, asked me to go as a date. I was a friend of the family. That's what I was doing there. What Merle was doing there, I really don't know. Maybe he went with Flo. I think everyone would have liked it if he had married her. Anyway, that's the way Merle and I met. I was only 16.

Then, after that, I kept on seeing him on my way to work, on the streetcar. Then he started taking me out and sort of *watching* me. I'd be out on a date with some fellow, and Merle would just be there and kind of watch me. I'd be sitting with a date, eating a pecan roll, and Merle would be sitting over there with a boy-friend. [Chuckles] And then, when I went to work at my uncle's drugstore, all of a sudden, Merle was working around the corner. It must have been coincidence. He just kept coming around the store. I was going with someone else, but . . . Merle was just very, very persist-ent. He didn't let me go. The other boy wasn't too anxious to get married, and Merle was *very* anxious and he really kept after me and . . . I just made a choice. That's what it was.

The other fellow was very charming. A charm boy. I thought Merle had his share of charm ... but ... the other one, whenever we went somewhere, he was so full of charm that everyone just *hung* on him and no one ever noticed me. I think one partner has to be willing to be a little quieter than the other and more admiring of the other, and let the other be admired. Not that Merle is so shy and retiring. But he's always let me get my share of glory. He thought I was the apple of his eye. He still does.

My mother and father were both from Russia. My mother's father was a very handsome man. But he died very young. My mother's mother was a very vain, very hard-working woman. She took in boarders. My father's father was a very handsome man, too. Beautiful blue eyes and gray beard and tall, and he was very successful financially. He owned a bag factory in Canada. He was rich but very stingy. One time he went to the doctor in rags so he couldn't charge him too much.

I don't know how my parents met. But they

met. My mother was *very* beautiful. And very vain. Just like her mother. I guess a little of that rubbed off on me. I'm vain—I'll admit it.

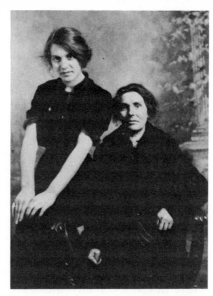

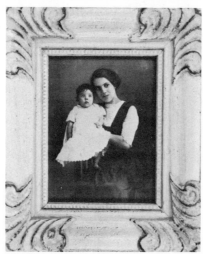

My father, all his life, was a dreamer. An idealist. He never was very good at making a living. I don't know very much about him. He was gone so many years. He probably was never good father material for five kids. He became

interested in communism and reforming the world, and literature, and music, and paintings.

My parents lived in Canada, and I was born there. May. 1915. A Taurus. My sister was born there, too. My father ran a grocery store. My mother had an older brother who was in the building business here in Buffalo. So he kept saying, "Come to Buffalo and come into the building business." So they finally *did* come to Buffalo, and he went into the building business and they lost everything, and they went back to Canada. Meantime in Buffalo were born three more kids. We went back to Canada, and my father opened another grocery. Where I stuffed myself. That wasn't too successful, so we went back to Buffalo. I was 11 years old. My father opened an ice cream store. I ate a lot of ice cream. Then I guess he finally took off. He just left town.

He couldn't handle the responsibility. He was a radical. It was his ... true love, and my mother was stuck with the five kids. She was the kind of woman that always wanted things to be *perfect*. Her mother always put on airs. You would have thought my grandmother was a madam queen. She was always dressed up and made up. Her hair *perfect*. The table, *perfect*. Everything had to be perfect, and my mother was like that, too. We always had a beautifully set table, and you would never know anything was wrong in our family. My mother was very proud of us and talked about us a lot to the point where I'm sure everybody wanted to kill her. It was very embarrassing for us because she'd talk about us so much and we were nervous when anybody met us. We knew we just couldn't live up to that image that she had given out. We didn't want to live up to it. My father just couldn't handle it. He wasn't interested in appearances. Or anything else that had to do

with raising a family. Like finances.

When I was a girl, I was very shy . . . We all were. We were poor. My father was scrounging around, trying to make a few bucks, and I remember when we really didn't have quite enough to eat, but we'd laugh about it. The teacher would ask us what we had for breakfast, and we'd pretend. We'd make up a fancy menu. Cocoa and pumpernickel were our favorites. When we were at home, we'd dance around the house and sing at the top of our voices. While we'd do the dishes or make the beds. A couple of us would make a bed and we'd always say, "It's always easier when two make a bed." Later on, we used to sing all over the streets. We'd sing [she sings]: "They don't need a band/They keep time by clappin' their hands/Happy as a lark/When the darkies beat their feet/In the Mississippi mud." We even had a dirty one [she sings]: "Violate me in violet time/In the vilest way that you know/Viciously, savagely, ravish me, ravish me/On me no mercy show . . ."

I had a few girl friends, but it was difficult because we didn't have much even in the way of nice furnishings. It was embarrassing to bring people to the house. Even though my mother took a lot of pride and we covered up and all that, I'm sure that it wasn't a normal kind of household when your father is not home very much. It's not very normal. Divorce wasn't that common. People whispered about it in those days.

My mother worked as hard as she could. She did everything. She sold door to door. She sold picture frames. She sold hosiery. She did a million things so that she could support us but not leave us alone when we were young. Then, when we were older, she started working as a practical nurse. She did that for many, many

years, almost until the time she died. She took care of babies and infants when they were born and that sort of thing. Somebody was sick and she'd step in and cook and take care of the house. My mother really supported herself. We never helped her. She wasn't like my mother-in-law, who just sits around, selfish, waiting to be given. For her sons to come. To take care of her. Like she's going to die any minute. We never helped my mother. She worked till she died. She was independent. She'd work and make money and then she'd take a trip— 'cause I had a sister living out in California— she'd go out and visit my sister. She took care of my children when we went on vacation. Then she'd go to Florida for a winter, and she'd work up on the roof part-time doing massages and stuff so she could earn her money to stay in Florida. We never gave her any handouts. She never, never took any money from us. When she died there was just enough insurance to bury her. She had a colostomy about eight years before she had cancer. She had a colostomy, but she always looked like a million bucks. No one ever felt sorry for her.

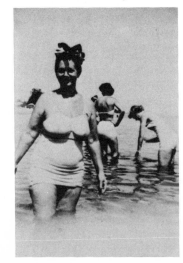

I finished high school in 1931, and I started working right away. I wound up working in a drugstore that one of my uncles owned. It was right in the middle of the used-car district. The place was booming. Everybody came there. We had a lunch counter, and customers would come up to the cash register and flip double or nothing for the bill. The place was packed all day long. One time my uncle asked me to go dancing. [Laughs] My aunt was tough. She was always on his back. And he liked to have a good time. He liked to go out and dance. But he was too short for my aunt, and he was too short for me.

Merle and I got married when I was 23. We had our first child in 1941. Merle went into business at the end of that year. We started off in an apartment. Then we moved to a two-family house. We lived there two years, and then we bought our first home. We lived there eight years. We had two more children. Merle started really doing nicely. Then we moved again. We bought another home, and just about the day we moved in, and I thought it was a

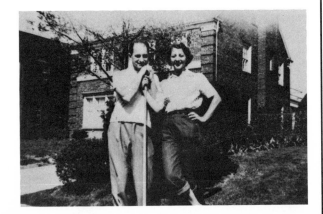

pretty nice house, Merle says, "Well, this'll do until we build our own." So I knew that was temporary. We lived there five years. And then we built our own house. We kept it until all the kids were grown, and then we moved into a very nice apartment. But it just wasn't big enough, so we bought a nice little house,

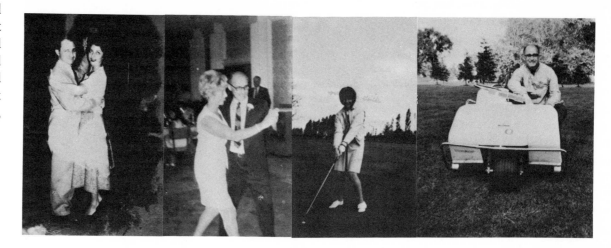

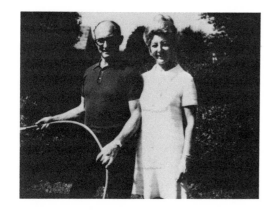

here in town. And, of course, we have the condominium in Florida.

We always enjoyed ourselves. We always enjoyed dancing. After our second child we went to a resort in the Borscht Belt and—that's thirty-four years ago—that was the first time we saw Latin dancing. And we just flipped for it. When we came back, we took lessons and we really got interested in knowing how to do ballroom dancing.

He's really crazy about dancing. Even more than me. I don't know how he does it. I don't know how a man can put as much time and effort into his business as he does and still have the energy to go out and do things but he does...we do...We go out to nice places. We play golf and tennis at the club. We enjoy our vacations. We really have a nice time. Otherwise, I guess it would be awful, but it's not totally.

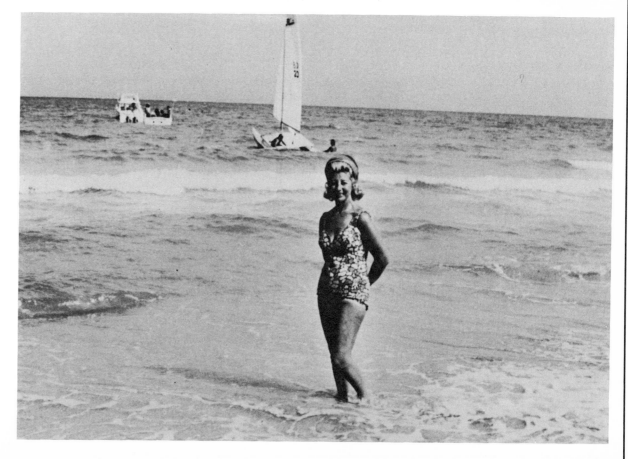

Jimmy

JIMMY: My parents met at a party. It was some left-wing function. My father was *very* interested in left-wing affairs. My mother probably just went along for the ride. My mother told me that she was just awed by him because he was a very handsome man. He was wearing a white suit.

My father's name was Nathan Green. My mother's name was Dinah Beeman. They were the same age when they met. They were both 36. Very late in life.

My mother lived very nicely. She told me she had the first two-tone tan Oldsmobile coupe in Buffalo.

My father was a very tall, very handsome-looking man. Movie-star looking. He was, many times, stopped on the street because he looked like Robert Ryan. He did not look at all to be —of the, ah, Jewish race. That caused some interesting vignettes in our life. I recall once going to Chattauqua with them in 1945. My father and I walked into one of the lodges. And they said they'd be happy to accommodate us. Then we brought my mother in, and right away, "Your kind stay across the lake." My mother was far more Semitic-looking than my father.

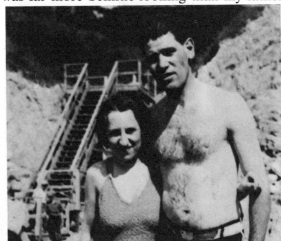

At that point, my father, who was not a violent man by any stretch of the imagination, reached across the counter and grabbed this little twerp. He was ready to make him into part of the floor. My mother controlled him.

I was born fourteen months after they were married. September 23, 1937.

I suppose I could go into a lengthy discourse about my relationship with my father. My father: a very *intelligent*, self-educated person. Very much into politics. He read constantly. He was very *cultured*, in the sense that plays and music and opera were most important to him. He also was a very fine gardener. He never had any trade. When he was young, I believe, he sold insurance. And then he managed an A & P store. His uncle got him a job as a traveling salesman just before I was born. He sold maternity clothes.

I didn't have much of a relationship with him. He was on the road, constantly. He *enjoyed* it. It became a way of life. He worked. But he never made any great effort, when he was back, on the weekends, to spend any time with me. He seemed to have a very difficult time accepting the role of parenthood. He never made any effort to take me to any of the things that I might enjoy. I was interested in sports. He wasn't. Those few things he did take me to were probably at my mother's urging. Everybody told me what a wonderful person he was—they told me subsequent to his *death*—and I had to nod in agreement, even though, in my own experience, that wasn't necessarily so. He wasn't nasty. Not by any stretch of the imagination. He was . . . a pleasant person. But I recall he would come home, and he would go spend the time puttering around the house or gardening. He had a big vegetable garden. I would stand there, with "the corn as high as an

elephant's eye," hating every minute of it. My mother would force me to go out there and help him in the garden. Which I didn't like. Here's the picture. I have this rather bored look on my face like, "All right, I'm here. Take the goddamn picture." Be that as it may. That was his bag, not mine.

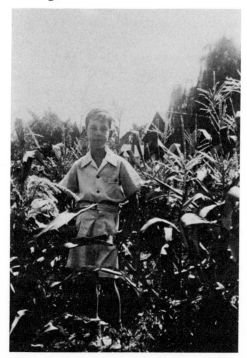

He was into left-wing politics. He probably was a member of the party. The Communist party. That created some great misgivings and tensions when I was growing up. Particularly in the 1950s, when I was a "sensitive teenager." In the late 1940s, he took me to sell the *Daily Worker* at an industrial plant. I remember being spat upon and being called a Dirty Commie. All the wonderful things that people will say. I remember one other particularly shocking experience in my life: I brought a friend home, to study with, from high school, and he spotted a copy of the *Daily Worker* on the sofa. He said, "What's that?" I said, "My father picked it up, just to read it, you know." I shudder when I think about it.

I found it to be a very difficult thing to accept! You have to remember the times! The Communists were the enemy within and without; to be a Communist or to have any identification with communism was considered traitorous and treasonous. I understand it better today. But while I don't in any way, shape, or form have any Communist or Socialist views, I can appreciate why the people became involved in it. My father got involved in it because of *his* father, Joseph, who was *quite a liberal* thinker, as well as a tyrant and a bastard.

On *at least two* occasions the FBI came to our house, and on one occasion they called my father on the phone. An anonymous phone call on a Saturday morning. It was very frightening. I was 14 years old. I was in the bedroom. My father became *very* upset. He told them to go to hell. Then the FBI came to visit the house. I was there. It was frightening, very frightening. They were asking information about other people and saying that they had the records. He said, "I don't care what damn records you have. It's not going to bother *me*, and you

can get out."

My mother handled all that very well. My mother was a great admirer of my father. She was a very intelligent woman. Very well read. She didn't have anything else to do once she was married. So she read. She was very attentive to me. I was her only child. She doted on me. Probably more than she should have. I

suppose she spoiled me. She pretty much let me have what I wanted. My mother encouraged me to go into acting because that was something that I loved very much. Had my mother lived, I might have become an actor instead of a lawyer.

It was my mother who raised me. My father was a presence without a substance. Then, when I was 10, my father's sister, Flo, came to live with us. She was unmarried at the time. She was very fond of me. She was almost a sister to me. She was twenty years older, but she was a lot of fun. She ran my Uncle Lenny's golf course after he got drafted during the war.

We lived a very nice life, under the circumstances. When I was older, we lived in a brand-new house. It was in a very nice neighborhood. There were no houses on either side of us. My father used the field next door to plant a garden. Behind us was a country-club golf course. And on the other side of the house was a lot where we used to play our sports. I was considered one of the leaders, if not *the* leader, of the neighborhood. The house was always open for everybody. I was sort of like the social chairman. I was always *very* popular as a kid. When I went to camp, my last few summers, I was head of the cabin and the baseball team. It was always very pleasant for me. I was always *very* accepted. I didn't have any feelings of rejection.

My grandfather, Joe Green, was a cutter in the garment business. Somehow, he got into real estate. And he bought this very large, old, somewhat colonial house. Which we went to on rare occasions because my mother couldn't stand the Green family. Joe Green was a real bastard. He treated my grandmother most shabbily. Eventually divorced her. He treated

his children very shabbily. He was a scoundrel. He physically abused the children as they grew up.

He was a scoundrel because: one, I have heard stories of his extramarital activities; and, two, while he was being successful in real estate, he never passed that success on to his wife, certainly not to his children. He was a tyrant in the house.

My father would go see him. Because he was the eldest son. I think he had a real love-hate relationship with his father. I think he *wanted* very much to be like him. His father became successful. And he was a tyrant. I think that my

father would have liked to be more like his father. He would have *liked* to have been a greater financial success. And I think that had he been a greater financial success—not that he didn't make a good living—but I think that if he would have become a true capitalist landowner, like my grandfather was, he would have dropped many of his left-wing views.

I remember one occasion when a left-wing lawyer friend of my parents called up my father and said he had obtained a Fleetwood Cadillac, in the 1950s, for a fee. He knew my father traveled. So he said, "Nathan, you ought to have a good car to travel in. Here's a great car. You can buy it for $2500." A very favorable price. My father *desperately* wanted that car. He thought it would be great. And [louder] *I* desperately wanted it. Because that would be great, to have a Cadillac. But my father finally said, "I can't, I can't do it, because I'd feel like a capitalist."

We used to spend time with my Uncle George and my Aunt Blanche. My father was never comfortable with them. Because they were truly *nouveaux riches* middle-class social climbers. Particularly my aunt. My uncle, after World War Two, got involved in the steel business. He had never made any kind of a living until, all of a sudden, through the good offices of his wife—social climbing—he met a fellow and they went into the steel business. Then he started to make a tremendous amount of money. In those years, he was probably making $70,000 or $80,000. Because of the income disparity between my parents—who made a comfortable living—and my uncle, there was tension. The fact that George had made *so* much money *so quickly* always bothered my father. Because George was a very unintelligent, uncultured, unsophisticated person who happened to get

this lucky break.

Then my father tried to make more money. He tried to sell other maternity lines on the side. But his own company found out and they fired him. It was right before he became ill. During the time my mother was sick.

My mother was sick for about five years. It started in 1950. I guess maybe he knew that my mother was ill. They did blood tests on her, and he was told. I remember this story: when the doctor told my father what my mother had—Hodgkin's disease or one of the blood diseases—he passed out in the office. She was constantly in and out of the hospital. The treatment was primitive. She was constantly sick. It took a tremendous toll on my life, because—ah—I—ah—I lost the stanchion which I had always looked up to.

Of course, I never knew that my mother was terminally ill. I *never knew this*. I was a *child*. I was involved with my own things. Until—it was my first year in college. She died in January of '56. I suspect she was diagnosed in '51. I never knew how bad it was. I knew she was very sick. She had a bed downstairs in the dining room. She had a nurse.

My whole senior year in high school—which was a *great* year for me, I had a great year in high school, and a bunch of friends that I *really* liked a lot—my mother was dying.

My father became ill in June of that year, my senior year in high school. But never told anybody. He was home a lot more to minister to my mother. He was wonderful to her. Whatever was necessary to do, he would do. Cook, clean. Any of those things. He had multiple myoloma. Same category as what my mother had.

In October 1955, my first year in college, I was pledging a fraternity. And the fraternity became very important to me. We did a pledge

prank which kept me out of the house until almost midnight. I left my mother alone. She was immobilized in her bed. And my father was out of town. He was working, and I was supposed to be—she had a nurse during the day, but I was supposed to be there at night. And—typical, inconsiderate college kid—I had gone down with my friends, and left her alone. Fortunately, nothing happened. My father came home that weekend and he took me upstairs, and he explained what was going on. And he was just furious with me. It was the only time I can recall his raising his voice to me. Calling me selfish. And then he told me. And it was a very traumatic thing for me. How serious she was. I didn't know. And, almost a week or two later, they took *him* into the hospital. And they didn't tell me that, either. My uncles told me he had osteomyelitis. That's a degenerative bone disease. It didn't sound like a big deal. That's what Mickey Mantle has. All it did was stop his career. So I said, "O.K." But I could see my father going downhill. And finally I insisted they tell me.

So, my mother died in January of '56. And my father died in February. That's the end of Nathan and Dinah Green.

Their will provided that my guardians would be Uncle George and Aunt Blanche... So I went to live with them. They were inconsiderate, insensitive people. I'd play classical music, because I grew up in the type of house I did. I'd play classical music and George would come running in, screaming, "*Turn it off or turn it down!*" I remember once saying I was going to see Beethoven's Ninth Symphony. And I was all excited because I had the *last two tickets*. And I was taking a date. It was a Sunday afternoon. And he sneered at me and he said, "Don't you know there's a *football game on?*"

He said, "What's the Ninth? Is that the last hole?"

I lived with them for four years while I was in college. My parents had left me well provided for. I had enough money to go to college, law school, and live *very* nicely. And, I started identifying with material things. I started buying

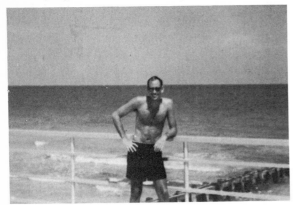

automobiles. I took my parents' cars, and I traded them in and bought a 1956 black Chevy convertible. This is the *same* year my parents die. I buy this car. I'm 18 years old. I'm buying clothing. *Anything* I want. A year later, I ripped the Chevy all to hell, so I traded it in for an Alfa Romeo that was a lemon. And then I traded that in for a Ford. I went through five cars in three years. I couldn't stop buying things. It was a disease. I didn't need all the things I was buying, but it made me feel better to have them. I had a lot of clothes. And I was building up this large record collection. And I was buying stereos. I was going on dates and never thinking about money. Now, I know *exactly* what was going on: I would not tell anyone what the loss of my parents meant to me. I was *very* bitter. I was very *hurt*. I was in shock. For a *long*, *long* period of time. Much more than people ever imagined. I overcame a lot of it by becoming a wise guy. People would say to me that they

were just amazed at my affability and my sociability. That I'm not showing anything, et cetera. And I never did. I never did show it . . .

All through college, whenever anyone asked me what I wanted to do, my answer was that I wanted to go to Harvard Law School and be a lawyer. I don't know why. I guess because I'd always wanted to be an actor, and there's a good bit of acting that goes on in law. And since I'd always liked the good things in life, I thought, "If you go to law school, go first class, go to Harvard." But Harvard didn't accept me. I got into Columbia, Chicago, Michigan, and Cornell. I didn't go to Columbia because I was *afraid* that, if I was in New York City, I would go completely berserk. So I went to Michigan . . .

But I didn't study. I had a good time. I had a great time. There were girls from all over up there. We had girls for weekends where, by the end of the weekend, I couldn't talk. We were having a really good time. We had a house, and we painted it completely blue. Including all

this gorgeous carved woodwork. When the landlady found out about it, she [laughs] died two weeks later. We had a good time in that house.

My first two years, school was very boring. The third year, I liked it. And the third year I met Ann. I had been dating an acquaintance of Ann's in my second year. This girl—she just wouldn't leave me alone. She was out to get married. And I had no more interest in marrying her than I had in marrying Lassie. I decided that—well—since she was hot to trot, so to speak, I'd invite her to visit me in Buffalo. She thought she was going to stay with my cousin. But I never told my cousin. She said, "Are you *sure?*" And I said, "Yes." In those days, a nice girl didn't do things like that. I convinced her, when she got off the plane. I said my cousin was gone, and that she'd have to stay in the house. "But," I said, "when you see the house, you'll see it's a big house. You don't have to worry. You can just stay upstairs, and I'll stay downstairs." She was very hesitant, but I talked her into it. When she saw the house, right away, she figured she was going to get married to big money. She kept walking around the house, looking at it. Eventually, it ended up that I was—ah—forcing my affections upon her. And she went back to Michigan under not very pleasant circumstances. [Laughs] She told everybody to watch out for me because I was a son of a bitch.

I met Ann at a party. She was a senior in college. I was three years older than her. I called her up to ask her to go out with me. She was intrigued. So she went out with me. Things happened very quickly. She was very intelligent, very physically attractive; she had a very good sense of humor. She was mature. She was a leader. She was just right. We had a great time. Quickly. We had a weekend in Detroit,

three weeks into our relationship, and we decided to get married then.

I graduated from law school, went into the army for six months, and we got married. Then I got a job offer from the Chief Counsel's office of the IRS. Nothing terrific. It lasted five years. And I enjoyed it. We had a *great* time in Washington.

We came back to Buffalo in 1968. I felt I would have an *entrez* to Buffalo because I was a native. And I liked the city. It took me a while to get a connection, though. I had two jobs that just fell apart on me. I was getting pretty down and pretty bitter, and then I caught a lucky break. I was approached by a lawyer who I'd never known. He got my name from a guy I'd roomed with at Michigan. He asked me to come to work for their firm. It worked out very well. I stayed with them for three years and then, in '72, some of us formed a firm of our own.

About February 1975, I received a call from a friend who I'd worked with in Washington, who was practicing in Chicago. He said that a client of his, who was a very successful businessman, entrepreneur, investor, was interested in buying the Great Northern Bank. And— would I be interested in representing him? I said, "Certainly, I would."

Within a two-day period, I learn that the Great Northern Bank may be going into default. It's starting to hit the newspapers. I'm on the phone constantly with these people, telling them what's going on. So this lawyer friend of mine says, "Well, maybe I ought to fly into Buffalo with my client."

I said, "Fine." I met this fellow: a fairly young man. He tells me this incredible story: he owns a big cemetery. There's property adjacent to the cemetery that he wants to subdivide and build on. He needs funding. And he can't get any in Chicago, because he's strung out with every Chicago bank going. On all his enterprises. Cemeteries. Funeral homes. Apartments. Real-estate developments. From coast to coast. He has a yacht; he has an apartment in Acapulco. He's got an income of about $8 million. He's signed about $40 million in loans. A very interesting guy. He started as a grave digger. [Laughs] In Minneapolis.

He had a mortgage broker in New York. And this mortgage broker told my client, Eliot, that there was a bank in Buffalo called the Great Northern Bank that was a new bank, very aggressive, and looking for new loans. So . . .

Eliot calls up two characters named Copely and Gerig. Copely's a Yale graduate who'd been fired from one bank already. Formerly, president. There had been some talk that he had given loans to his friends, his wife, et cetera. And the other character, named Gerig, used to be State Superintendent of Banks. He gave a lot of bank charters and received a lot of money for this. These guys are in charge of the Great Northern Bank.

So. He gets introduced to these two guys and they say to him, "Eliot. Tell you what. We understand you got a lot of good contacts in Chicago banking. We want to buy two more banks. But we need the money to do it. If you find the money for us in Chicago, we'll give you a $600,000 open line of credit so you can set up your cemeteries." So Eliot says, "Fair enough."

Copely and Gerig took their own bank stock—which already had been pledged—and went to the Drover National Bank in Chicago; and, in twenty-four hours, they obtained a million and a half dollars' worth of credit to buy these two banks. Because Eliot, my client, vouched for them. At that time, there was a lot of swinging going on in banking.

So, Drover gives them the money. These guys sign. They'd sign anything. And they buy these two banks. And within about three weeks the Great Northern Bank is called in by the FDIC because their liabilities far exceeded their assets.

Meanwhile, Eliot gets his $600,000. Draws it down. Signs a note. By the corporation as well as by him personally. And he walks away.

I call him. I say, "Eliot, the bank just went under." He's very nervous. He says, "How do you think this thing is with me?" I says, "Well,

it isn't terrific, but I don't really see any problem at this point . . . "

Nothing happens for a while. About six months later, I get a panic phone call from Chicago. Eliot says, "I just got called by the FBI. They're going to interview tomorrow. I want you to be here with me." So I said, "All right." I hop a plane to Chicago. Eliot, in his usual style, has his Cadillac limousine pick me up. And takes me to his offices. Where there are these two rather fatuous FBI men. Who are completely *insane*, *stupid*, *moronic*. Asking the dumbest questions. They have a lot of trouble understanding the nature of the transaction. We had to go over it seventeen times, that Eliot just *introduced* Copely and Gerig to the Drover Bank. He didn't sign anything. They couldn't understand: a million and a half dollars? In twenty-four hours? He said it was just the spirit of the times.

Annette

ANNETTE: His name was Daniel Halevy. He was born in New York City. His father was Charles. His mother, Rachel.

I don't remember where he came from. Somewhere in the Ukraine. He told me his father went to seek his fortune. He went to Capetown. He left Rachel in Europe. They got married and he left her to seek his fortune. Which I guess everybody used to do in those days.

He settled in Capetown. Capetown! I haven't the slightest idea why he went there. Started a cab service. And was there about four years. I guess he made enough money. Came back to Europe. And they decided to come to the States.

They settled in Connalsville, Pennsylvania. Outside of Pittsburgh. Uniontown. Around there somewhere. They *settled in Connalsville*. My father-in-law opened up a general store. And, of course, the miners were there. It was a mining town. And he did very well there. As he began to make more money, he sent for *the whole family*. Brought them *all* over to America. And they all settled in Connalsville. He brought over his sisters. He had brothers, sisters. The Halevy family was a big family. My mother-in-law sent for *her brothers*. So they all settled in Connalsville. Like a tribe.

My father-in-law did very well.

Then my mother-in-law had children. And I guess the first four—she had a daughter, the first one, who lived to be about 4 years old. And she died. Of intestinal flu. Diarrhea. They died like flies. Then she had two boys. And they both died. At birth.

So, when she became pregnant with my husband, they decided she should go to New York to have him. That's why I say he was born in New York City. And then she came back to Connalsville. They stayed there until my hus-

band was about 9 years old. Then they came to Buffalo.

And, what can I tell you? When I first started going with my husband, I was about 15. I really wasn't serious with him until—well, he made me a "sweet sixteen" birthday party. And then [smiles] I began to notice him. [Laughs]

See, I have a story, too, and I'll have to combine it to make you understand. I was an orphan at 12½. The oldest of five. I had to quit school to go to work. It wasn't easy in those days. My mother had had a breakdown, because she had married off her only sister, two weeks after my father died. So it was quite a *blow* for her, and nobody . . . She had a very trying time. And that's why I went to work. Fourteen and a half and I went to work.

How I met my husband, I don't know. At a party or something. He was helping his father. His father had an A & P store. They owned a lot of property. The Halevys were not poor people. They accumulated a lot of money. Bought property. They opened up this big store. And he helped his father after school. He was going to a technical high school.

I met him [as if reciting a boring poem] at a few parties. He was a very quiet, reserved person. And I was [with feeling] more gay—I loved dancing. He was very quiet. But he was good for *me*. And we began to notice each other. And even though I had a *lot of company* at the house and all, I began to look to him. Maybe he . . . maybe he made me feel secure and all that. I don't know. He just gave me that feeling. And [in a bored voice] before you knew it—we were going together.

Well, we went steady until I was just 20. If it was up to *him*, we would have got married right away. But my in-laws wouldn't think of it. They called us a couple of *young ones*. It wasn't *right*. And this and that. But I guess it had to be, you know? So. When I was 20, and he was 21, we got married.

First, from his father's store, he used to—with a horse and wagon—deliver sugar. And salt. To the bakers. My father-in-law was a distributor for American Sugar Refining Company.

He used to have all that in a warehouse.

There's a little story there.

The night the Parrelli Brothers got killed. The Parrellis and the Lenardos—they had a *war* between them. During Prohibition. They had a shoot-out. My father-in-law was a wholesale sugar distributor. Well, *overnight* he was *bombarded* by people who wanted to buy sugar. Prohibition had come in; you couldn't buy sugar; you needed sugar to make whisky; so anybody that could supply sugar could name his own price. So, *overnight* they came to my father-in-law.

Well, since my father-in-law was such a big distributor, he could get all he wanted. The money! Just name it! That's *how bad* they wanted sugar. Overnight the Halevys became the Sugar Barons of Buffalo.

Then, one day, nine months later, I met [endearingly] *Elliot Ness*. The *nicest* guy. My husband introduced me to him. And—I'll never forget this—he said to my husband, "You know, Dan. You're *such a nice young man*. Get out of this. Get out of it." And Dan did. Because—you know—what did he need it for? He didn't need the money.

Mr. Ness came to the store. And sat down. He was a *lovely person*. Yes, he was. And took *such a fancy* to my husband. *Yes, he did*. But that's the last time we heard from him.

Because my husband started thinking. He had a mind that always looked ahead. He started thinking about a rubber factory. He started thinking about *automobile floor mats*. 'Cause he was looking for something to do. And he started buying mats. Automobile mats. And he set up a retail business. [With sweet delicacy] O.K.? He took part of his father's store. And that's what he set up as an *office*. And he started contacting customers.

Then about a year before we opened up Keel Rubber, *he started thinking*. And I never forgot this: "Why should I buy retail when I can make them?" [With the same sweet delicacy] O.K.?

He began to do a lot of research. And—I'll never forget—he went into the back, and he said to his father, "Dad. I want to open up a small plant. We have to make mats." So, then he says he needs *capital*. So, my father-in-law went to the bank. He had a good name, and he got him the money.

And that's when they opened up a small rubber plant. That was in 1932. We'd gotten married in 1931. Then he contacted *a very brilliant* chemist whose parents were *real* high-class Yankees. The Pierpont family. And Peter—their son—had just started out. He was a little older than my husband. In his late twenties. A very eccentric person, but *brilliant*. He became our chemist. Then Dan got himself a *brilliant, brilliant* engineer! Carl Cadel. He was with my husband until he sold the business. Until '65. Carl and Peter and my husband.

Then, unfortunately, my father-in-law's brother had taken a beating in the 1929 crash. He lost everything. He'd been a radical till he made money, then he wasn't so radical any more. So, in '31, just as the business was beginning to build up, my father-in-law came to my husband and said, "Dan. Do me a favor. Take your Uncle Meyer in as a partner." And—he did—for nothing. 'Cause it was family. Which was a

126

terrible thing to do. I don't believe in families being together in business. I learned that later in life.

The plant kept growing and growing. Accounts were coming in. I remember my husband after I had our first son—I never *saw* him. He would be gone months at a time. He would pack his one or two suits, his few shirts, and he'd hit the little towns. To build up accounts. They stayed with floor mats. I remember him: traveling, traveling, traveling. Accounts began to build up. Business started to come in.

And then he took his brothers in with him. His brother, Oliver, was working for an attorney. Oliver came to Keel Rubber about a year after it started. And he became the desk man. He handled the monies and the orders that came in. My husband was strictly in the plant. He was the builder. He had a mind. He looked ahead. He wasn't happy unless he was busy. They began to *really build themselves up*. The Halevys really started going places. Because they were *hard* workers. They were honest. And their name became *gold*. Oliver and Dan. My father-in-law. And Meyer. And then, later on, the twins, Ed and Jack, Dan's two youngest brothers. When they came back from the Second World War, he took them in. So that's how the Halevy family came to be.

When the war broke out, the army wanted to send my husband to the Malayan jungles. Because he knew rubber. He was 1A. They tortured him for two years. He didn't want to go. Well, thank God, he didn't go. I don't know how he got out of it. Except that when the war broke out, the government took over the plant. The plant was running twenty-four hours a day. War orders! War orders! Everything! So, I guess they thought he was important enough to remain here.

The business grew. Keel grew. And before you know, we moved. We got bigger and bigger and bigger. We built a new plant. There were presses that were two stories high. Mixers for raw rubber. From one division to two divisions to three divisions. A whole *street*. He got

accounts of all the automotive-parts wholesalers. We made the parts ourselves. Besides mats. Out of rubber. We had a steel division. We made *everything*. *Anything* that had to do with the automobile. We used to make for General Tire. Goodyear. We used to make for them. They used to put their name on it. Replacement parts.

My husband didn't care what was going on

upstairs in the office. He was interested only in what was going on in the plant.

Our business was booming. It was going full blast. My husband started to spread out into the city. He became philanthropic. He met other men like him. Together, they built the Great Synagogue. Dan went to New York and studied the plans of the Hayden Planetarium. He studied the plans of the dome. He could tell you everything that went into it. All the materials. What will oxidize this or that. So, when the synagogue built its dome, he knew all about it. He helped them save a couple hundred thousand dollars on the construction. Then he became a vice-president of the synagogue. And the Halevy family became known as one of the big, big givers for Palestine. It was Palestine in those days. Not even Israel yet.

In '47, I get a call from the Jewish Welfare: "Mrs Halevy, we'd like to ask your husband to go to Europe and Israel. We'd like to have his viewpoint as an industrialist. To study the conditions. And then come back." Naturally, that

meant to come back and talk about it, and raise money. But they got the wrong person! My husband had his *own mind*. What he wanted to think! Nobody could tell him what he couldn't say!

So, he said, "O.K. I'm going over. But I'm paying. I'm not asking for anything. Nobody to send me over. If I feel I want to say—that's the way I'll say it!"

He went to Europe. He was gone almost three months. He studied. He went to the D.P. camps. And he took notes. Notes and notes and notes. He was all over! He was in Casablanca; he was in Morocco; wherever you can think of, he went. [She speaks as if she were reciting the adventures of Odysseus.] He was even on the little tugboat that brought the *Exodus* into port! He was *all over*. He saw

everything. When Patton came into Germany, *he was there*. We saw movies he made of the gas chambers.

He was gone three months. *But!* After three months, we were told when he would be home. And we met him. We flew to New York. And it was like looking at a stranger. As he came through customs, I saw a *very tired*, a very weary-looking person. His face was so strained.

We went back to the Waldorf. He was 37. He couldn't talk. He really couldn't talk. Then that night, he began to shake. Like a nightmare. Luckily, one of the family was a doctor in New York, and I called him. And I said [casually], "Phil, Dan isn't feeling well. Could you come and look at him.?" Phil came over to the hotel, and he had to give him something to quiet his nerves.

I guess the reaction of that long, strenuous trip. *Seeing all the refugees. The camps.* The way they were *living*. What had *happened*. And then into Israel. I guess it got to him.

I know that in Rome, a woman had pleaded with him to get her into Israel. Before she had her baby. I remember—somehow, he got her out of that camp. And got her into Israel. So she could give birth to her child there. She sent him a tablecloth—made of rags. *Rags!*

Years later he met a young woman who remembered him when she was in the camp. Later on. On one of his trips. She said, "Aren't you Mr. Halevy? The man with the notebook? Always writing what we were telling you?" Years later.

It was *rough*. He had emotionally broken down.

We stayed in New York a few days until he calmed down. And then we came home. And then it began.

Jewish Welfare wanted him to make some trips. Go around the country. And I really didn't think he was ready for that yet. 'Cause this had *hit* him. I remember him meeting with this rabbi here in the city. The rabbi started to tell him this and tell him that. And I'll never forget that. I had never seen my husband mad. But [in a strained voice] that was the first time

he showed temper—in front of *me*. He *refused* to say what they wanted him to say. This rabbi was with the *Histadrut*, the National Labor Union in Israel. It's like the AFL-CIO. Only what it is, in Israel, *I think*, is a government within a government.

My husband decided that Israel needed an industry. That there were human beings who were *important people* in Europe—you couldn't throw them *charity!* That wasn't what they want. They want to feel like *people* again! He felt that there should be a business set up—a *company*, whatever, an *industry*. That's when he began Bond Tire.

He wasn't happy about the *Histadrut*. He saw money there. Lots and lots of money. They built a building there. I saw. During the austerity. In 1951. It cost [in a creaking voice] a *fortune*. Union offices! [Softly, as if to a sick child] O.K.? Well, he was against all that. And that is where he differed. He didn't want to agree with that rabbi. He crossed them. They wanted to write his speeches for him, and he refused.

I'll never forget: the first trip we took, I went with him. To Chicago. Where the United Jewish Appeal set up a big dinner. He got up. And, my husband was no orator. Believe me. Far from

it. He only spoke from his *heart*. And he got up! And he told of his trip. And the things he—he broke down. That he saw there. The children. Everything. Do you know? That one night alone he brought in almost a million dollars. Dan spoke from his heart. He didn't want nobody to write speeches for him or to tell him [her voice trembles] what *they* wanted him . . . they couldn't *make* him do these things. So, when *he* went on these trips and he talked about these things, Daniel Halevy did it from his heart. It was honest. And they all believed him! That Israel needs help. But in the way *he* felt it should be done. And [gleefully] people went along with him!

I could tell you so much that we went through on that first trip. We all went by boat. All the Americans who had invested in Bond Tire. The day we got into Athens, the Israeli Embassy had opened up. We docked in Athens. The embassy received us. They had a big party for us. They had sent from Israel a young woman to escort us. Into Israel. She was going to clear everything for us before we reached customs. So we could go right through. She cleared the

way for us. She had been with the Hagannah and all. Now she worked for the Foreign Ministry. They had sent her to escort all of us, this caravan, to the dedication of the Bond Tire Plant in Israel.

She got everything cleared. But I'll tell you one thing! She got all the men. She knew what she was doing. She had every man. She came to me and she said, "I am *so ashamed!* To be with *you*. Because look at my shoes. And look at my clothes. *I* am going to be your escort. I am so ashamed." So we went out into the streets of Athens to buy her clothes.

We got back on the ship that night. And [laughs] the fun began! She calls my husband. She says [in an appealing voice], "Dan, I don't know how to start the shower in the bathroom." [Laughs] So, my husband says, "You know, I'd better go in and show her. She doesn't know how to work the shower." So I said, "O.K." From then on it started with her. It went on quite a while. It wasn't a joke any more. She took them over completely. And my husband was *fascinated* by her.

She was a very nicely built girl. One of those little Russian girls. She was plain. She had nothing. But I saw in her something. As a woman. My husband was such a good-hearted Joe—he saw no wrong in anything. It started with a shower. From then on—I had no husband. [Laughs] He was the head of the Bond Tire Company. *She took him over completely*. It got so that I couldn't ride with him. She said, "*You* go with *them*. And I will ride with Dan." And this went on for about a month. And so I became very angry myself already. And before I knew it, the wives aren't talking to the husbands. There was one man from Oklahoma, he owned *a hundred and eighty chain stores*. His wife said to me, "I had to come to Israel to

have aggravation with my Ritchie?" [Laughs] She took them over completely. They were older men, and they fell for her story! She had been in the Hagannah. Like she used to say, "For a pack of cigarettes. Or to keep warm. I used to nestle in with a soldier." She admitted it! She admitted all that. Fine!

All right. So we got into Haifa. We got to the coastline of Israel. I got up at 5 o'clock. We were ready. We approached the shores of Israel. You couldn't tell the skies from the water. It was like *one*. It was so beautiful then. We got into the port. People were waiting behind the fences—the big iron fences—with [in amazement] *flowers* at 5:30 in the morning. To greet *us*.

When we left New York, we had a beautiful party Golda Meir had thrown for us at the Waldorf. Big baskets of fruit and everything with it. On the ship, they put our fruit baskets in the refrigerator. But the cold softened the plastic the fruit was wrapped in.

As they were taking everything out for us—we walked through customs already—we were waiting for the cars—big limousines were meeting us! (Where did they get them?)—As we were waiting, my basket broke! Went all over the place. The fruit, the oranges, everything, rolled out.

My basket broke! And I hear [in Yiddish], "Oy! Just to have an orange! An apple!" So I said [in Yiddish], "Take! Take!" They *looked* at me and they said [in Yiddish], "*You* speak Yiddish?" And I said [in Yiddish], "Does a *shikse* speak Yiddish? Take!"

We got to our hotel, outside of Tel Aviv. And that night, we go down to dinner. All sixty-five of us. I'm supposed to be "Mrs. Halevy, the Hostess." I met a lot of women from all over the U.S.A. The caravan consisted of all the

people who had invested in the plant. It was a private enterprise. It wasn't built by Jewish Welfare money. A group of people got together. Believed in it, invested their money. Whether they would get anything out of it—they just knew [in a whisper] *it was to help Israel.* My husband went after some of *the* Jews of the United States. A judge from L.A. A cancer research doctor. Chain-store multimillionaires from Oklahoma, Virginia, Pennsylvania. All of my husband's big accounts. Anyway, we met in Tel Aviv. From all over America.

The first night in the dining room. That's when I realized there wasn't any food. They had nothing. Really nothing. They brought us a bowl of soup. It was a bowl of water. With carrot slivers in it. Margarine. Mushrooms. Fish. Frozen veal from South America. And eggs. They counted the eggs. That night, I knew there wasn't any food. My American friends, my Yankee Doodle friends, were unhappy.

In the daytime, I didn't see my husband. He began to spend time at the plant. They didn't have the roof on yet. And he yelled. Then he got angry because he'd bought a nine-passenger limousine in the States and shipped it to Israel so the office men at the plant could ride between

their homes and work. But, when we got there, the Israelis wouldn't take it off the boat. The customs agent was away for ten days. The office was closed.

That week, we were invited to Ben Gurion's home. In Jerusalem. The government house. And that's when I *heard* my husband. I heard him. *Arguing* with Ben Gurion! About the *car.* My husband said, "A corpse! A person dies! Is his body held for ten days? Because your man has to go away? So there's nobody there to release anybody? A body, or anything?" Ben Gurion saw to it that we got it. Ben Gurion explained to him. *Here* sat Ben Gurion. *Here* sat my husband! And everybody was listening! The place was full of VIP's.

So, Dan says, "There's no roof on the plant! We're going to dedicate the plant? And there's no roof? Where are the people? Why aren't they building?" So, Ben Gurion said to him, "Well? What should we do?" And my husband said, "*I'll tell you what.* Just take me to a kibbutz! We'll *find* carpenters! *We'll put them all to work!*" And that's what he did! [Laughs] That roof went up. He got his way! *He commanded.*

He [laughing] did the whole thing! He showed them what had to be *done*.

But you know what they wanted from my husband? They wanted to own 51 percent of Bond Tire! He told them to go fly a kite. They ended up owning 28 percent. *They wanted to control* the plant! But they didn't get their way with him. And they loved him after that. They were his best friends.

S-o-o-o. The roof went up. The plant was dedicated. The first tire came off the press. And here's my husband and Ben Gurion!

While my husband's at the plant, I and the other women started to make the rounds. We saw refugees in tents, the numbers on their arms still *fresh*. Fresh!

We went everywhere. We saw everything. Fields—on one side barren, on the other side *green*, planted with trees. There was a place they took us. A secret place. In a grove of trees, nothing but a grove of trees. The ground opened up. And we went into the earth. They showed us a city beneath the ground. It went on for miles and miles. Corridor after corridor. Places where people could live. Swiss machines. Huge machines.

Don't ever think that Israel ever sleeps!

We were all over the country. The doors were open to my husband, wherever he went in Israel. He was a VIP. They saw he was a true son of Israel. He was so simple. He was so happy. Ben Gurion even asked him to be a minister of industry. That was a dollar-a-year job. He could have [sadly] done it then. It was my fault. I blame myself. Do you know why? Because I felt that in one lifetime—*there is a moment*. And if you don't [sadly] take that moment, it's gone. *That* was his moment. Even today, he's gone, I feel bad. I say, wherever he is, if there's such a thing as reincarnation and he comes back, I hope he makes it this time. I really do. *That was his moment*. But I didn't want to live in Israel. I had my sons here, and my family. I didn't want to stay there. I should have. If he would have said [decisively], "*This is the way I want it!*" then maybe I would have done it.

They *begged* him to stay there! They offered me a home! They offered me *everything*. I didn't want it.

I was the bad one.

But. The moment passed him by. He comes back and it's different here. Jealousy. Competition. [A long sigh] You see, he didn't work for six months after he came back. He traveled. I could see he wasn't himself. He didn't care about the business. He just wanted to *go* and *do*. His brothers began to get angry. Like he had lost interest. But he had been away in another world. A world that not many people see. And he saw. *He saw it*.

He would get up and tell a little bit in his own way. His eyes would fill with tears. He would cry! "HELP THEM! I SAW WITH MY OWN EYES!" he would say. "HELP *OUR* PEOPLE." And what else could they do? The checkbooks would come out and they would start writing.

So. I learned to know the man. Sometimes I could have throttled and killed him! He was *so damn stubborn!* Like all you men are! But there was a side to him that wasn't *real*. He wasn't for *himself*. He could care less. He had three suits in the closet. We used to fight him to go buy shoes. He didn't care. He had *ideals*. He just didn't fulfill them on this earth.

With his brothers [in a tired voice], it was a lot of envy. It was envy. He did his job. He brought in the whole family. They all had their bread and butter. He never *asked*. The place was big enough for everybody. He cared less.

It was a dynasty. It wasn't a healthy situation. It grew and grew and grew. When the second generation [sadly] came in, it got rough. What happened was: "If my son works . . ." then this one comes in and their son works, or the daughter gets married and they want to find a job for her husband. It gets very complicated after a while. There must have been ten or eleven relatives on the payroll. With the cousins and everybody else. Anybody need a job in the family? They got a job. They formed little cliques. This one would work against the other. It wasn't healthy. [Softly] It wasn't healthy.

They built a big business. And there was much love between them. But, I think, when the younger brothers came back from the war, they resented the relationship between the two older brothers. Who had really worked up the business. And that's how problems happened. *Jealousy! Envy! Competition!* The younger brothers against the older brothers. Maybe they just had it against their big brother. Who knows. I don't know! What I honestly think is that the older ones should have stepped back and given the younger ones a chance to prove what they could do. Dan and Oliver had been at it since 1931. It was time to sit back a little bit. But they didn't want to give up the reins.

There was *so* much resentment.

So, in 1965, Dan sold the business.

It was healthier. He'd meant well when he'd created all this. That everybody should have something. But he created a monster.

He just changed completely after that. He

had just worked so *hard*—from a boy on. And this *dream* of his, this company grew that he founded: Keel Rubber. He was just 19 when he started thinking about it. And then his dream came true with the company being born.

I mean, he did such exciting things! In the middle of the night, he'd say, "Pack my bag! I got to go somewhere!" I tell you, I never saw him. He was gone for months at a time.

He was a dreamer. A builder. He was always inventing. Always doing something. Even with the dome of the synagogue. He used to stand around and watch the bricks go up. *It was part of his life*, you know? He reaped something from it. It was his pleasure.

When we sold the business is when my husband got ill. He sort of withdrew. He became disillusioned. He was heartbroken. He didn't want to know too much. He stayed home.

One time, I had this big garden party. I became president of something or other. The Women's Auxiliary of the Convalescent Hospital. We had about four hundred women that day at the garden party. We had a *big* place.

My husband went around with a rake. Digging up the garden in the back. His trees. His fruit. His vegetables. Wore his cap over his—but I saw that far-away look in his eyes. I never said anything to him. And all the women wondered if he was the gardener. When he walked in, one of them said to me, "Since when do you let your help walk in the house?" And he said, "Lady! I *own* this house!" [Laughs]

That was August of 1972. In September, I had to go into the hospital. I stayed there ten days. I had some surgery. My darling helped me. But there was such . . . everything I could see, I could see he was *far away*, *far away*. Everything he did, you just felt it. And he died, he died three weeks later.

I don't know! There was something about him. He just didn't belong! Did you ever meet somebody who just didn't belong?

It took him seven years to die. He died of a broken heart. His first coronary came on in '67.

After that . . .

What he *died* from was heart failure. Where you *drown*. Like it fills up. But he didn't die from that.

You see, I *knew* he was dying. That week— it's funny how God works out things for you. My maid was off for the week. So, I had a lot of time with him.

But I saw he was struggling with himself. And all of a sudden, he didn't seem to care.

Friday, he got dressed. He was fighting with himself. I said, "Honey, you look *good*." I combed his hair. I used to give him his haircut. His hair was turning white. And he really looked nice. But his eyes were far away. I could tell something was happening to him. I took him straight into Emergency.

We sat there. Waiting and waiting. Finally they took him to a little room in the back. There was some Oriental doctor examining him there. He said, "I see nothing wrong with him. His heart is *good*."

I said to him, "I'm only a layman. But if you look at his eyes, you'll see there's something wrong with him." He said, "*Lady!* He's *fine!*" He says, "I think we'll let him go home!" I said, "*Oh, no, you're not!* I'm not taking him home."

He says to my husband, "Stand up, Mr. Halevy." Dan's looking at me, but *he's not looking at me*. I said to the doctor, "Take a look! *He doesn't see me!*" The doctor doesn't say *one word*. He says, "We'll admit him." It was 4 o'clock in the morning.

They took him up to Intensive. And they started the whole routine again. With the reflexes, and "Can you see this?" "Can you see that?" I said [pleading], "What are you *torturing* this man for? There's something wrong with him." And they said, "He seems all right." "But he's talking to me and he isn't looking at me!"

At noon, he's in bed. All of a sudden, he gets out of bed, *with nothing but his pajama top on*. He shouts, "I WANT MY MEDICINE!" I look at him. *That's* not my husband! No modesty. He wasn't acting right. I go to the nurse; I say, "He's not acting right." She says, "Let's get him back into bed." He gets into bed, then he gets out again. I got a little scared. I said [softly], "Honey, you ought to get into bed." "NO! NO! NO! NO!"

I was sorry to witness something so unpleasant. Because when you have a massive stroke you lose all coordination. And you just go like a top. You crumble. [Quietly] You just go down. Like you see a puppet they just let go? That's the way they go. And *he pulled me down with him*.

It took three people to pick him up. We saw him go through the whole thing. The stroke. The mouth gets crooked. I knew that was it.

But you know what was beautiful? And I'm not being emotional. We always had an agreement that we'd never leave each other if something happened to one of us. We never trusted a hospital. Because so much had happened.

I put my hand on his cheek, and I said, "Honey. Everything is all right. Because I'm here." And I put my hand on his cheek and he turned his head. And that was it.

What else can I tell you?

To go back over the years? They were beautiful years. I had a *beau-ti-ful* life. I really did. I knew from no want. I met him when I was a young girl. I'm going to cry. God was good. And sent him to me.

Jacob

JACOB: There was always reasons why we mutilated our photographs. We removed the corner—where the picture was taken— because we didn't want to reveal where we came from or what we were doing there. We destroyed a lot of correspondence. We were supposed to be *Greek* Jews. [Laughs] Now, how can you be Greek Jews if your picture's from Poland? [Laughs]

I once had a picture—the only picture I ever had—of my mother and father. I—for some reason—I don't know what happened. There is one picture, somewhere, where there is a *little, little corner* of my mother. Visible.

I was born on November 11, 1915.
And my full name is Jacob Wolf.
My mother's name was Bertha.
My father's name was Herman. He died in 1919. It was an epidemic of influenza. He was a young man of 38.

I was *born* Austrian. But the First World War had broken out. And so my papers were Polish.

My father was connected with a coal mine. He was a sales representative. Rather well-to-do. When he died, he left my mother with a lot of money.

The inflation took *every penny* of it. It set in in the early twenties. My mother had to work. To support her children. I was 3. My other sister was 7. My older sister was 9.

Somehow or other, my mother came to own a little resort hotel in the mountains in southern Poland.

She worked very, very hard. She was untrained, unskilled. But she managed. She gave us all fairly good educations. We all made it —*up to that point. I* was the *lucky* one. To survive.

I went to a *Volksschule*—a German-Jewish

school. The town I lived in was, politically, in Poland. But ethnically, it was German. The people did not speak Polish. They spoke German. So all schools, everything, was German.

Then I went to a *Gymnasium*, which also was German. But, in the meantime, the "Polanizing" trend started: everybody had to speak Polish. But most people, in schools and factories, couldn't pick up Polish. It's not an easy language to pick up. By the late thirties, if you went on the street and spoke German, you could get beaten up! But in school it wasn't too bad.

I got into a technical college. But it was not easy. There was an unwritten regulation, a *numerus clausus*: they accepted just so many Jews and that was it. I didn't get accepted in the mechanical department—which I wanted—but in the textile department. With the provision that if there would be an opening, I could transfer. And I did.

Once, we had a little trouble. It suddenly happened that one of the professors, who was a radical Polish nationalist, started agitating against having any Jews in school *altogether*. And the students started a boycott against us—all three of us. The milder form of it was: we went to lectures and we sat on one side of the room and they sat on the other. But that was not the end of it. One day the professor said, "That's enough! We don't want you even sitting there!" And they threw us down the stairs. As a result, the professor got fired. And we were allowed to continue our education. And I did, eventually, graduate.

By then, my mother had the hotel. My older sister had become a bookkeeper for a big oil company. And my younger sister helped my mother.

I got my first job in a Jewish company. Through an uncle of mine. I couldn't get a job in Polish industry. That was *unthinkable*. The firm where I worked was Jewish-owned, but the staff was all German. Among those Germans, there were those who were National Socialists—followers of Hitler—and those who were Social Democrats—who were very nice people. The plant manufactured wire and wire products. It was part of a cartel of ten companies.

I worked there for two years until the war broke out. I started out as a draftsman. I eventually became an assistant to the chief engineer. In charge of one of the manufacturing plants. I was a young kid, but I was making my headways.

My mother was making a living. She didn't get rich on the hotel. Just tying end to end. Nothing spectacular. On weekends, during the summer, there was *always* a lot of work, and I would come out and help. There was an orchestra playing. Dancing. Merry-making. Very pleasant times. But my mother had a hard life. Getting up at 5 o'clock in the morning, doing the cooking, supervising in the kitchen. And went to bed, 12 or 1 o'clock at night. The whole summer. Awful hard job. My one aim and hope was one day she would *stop doing it*.

In the summertime, I made my money by playing tennis. [Smiles] Teaching women playing tennis. [Laughs] I would sit at the court from 7 o'clock in the morning until 9 o'clock at night. Noontime, I rushed to help my mother.

Right across the tennis court, there was a little village hut that guests rented in the summer. One summer there was a family living in that house, and there was a girl who was always sunbathing there. Beautiful. And one day I approached her and asked if she would come to the dance that night. She said she would. And when she came, she brought her sister along. And her sister eventually became my wife.

Ruth, my wife, had seven sisters and brothers. Seven *beautiful* people. They all perished. She was the only one of her family, and I was the only one of my family to live. Out of my twenty cousins, three survived. Three were left.

We planned to get married in 1939. We decided—I told my mother, "1939 is your last season in the hotel business. In October, we get married, and you come to live with us."

But Hitler had different ideas.

The war broke out, and our plans were *slightly* changed, if you can call *anything* at that time a "slight" change. Because we *did* get married. Not in October. It was November. Circumstances were . . . different. In Cracow. The reason in Cracow was, well, I have to back up a little bit, how I did get to Cracow.

Just before the war, I took very ill. I came down with double pneumonia. While I was in the hospital, in my hometown, there were rumors that war was imminent. So my mother and Ruth and my sister and one of my aunts took me to Cracow. In an ambulance. There was another of my aunts living in Cracow who consulted one of the leading doctors: what should they do with me? They decided we should move to Warsaw. Outside Warsaw were resort places where people with lung diseases went because of the pine forests.

We caught the *last* train out of Cracow. August 30th. The day before the war broke. They put me on a stretcher. As a casualty of some kind.

September morning, about 5 o'clock in the morning, we got to Warsaw. And took a suburban train to one of the resorts. People were

running criss-cross at the railroad station! They didn't know *where* to run! They knew war was started—they didn't know when and how! Everyone tried to get away. They didn't know where to.

We got to the resort. There, people were still *calm!* They didn't know what was going on. There were porters at the railroad station, *waiting* for people. "What hotel do you want?" So one of those guys took us to a hotel. My mother didn't like it. I was surprised. I was so *damn* tired. I could hardly wait to get to bed. So we went to another one down the street.

I crawled into bed.

Ten o'clock the bombardment started. The first bombs that came to the town *hit that first hotel!* Its sounds unbelievable, but that's what happened. That was the first incident in the war that saved my life. My life, my mother's, and all of us!

Then the Germans came and there was nowhere to run. *We tried.* When the Germans were approaching, we packed whatever we could, used whatever locomotion we could get —horses, buggies—to go east. Where to, no one knew. I felt terribly—I had the fate of three women who really sacrificed themselves for *me.* They wanted to save *me* because I was the sick one! They would do anything for me: if I couldn't go any further, "Well, let's sit down." I felt I was endangering *their* lives. And they were afraid for *my life.* They felt the Germans would rather harm a man than they would harm a woman.

Thousands of people were running away from the Germans.

But their motorcycles and cars were faster than we. And one morning, after maybe two or three days of *running* and every day shedding *more* of what we were carrying with us, finally [laughs] we ended up with *one* suitcase and *one* umbrella—sitting in the forest. We heard trucks and motorcycles passing us by. There was no sense in going farther. We went back.

No harm came to us. The Germans came to visit us. Looking for—*valuables.* Whatever we had. Even watches they took from us. But didn't harm *us* in any way.

In November, we decided to go back to Cracow because we knew my two uncles were there. One was a hotel owner near the railroad station. The other one had a restaurant.

I was in good health by then. That running away from the Germans put me on my feet. [Laughs] We went back to Cracow. And we all congregated in my uncle's hotel. There was a lot of room. There were about thirty-five members of the family in the hotel. The only one who wasn't there was my older sister. When the war was imminent, all the leading officials of her company were called to the central office in Lvov. And she went with them. So she ended up on the other side of the dividing line between Poland and Russia.

The Germans *started* their pressure—they were picking people off the streets for the labor brigades. Then they enforced the wearing of the Star of David.

No one knew how long it would take—a year? A half a year? The war must come to an end. And our money run out. So I tell my mother, "Elsie is in Lvov. People go there. And somehow they find work there. Why should I sit here and be a burden on you? Let me go there. I find a job! And you follow me!"

I was 24 years old.

My whole family said, "DON'T GO. Whatever'll happen to us will happen to you. Sit here with us."

My mother said, "No! If you feel you want to go, you'll go."

So, before I went, I got married. We found a rabbi from somewhere. We made a *hupa* in my uncle's apartment. The Germans were walking down the street. We got married.

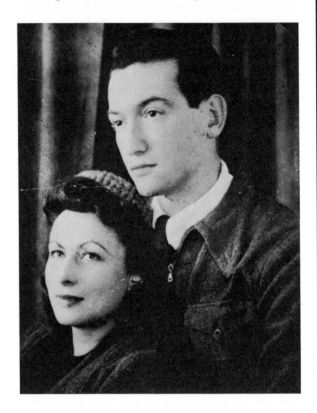

Now, how do you get to Lvov?

When Poland was divided between Germany and Russia, Lvov got to be Russian. And it was not *legal* to go across the border.

But there were men who were in the business of guiding people back and forth. People from Lvov wanted to come to Cracow. People from Cracow wanted to come to Lvov. We found out the name of a *reliable* man. But he said he *couldn't.* So he gave us the name of another *reliable* man.

We had a group of five people. A dentist. A translator. A medical student. Myself. And my wife.

We took the guide. Or, rather, the guide took us. We were supposed to go across the border. By train we went to a town on the river Sun. Which was the new border between Poland and Russia. We got to a hut somewhere out in the fields. It was December. Muddy and snowy. Cold. Dirty. And the following morning, we were supposed to cross the river. By boat.

The guide said he's going to bring over the guy who has the boat. And the guy came! He says, "All right, let's go!" It was just before daylight. And we all walk out to the river. It's dark. And the river is *full to the brim*. Because of the snow and the rain. Terrible situation.

He said he was going to get his father with the oars. He left us and never came back. Oh, he took our money all right. Fifty dollars a head. *Dollars*. And we stayed there in the field. It gets daylight. Where do we go? And here comes a German patrol!

We decided among ourselves just to tell the Germans what really happened. Then there can be no confusion. So, the German patrol came up to us. "What are you doing here?" We told them the story. So they took us to a farmhouse. To a big estate. Checked our baggage. Whatever we had of any value disappeared.

They behaved very nicely, I must say. The Germans were in the Wehrmacht. There were no SS. They were regular soldiers. As a matter of fact, while the officer was checking our clothes, he stayed a few feet away from my wife. She had to take off the blouse. And invert her bra. To show that there was nothing there. But he would not come even close to her. She complained of headaches. They brought her blankets and aspirins.

Then he said, "Well! You say that man promised to take you across the border? Let's go and look for him." So, a corporal on a horse and an officer on a horse and I and the dentist—we went. We went to the village. We went from house to house. And you should have seen how they beat up those poor people. *Poor people!* I shouldn't say "poor people" because they were *bastards*. Till finally they found out who the guy was who promised to take us across.

It was a Ukrainian. They chained him to the horse. And drove him back to the farmhouse. And they said, "O.K. Where's the money you took from those people?" He gave us back our money. But! German punctuality! The officer said, "All right. Here's your money back. *Sign the receipt.*" So we signed. Then he said to the Ukrainian, "Now. Take these people across the river." So the Ukrainian says [in a high-pitched, pleading voice], "I don't have a boat!" The officer said, "We take care of that. Just take them across."

So, again, we go to the river. It was night. And here's a *big* military pontoon boat! [Laughs] "O.K. Get the people across." And that Ukrainian was a little guy. We were sure that once we were out on the river, they would take a machine gun and—*shoot us all*. Why would they do this all? It was stupid!

We had to push the boat because the Ukrainian couldn't. In the meantime, we were making such a racket on the river that the Russians picked us up! They were waiting for us. The minute we landed on the other side, *miles* down the river, they were waiting for us. They jumped us! *With dogs!* They scared the hell out of us.

They put my wife, just my wife, on a wagon. We had to walk. Because the Ukrainian—we didn't speak Russian and I didn't understand Ukrainian—*told* the Russians that *we were spies*. He saw us accept money and sign for it. "*They spies.*" *That* was all he had to say.

They really started checking our luggage. Smashing. They sent us to jail.

Naturally, we weren't the only ones caught on the border. There were *thousands* and *thousands* of people caught on the border that had tried to get away from Germany and enter Russia.

But, we being *spies*, they right away got the prosecutor out of Lvov. *Specially*. To investigate our case. They split us up.

Naturally, they were not much interested in women in the jail. It was overcrowded. But the women *didn't want to go*. I say "women" because there were many other women, with their husbands and brothers, who were in the same situation we were. They say, "We not leaving the jail without husbands and brothers." So the Russians said [in a placating manner], "But you cannot stay *here*. This is a jail for *men*. We take you over to a jail for *women*." So they packed them all up. Lined them up. Marched them out the door. Closed the door. "*Go to hell*." Just threw them out. It was one of the most severe winters in many a year.

Conditions in the jail were [in a whisper] *terrible*. There was no sanitation. There was hardly *anything to eat*. There was nothing. People got sick. Ohhh! People slept on the floor—*if there was room*. There were so many people in one cell. The four who had been with me—I never saw them again. *Never*.

My wife tried, naturally, whatever she could. She got in touch with my sister, but she couldn't help anything. She was a hundred kilometers

away in Lvov. Finally she got to the prosecutor. And *I could have got out*. For a price. I'm glad she didn't pay. He wanted her to go to bed with him! Then he would have done—who knows? So. She didn't. And I wouldn't have got out, anyhow.

One day they bundled us up and said, "We transferring to another jail." And. My wife didn't know about it. One night they came, took us down the road, and down we went to Harkov. It's one of the major cities in the Ukraine.

There they *really* took everything from us. I had *tiffilin* [phylacteries] in my rucksack. I didn't use them, but they were the one thing I had from my father. The Russians—when they check you out—*they look in every orifice* in your body. And I mean, *every orifice*. And they found those *tiffilin* and they didn't know what it is. They thought I was *hiding* something there. So they just tore it in little pieces, in *shreds*, and threw it out.

From there we got transferred to a jail. In White Russia, somewhere. And in that jail, I spent eight months. How my wife found out I was there, I don't know! But she did, eventually, find out I was there because . . . I didn't get them—but *my interrogator* had letters which were written to me. Which he tried to blackmail me with.

I was in jail under two statutes: illegally crossing the border and suspicion of espionage. The interrogations started. Interrogation was, normally, not done in the jail. It was somewhere in a police station. Down the street. Maybe a mile or so. Mostly at night. They will take me out of the cell. Four soldiers. One in the back of me. One on each side. One in the front. All with *drawn revolvers*. Like I'm a *Big Man!* [Laughs] And the front man would *whistle*. And if anyone was approaching, the soldier

would blow a whistle, and they would have to turn their face. To the wall. So they *wouldn't see*. So I couldn't give them any message or whatever.

The warden in the jail was a Jew. *A very elegant man. Always in gloves*. Very well dressed. Very elegant. Always smelling of perfume. Very refined. [In a whisper] *A bastard*.

The interrogator—*who also happens to be a Jew!*—he got me to tears. He never hit me! But he had ways to get to me. He would blackmail me: "You want to see this letter here? I have a letter from your wife. You want to live? You want to see her again? Now tell the story. Who sent you? What for? What do you do here? Why do you come here?" And he will go *on* and *on* all night [in a whisper] *for no end*.

Of course, I always said, "You *know* why I'm *here*. [Laughs] *I tried to save my life. That's all! That's my crime*."

One day they called me out. To the warden's office. And say, "Here! Sign it!" I said, "What is it?" "That's your sentence." I said [irritated at the presumption], "What do you mean? My sentence! Who is the judge and the jury?" [In a harsh, nasal voice] "We don't deal that way. That's the troika." It was a committee of three. And they judge you. Without your presence. And I got—*ten years of hard labor*.

I never signed the verdict. They said, "It doesn't matter if you sign it or not. You still get your sentence."

I got tranferred to the labor camp. That's a story in itself.

There was a place, a distribution place, for all the northwestern Russian camps. The name of the place was Kutlass. I can show you on the map, if you want, where it is. It was a huge

place. There were a few tremendous wooden structures, where, inside, you climbed by stepladder, up to shelves, where you slept.

They stripped us of *the rest* that we had. Belts. Shoelaces. Whatever was stringy. No toilets. Just *pits* in the ground. There was one of the most terrible things I have seen people do to people: when a pit was full, they would cover it with lime and soil. You couldn't see it. Then the soldiers, on the transport, who had taken all your valuables and belts—when they wanted fun, they would say, "You want your belt?" And they would throw the belt over the pit. And people ran—and fell over their heads [very quietly] in shit. And *they* would stand there. *Laughing and having fun*.

From there, I got on the train which would take me to my first destination. The way you got there was on *open* flat cars. Every second or third flat car had a machine gun on it. You couldn't run. Where could you run to? Anyhow. I got sick. I got the dysentery. And. They took me off at a substation.

I got into a camp that was *purely* Russian. I still wore some of my clothes I had from home. Which those Russians had never seen! I had *shoes*, which they were amazed about. [Smiles] I was like a *toy* for them. I really had a good time with them. They were criminals. Murderers. Robbers. But I was a novelty. And there you got food if you worked. You had a certain norm to fulfill. If you didn't fulfill it, you just got half a portion or nothing.

I never went hungry there. Because they had fun to see me take a wheelbarrow, going down some boards, full with soil. I couldn't *possibly* hold! [Laughs] *I never did it*. So they laughed! "Try! Try again!" And when the food came, I never made my norm, *but they* fed me. I had a good time. I was a joke. They

took everything from me. The *shoes* were not too long with me! [Laughs] The *fur coat* was not too long with me!

Then one day they sent me to another camp where there were a lot of Polish Jews. And there [sadly] I *saw first misery.* Close to the Arctic Circle. There, people were fighting for survival. By all means. They were not like the Russian criminals, who had their morality: "If you steal bread, it's your head." In the new camp, there were people inexperienced in that way of life. *There was no morality.* One would steal from the other. *Anything.* Bread! Soup! Anything he could get a hold of. They were not used to work. And they *had* to work. People died [in a whisper] *every day. There was not a day* we would come back from work that someone wouldn't die. Or we would drag him back to camp. We went out to work in winter—40 degrees below zero. No proper dress. No proper food. *Nothing.* Not even proper tools, to do the job they wanted us to do! TERRIBLE.

In the morning, when you went to work, they would line you up in fives. In brigades of twenty-five men. The soldier who would take you out was responsible for you. *Dead or alive.* But he was responsible for you. So we were counted up and we went out the gate. Then he would stop you and give a little speech. He says, "*One* step *left, one* step *right,* and we *shoot.* Without warning!" That was [laughs] the morning prayer.

I saw a Pole, a sample of health, like a marine here, break down and die in ten days! He broke down *spiritually, mentally, physically.* You had to *hang on* there. You had to have an incentive to live. Every morning, I remember, when I got up, I had *a choice.* Do I or don't I go to work? If I don't, *it's the end.* If it's the end, then I have the responsibility of my mother, my

wife! No! I better go! And you lived from day to day there. Every day, you'd say, "I *can't* any more." But in the morning, you'd say, "*Got to do it.*" And you *survived.*

In the fall of '41, they organized the Provisional Polish Government in Exile—in Russia. [Ruefully] Their first official act was an amnesty for all Polish citizens. That was lucky. Because we were in an area where they couldn't even bring the daily food to us! We had a few sacks of flour. That was all. We had no winter clothing, and it was late September, the winter was coming, it was already freezing and snowing. When the amnesty came, we got out of there; otherwise, *none of us* would have come out of there.

They were going to discharge us.

And the question is, "Where do you want to go?"

Well, I have to back up a little bit.

When my wife got thrown out of the jail, she eventually wound up in Lvov. With my sister. And eventually, she got resettled from Lvov—*to Siberia.* Not under sentence. But as resettlement. But she had to stay there and not leave the area. She wound up in a *kholhoz*—a collective farm. A lot of Polish people were in that area.

She *knew* where I was. I really don't know how she found out. But, through the two years, I got a postcard. So, I knew, more or less, in what area she is.

When the day came, they ask me where I want to go. Everyone, *naturally,* want to go *south.* To the *hot* area. To Central Asia! To Tashkent! [Laughs]

And I asked for a ticket to Novosibirsk. The guy thought I'm crazy! He says [amazed], "What do you want with Novosibirsk?" I said, "My

wife is somewhere there." He said, "You nuts? You go *there?* You will find your wife? In Siberia?" I said [very quietly], "*I want a ticket to Novosibirsk.*" It was the highest-priced ticket. Oh, my God! I don't recall, it was a couple thousand miles away!

It took me a couple of weeks. There were no trains. Although I caught a train, eventually. A Trans-Siberian express. At first I went on *any kind* of freight trains. Whatever I could catch. But it was taking *so long.* Because there were military transports going. And every time a military transport came, it had priority, so we could stay in the train yard *for days.*

And here, the other side of that period came to light: *The soul of the Russian people! They are good people.* They fed me. They hid me. Thanks to them, I got to Novosibirsk. I didn't have any money for food. I was illegally on the train. I had no ticket. So they shoved me under the seat. They put me on the top of the shelf. They *fed* me there. *Watched* for me. They really were good for me.

I looked *terrible.* I had no shoes. I was wound in rags. I had nothing.

I got to Novosibirsk. Which was just the first stop. From there, I had to go on a railroad, north, up into Siberia. But there was *no train* any more! I *knew* I was going in the right direction. Where my wife is supposed to be.

I got up there and started *walking.* Living off the fields. [Laughs] Whatever was edible, I ate! And I walked for three days. And one day, I walked *in a circle.* It was the steppes. You have no direction.

Finally. By came a Russian troika. Four wheels, a board in between, three horses, and *they go like hell!* They picked me up! I told them the name of the farm. He said, "Oh, it's a long way! But we go in that direction. We

take you as far as we go."

So, I went with them. And they dropped me by a station. *And here, some people come up!* Which I knew are not Russian. *They were Polish people!* I say, "Where do you come from?" The first one I asked, he told me, but I didn't know where it was. Till I found someone from the place my wife was! I said [softly], "Do you know Ruth Wolf?" He says, "Yes. She is there. But she left. She must be on her way here." So, "How long will it take her to get here? And how does she get here?" "Well, they come mostly by river. Who knows how long? A day? Two, three, I don't know."

So. I went to the river.

Made myself a tent of leaves.

I sat there.

And waited.

And one day, I sit there, the river, and by goes a woman. And I recognized her coat. A coat I had bought the material for, years before. For a winter coat. For my wife.

And here she walks.

She walked right by me. She didn't recognize me. If I weighed 110 pounds, it was a lot. I was just skin and bones. And blue.

So. Anyhow. *We met.*

We went south. To Tashkent. On a cattle train. It was a long ride to Central Asia. We got as far as Leninabad. We were sleeping on the ground by the railroad station, and thieves came and cleaned us out. So, we settled there.

I found a job as an assistant to the master mechanic of a shoe factory. He was a victim of the Russian Exile of 1937. He took me under his wing.

I found out for the first time—in camp I didn't feel it as badly—what *hunger* is. What it means to have a little piece of bread. We would get a little piece and divide it: one piece

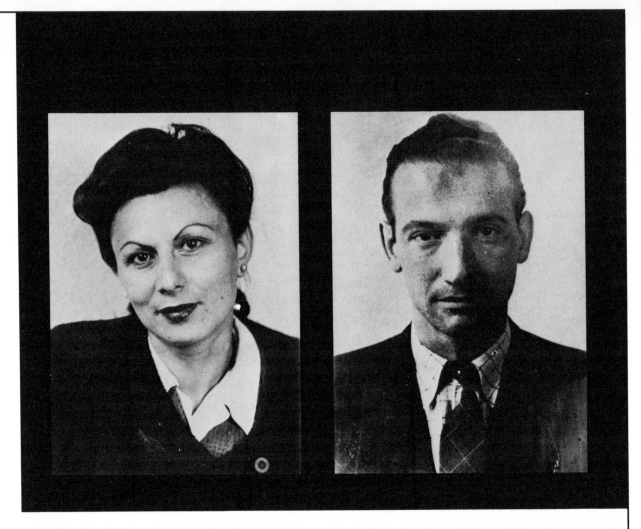

for today, one piece for the next day. And we both wouldn't sleep at night. Because we *knew* there is the bread. The knowledge *did not leave you alone* that there is a piece of bread you could have *right now*.

In that area in Russia, you could not survive unless you stole and sold on the Black Market. But some people began to steal, not to survive, but to make a fortune. There were a lot of very enterprising young people in the shoe factory. And they stole leather. By the tons.

I had to steal, too! *But.* The first thing I stole was a piece of soap. And the upper part of a pair of boots. I brought it home. And my wife almost threw me out!

Gradually I learned how to steal. I became proficient. I had access. I could go into the factory at any time. To repair the machines. So, the other guys started approaching me. They *knew* that I could carry in and out. And I didn't want to. Except what I wanted for *my own survival*. That I will take.

My wife got pregnant. That was '45. She was due the beginning of '46. The war ended. There were rumors of repatriation of Polish citizens. But when and how no one knew.

I said, "I don't want my child to be born here. I'm getting out!"

I'd become secretary of an organization of Polish expatriates. And the N.K.V.D. began to suspect that we were plotting against the Soviet government. So, one night they took me in. Arrested me. Took my belt. Put me in jail. And began questioning me. The commissar comes in. Cookie. Tea. We started chatting. He says [smiling, showing all his teeth], "We friends! Aren't we! You want to go back home, don't you?" "Yes, of course," I say. "Well, before you do, why don't you tell me how you and your people intend to take all the gold and diamonds back with you?" He started to get *nasty*. He said, "Look! If you want to get out *alive* from here, *you better tell me! Or you'll never leave here alive!* I *know* what's going on! And *you* are going to tell me!"

It was going on for a few days. My wife didn't know *what* to do. Because it was the N.K.V.D. With *them* you *don't* fool around.

But. They let me go! They had no case. If I don't tell, what will they do? Shoot me? That far they didn't want to go. So they let me go.

I got out and I told my friends, "I'm getting out of here! It's getting too hot!" I had made some money from the Black Market. I bought tickets for the train. I bought false passports. I *bought* all the papers I needed. One of my friends asked me to take his parents with me. They were old people. I said, "All right." He said, "Why don't you take my sister, too?" I said, "O.K."

So, one night, I left everything in my little room. Just locked the door. Went to the railroad station. Got on the train. And off we went.

It was uneventful till we got to someplace in the Ukraine. We got there, and it was *terrible*. There were *thousands* of people standing in the railroad station. Nothing moved.

I said, "Oh, my God! Now I've *really* done it!" Here I am! With my pregnant wife. Two old people! And I start asking people, "How long are you here?" "Ten days." And I said [in a whisper], "Oh, my God! We have to do something!"

So I see a woman. An N.K.V.D. woman in uniform. Walking around. So I approached her. I said, "Look! I want to go to Lvov. [In a slow and steady voice] I'm here with my pregnant wife and two old people and a sister. Can you—anyway—help me?" And I throw in, "I'll make it worthwhile for you." So she says [in the voice of a little girl], "O.K."

I said, "How do we go about it?" She says, "I go off duty at 12 o'clock. Give me your documents." I said, "I'll give you a hundred rubles per person. I'll be here at 12 o'clock at night." I go back and talk it over. "Can we *dare* to give her *our* documents? What if she goes and we never see her again?" But I said, "We have to take the chance. We have to take the chance."

So she came and I gave her the documents. And, *sure enough* [in a very low, quiet voice], *here she comes*. We go far in the corner of the railroad yard. There is *one* coach. A Pullman coach. No one around. Nothing around. Just the Pullman coach. "Go lay on the upper shelves. *Keep quiet.*" So we did.

At daylight, a locomotive came and pulled that coach to the railroad station. And attached it to a train. And right away, soldiers with machine guns, standing right in front of it. And there's a lot of invalids and Russians trying to get on the train. They wouldn't let them. They almost *shoot* them. The coach was assigned to higher echelon [starts to laugh] military officers; and their wives and kids came on the train! We lay up there. They didn't pay any attention! [Laughs] We went to Kiev. And from there we caught a cattle train to Lvov. It got a little touchy. [Laughs] To ride a cattle train with a pregnant woman!

From there we got to Cracow.

And then [sighs], I made a trip to my hometown. To see if someone or somebody is somewhere. Whatever I could find out is all bad. Everywhere, the same story. All people are killed. *There was none left.* They were taken away and they didn't come back.

So.

We decided to settle down and await our daughter's birth in my wife's hometown. In January 1946, she was born.

I started looking for ways to get out of Poland. I got in touch with Zionist organizations. There were Hagannah brigades carrying people across the borders. *Everything was illegal.* Any border was illegal. People were trying to survive to find a place in this world! *Everything was illegal!*

We traveled from Czechoslovakia to Vienna, from Vienna to Salzburg , from Salzburg to the Alps in Germany. We had to walk. My daughter was a half year old. So. I *carried* her. Bundled up. In a blanket. When we got to Reichenbach, I found out I was carrying her upside down!

We found out that my wife's cousin had survived and was living in Bavaria. He had been in Auschwitz. He invited us to join him. He had a big apartment. He was dealing on the Black Market.

The Americans had coffee, cigarettes, butter, chocolates *by trucks!* The Germans were *hungry*

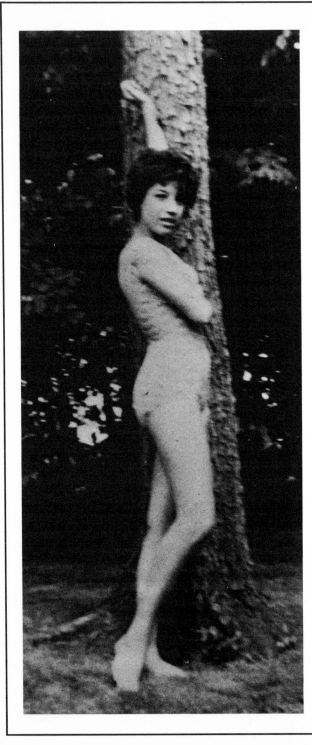

for those things. People were making fortunes. We made a nice comfortable living.

But then, in 1947, my cousin left. To America. And I applied to emigrate. I had the hardest time to decide where to go. Israel? Or America? Sentimentally, I wanted to go to Israel. For material reasons, selfishness, I decided, "Enough is enough." I decided to go to America.

We came to America, May 18, 1949.

My wife's cousin was in Buffalo. So, naturally, our destination was Buffalo. I spoke German, Polish, Russian. But not English. It was funny! My first job in the city! Going by streetcar to work! To a wrecking company. All along the way there were a lot of big, beautiful houses. One after the other! They all looked beautiful. And nice. They all had big signs in front. Which I couldn't read. I thought, "There must be good business here! A lot of money here!" [Laughs] When I learned English, I found out they were funeral homes. I had no idea!

Ruth died in August 1964. Cancer of the ovaries. Doris, my second wife, was her nurse in the hospital. She took care of her. She was head nurse on the floor.

DORIS: After Ruth died, Jacob sent me a lovely card and some gloves, thanking me.

Our paths crossed in many ways. We bumped into one another in restaurants. At tennis matches. We met in supermarkets.

In 1967, I was going to Europe on vacation. I was standing in line at the ticket counter in the airport. The agent took my ticket and said, "Fine. There you are Miss McNeil. Have a nice trip to Paris." And I said, "*I'm* not going to Paris." And this voice on my right said, "*That's my ticket!*" I turned around and looked and he said, "Miss McNeil!" And I said, "Mr.

Wolf!" We were both going to Europe! He said, "I'll see you on the plane."

The plane was packed. I was sitting next to a very nice gentleman. Jacob got on the plane and said, "I was wondering if you'd mind changing? This is a very old friend of mine." And the man very nicely said he would. So, we sat together. And he said, "When I come back, can I call you? And we'll have dinner together?" And I said, "Yes." He called me in June. And we were married January 1968. And I always think that if Ruth knew, she'd be very pleased.

About the Author

Michael Lesy was educated in Ohio and then went on to receive degrees from Columbia and the University of Wisconsin, where he held a Woodrow Wilson Fellowship. He received his doctorate in American history from Rutgers University. He combined his work as a photographer and a historian in his two previous books, *Wisconsin Death Trip* and *Real Life: Louisville in the Twenties*. He is currently at work on a book that will incorporate photographs from the collection of the Library of Congress.